D1164510

Sternberg Press

Barry Schwabsky

ORDS

FOR

ART

Criticism, History, Theory, Practice

For David Shapiro and John Yau:

poets, art critics, friends

PREFACE AND ACKNOWLEDGMENTS

Art can be both a pleasure and a challenge, but dialectically so. The pleasure comes from the challenge, but the challenge comes from the pleasure. The same should be true for what we write about art, and that's so whether the person doing the writing is called a critic, a historian, a theorist, or an artist. For nearly as long as I've been writing about art, I've been interested in the art of writing about art. And just as I've sought out opportunities to write reflectively about art, I've looked for occasions to write reflectively about art writing. And just as my writing about art has been done, so to speak, without a license—that's part of what it means to me to be a critic: to write as someone whose writing is not backed up by any credential but only

by the force of the writing he or she produces, its cogency and perception and eloquence—I've taken it upon my self to reflect on the writing of people whom I am not qualified to criticize, to write as a critic about a philosopher such as Jacques Derrida without pretending to be a philosopher or a historian of the order of Meyer Schapiro without being a historian, just as I write about the production of artists without being an artist.

In my view, what distinguishes art from other activities is the nature of its relationship to its public, which can be summed up in Marcel Duchamp's saying, "It's the viewer who completes the work." At the other end of some aesthetic spectrum from Duchamp, the street artist Banksy says the same thing: "A painting isn't finished when you put down your brush—that's when it starts. The public reaction is what supplies meaning and value. Art comes alive in the arguments you have about it." Science, for instance, does not exist for a public in the sense that art does; sport has a public but not one that is ontologically necessary to it. The role of criticism is to give a formal instantiation of this public. And yet to say that the viewer completes the work is to say the work is never finished, because there is always another viewer who will complete the work differently (unless of course the work is forgotten, lost to view, in which case it will no longer be completed). Metacriticism—the criticism of criticism, the argument about the argument—is the witness to this never-finished condition of art.

The twenty essays in this book, all but one of which originated as book reviews, were written across as many years, and for different kinds of publications. "(Speaking personally, what I write is art criticism with footnotes)," wrote Lawrence Alloway, an incredibly forward-looking writer whom I'd like to write about at length some time (I love the beautiful modesty of his parentheses). By the same token, and just as the news has been said to be "the first rough draft of history," what I write as a critic might be characterized as art history without footnotes—though in fact about half of the essays reprinted here did originally have footnotes. I've suppressed them in the interest of consistency but also in order to spare the reader any illusions that I consider these pieces to be finished scholarship rather than merely rough first drafts of a history that remains open. It is only natural that over time one's thinking changes—one likes to think it *develops*—and it might be that if I were sitting down to write some of these essays today I would write them differently. My belief is that my younger self should be allowed to express himself as he was at the time and not as I would now like him to have done, and so I have revised these pieces only lightly to the extent that I have done so at all. The only one that differs substantially from its previously published version is the second one, on Walter Benjamin's letters, which was published only in a very truncated form. Therefore this is the first publication of its full and original version.

Some readers may wonder about the inclusion of essays on Benjamin

in a collection of writings about art writing and art writers. Although he wrote at least one text that has been enormously influential in subsequent thinking about art, and of course he was an art lover to the extent that he took a drawing by Paul Klee as a sort of personal emblem, he was hardly an art critic. I could counter this reservation by citing his general importance for art criticism, and I hope the second of the two essays on Benjamin succeeds in suggesting that he could be even more important for the field, and in different ways, than he presently is. But there is also a more personal reason for his inclusion here. Since my educational background is in literary studies rather than in either art or art history, my main models for criticism have been literary: Roland Barthes, Paul de Man (with whom I was fortunate enough to have had some contact when I was, briefly, a graduate student at Yale University many years ago), and William Empson impressed me profoundly—and among modern writers on art, only Adrian Stokes and Clement Greenberg come close to them in my estimation—but Benjamin left a deeper mark on me than any of them; my writing would be something very different, and I am sure something poorer, without my repeated reading of his works.

It was also in a shared fascination with Benjamin that my friendship with Alex Coles took root. Although there are many people without whose aid and comfort this book would not exist, Alex is first among them. While this is a different book than the one he encouraged me

to publish, without that encouragement no book would have come into being at all. Thanks, Alex; I'll take up that other project soon enough. I also thank David Carrier and Faye Hirsch for many years of thoughtful discussion on art criticism and its pleasures and discontents, and of course all the editors who commissioned or accepted for first publication the essays collected here and who helped improve them with sharp advice; sometimes it feels alright getting your ass kicked. Faye was also one of these editors. Another was Kathryn Hixson, when she was in charge of the *New Art Examiner*. I miss her terribly.

WORDS

FOR ART

OCTOBERFEST

A Modern Art History?

As someone who once considered becoming an English professor but wound up writing about contemporary art, I've always been struck by the fact that while scholars who write about Shakespeare or Milton call themselves literary critics, those who specialize in Velázquez or David call themselves art historians. What does the art historian mean by disidentifying himself with the critic? In art writing, the distinction between historians and critics is generally based on a rough distinction, first of all, between the objects of their attention: critics write about more or less recent things, while historians deal with older ones. Of course, there's inevitably some overlap. These days the art of the

Yve-Alain Bois, Benjamin H. D. Buchloh, Hal Foster, and Rosalind Krauss, *Art Since 1900: Modernism, Antimodernism, Postmodernism* (New York: Thames & Hudson, 2005).

1960s and '70s is being combed for dissertation topics by young historians who may not have been born yet at the time, while critics remain loath to abandon it as no longer contemporary—after all, many of the era's protagonists are still hard at work.

But there's another distinction to consider: a historian is assumed to be a credentialed academic, a professional, while a critic may be something else altogether—what the art theorist Thierry de Duve once nicely described as someone "whose profession it is to be an amateur." Some critics may have scholarly qualifications—indeed, might themselves be historians on a day off, as it were—but those qualifications are of secondary importance. Instead, the critic is a self-appointed observer; all that counts is that he offers an articulate account of aesthetic experience: "Painting reflected by an intelligent and sensitive mind," as one of the greatest art critics, the young Charles Baudelaire, put it in 1846. Erudition is no impediment to the critic, but imagination and gusto are more essential; an aptitude for generating ideas and interpretations is more valuable than the ability to test and verify them.

From the critic's ill-founded endeavors, the historian takes a distance. The granddaddy of art historians, Heinrich Wölfflin, made it clear that the field's scholarly credibility could only be underwritten by a subjective removal: "Instead of asking, 'How do these works affect me, the modern man?' [...] The historian must realise what choice of formal possibilities the epoch had at its disposal." The historian's,

according to the author of *Principles of Art History*, is a descriptive and classificatory enterprise whose object is not so much the particular object or the individual artist as that series of "modes of vision, or let us say, of imaginative beholding" that are normally called styles.

Despite the intuitive attractions and methodological usefulness of this imagined distinction between the critic, receptive to aesthetic experience in the present tense, and the historian, abstracted from his own subjectivity, the better to reconstruct the mentalities of another time and place, the reality is that the two have more in common than either would like to admit. No one, not even an art critic, lives wholly in the present without a grain of historical consciousness, while the very definition of a field of inquiry under the rubric of art depends on implicit judgments about value, which by definition can never be free of critical subjectivity. The critic has to be at least a little bit of a historian, the historian something of a critic.

There was a time when questions about the boundary between art history and art criticism might have seemed immaterial because few people had much interest in crossing it. If you were to look back at an issue of *Artnews* from the 1950s, when it was the leading American magazine in the field, you'd see that articles on the art of the past were written by professional historians. Only occasionally did the latter care to engage with the art of their own time; a figure like Meyer Schapiro, the great medievalist who also wrote on modernism, was

distinguished in part by his rarity. By contrast, articles on the work of living artists would be written by critics who, for the most part, were either artists themselves or moonlighting poets. Sometimes their writing even earns the historians' disdain as an "associative and thus eminently arbitrary and subjective procedure"—so Otto Pächt put it in 1930—"already discredited by the known fact that one can project, with some complacence, anything whatsoever into a picture, sculpture, or ornament"; "a form of journalism all the more amnesiac for having constantly to adapt itself to market trends," as Yve-Alain Bois fulminated in the pages of *October* magazine some fifty years later. Sometimes not.

This clear division of labor between historians and critics began to break down in the mid-1960s with the appearance of magazines like *Artforum*, which became the organ for a new generation of academically trained art historians who were passionately involved in the art of the moment. For them, history became the engine driving art toward its future. They brought a new, hardheaded, formidably analytical style to writing about contemporary art. Its effect was all the more powerful in that it seemed to echo the equally hardheaded and intellectual style of much of the important new art of the day— of Minimalism and, soon afterward, of Conceptual art. Just as artists like Frank Stella, Robert Morris, and Donald Judd seemed to have stripped modernist painting and sculpture of all their indulgence in the mere idiosyncrasy of personal sensibility, taste, and doubt—re-

placing it with the stark conclusiveness of objects as austere as formal proofs and in which (as Stella put it) "what you see is what you see," nothing more, bereft of pathos or metaphor—so critics like Michael Fried and Rosalind Krauss seemed to abjure the vulnerable accents of merely personal sensibility in order to assume the authoritative voice of history itself.

Yet history, like God, never stays on one side for long. As ambitious young artists take pleasure in hijacking the future toward unpredicted destinations, it becomes difficult to disentangle the truly new from simple "market trends." The tragedy of the honest art critic is that sooner or later the only role left may be that of the curmudgeon. Yet the two-fisted historian/critics of the '60s found another way—to wait for the artists they championed as critics to become historical figures and for their own youthful writing to become part of the historical record, which they could then use as part of the material for a more scholarly account.

But they still had to go through their curmudgeon phase. For some of these writers, it started as early as 1974. In November of that year, *Artforum* carried an article by Robert Pincus-Witten on the work of artist Lynda Benglis. A photograph Benglis had originally hoped would be used to illustrate the piece had been refused, so she paid to have it published as a full-page color ad in the same issue: a self-portrait, nude and brandishing a huge dildo. Most of the mag-

azine's contributing editors signed an open letter of protest at the appearance in its pages of what they termed "an object of extreme vulgarity"; as Krauss later put it, "publishing that ad was tantamount to saying that we were all hookers together, the writers, as well as the artists. That we were all for sale." Soon afterward, Krauss and Annette Michelson resigned from *Artforum* to establish a new magazine, *October*—a magazine of contemporary art that would be closer in spirit to an academic journal, purer, more exclusive, and more insulated from the market. Moreover, it was to be a prime conduit for the fresh new ways of thinking and writing that were entering American culture under the rubric of "French theory." As the more analytic criticism of *Artforum* had been established in opposition to the belletristic criticism of *Artnews*, this new organ was created in opposition to *Artforum* and its perceived fall into the abyss of the spectacle.

All three magazines are still with us. *Artnews* is no longer home to criticism by poets like Frank O'Hara and artists like Elaine de Kooning but is more like what its name always promised, a magazine of news, of journalism. Criticism remains the concern of *Artforum*. And *October* is the established, now rather stodgy, academic journal with a critical position on the contemporary scene, though seemingly from a greater distance with every passing year; yet its pages continue to attract ambitious young scholars who yearn to become part of the establishment. Now, as if to cement its power, four of the journal's editors— Hal Foster and Benjamin Buchloh, along with Bois and their senior

partner, Krauss—have produced a monumental history of twentieth-century art.

Monuments, though, are iffy things. Krauss once found, in her famous essay "Sculpture in the Expanded Field," that "the logic of the monument" was no longer operative under the conditions of modernism—that a modernist sculpture could no longer function as a "commemorative representation" in relation to a particular place but could only embody a "loss of site, producing the monument as abstraction, the monument as pure marker or base, functionally placeless and largely self-referential." It turns out monumental histories have similar problems; Krauss and her collaborators understand this and have done their best to face them. In the first instance, they've done this by the mere fact of being collaborators. A generation or two ago, it was credible for figures like Ernst Gombrich or Horst Jansen to single-handedly cover the entire history of art from the caves to abstraction. Now even the art of a single century hardly seems something an individual can master. But the joint authorship of *Art Since 1900* takes a peculiar form—as if the four contributors could not decide whether they should speak collectively or individually, in unison or in counterpoint. This becomes apparent right from the start, with the four introductions that open the main body of the book. Each lays out a distinct methodological formula—psychoanalysis, social history, formalism/structuralism, and poststructuralism/deconstruction—yet they offer little hint of how these might be

synthesized; even concrete judgments on particular artists or movements are quite distinct, at times even contradictory.

So each of the four authors, it is clear, will have the freedom to work according to his or her own chosen procedures and to express an individual viewpoint; and yet the four introductions are not individually signed, so any reader unfamiliar with the authors' previously published writings—the average student, for instance—can have no idea who is actually staking out these divergent viewpoints. It's as if they wanted to retain the authority of the collective voice while still being unwilling to subsume their idiosyncratic differences within it. Likewise, readers in the know will readily identify the authors of most of the chapters that follow (a chronological pageant of significant works and events from 1900 through 2003); they will be aware, for instance, that the pages on Matisse could only have been written by Bois, although these too lack individual signatures. But how, then, does Buchloh's bald assertion that the human figure was "expunged from most modernist art for the first two decades of the century" square with the focus on Picasso and Matisse in Krauss's and Bois's entries for those decades? Only in a pair of roundtable discussions—the first appearing midbook, between the chapters on the years 1944 and 1945, the second following the last chapter, which chronicles the 2003 Venice Biennale—do the four voices emerge as those of distinct individuals in contention.

Sometimes the effect of these tacit disagreements can be rather

funny. Anyone who knows the story of Lynda Benglis's ad and its cat-alyzing role in the foundation of *October* will be amused to encounter it again as one of the very first works reproduced in the textbook produced by four of the editors of that magazine, and with a caption offering a very different and much more positive sense of its meaning. Far from being the vulgar, antifeminist paean to art as prostitution, as Krauss viewed it thirty years ago, the ad is here praised as an im-portant work in which Benglis "mocked the macho posturing of some Minimalist and Postminimalist artists, as well as the increased market-ing of contemporary art; at the same time, she seized 'the phallus' in a way that both literalized its association with plenitude and power and parodied it." That clued-in reader will also realize that this sec-tion of the book is by Foster, who is too young to have been involved in that bygone controversy, and that the presence here of Benglis's work must be a subtle in-group dig aimed at demonstrating his au-tonomy within the little family of *October*. A student reading *Art Since 1900* as a textbook, or an ordinary art lover looking to it for some clues about how to understand the things that turn up in the contem-porary wing of the local museum, however, would pass this by without the slightest hint of the tacit discord—and that's a shame, for the dif-ference of opinion says a lot about how art world attitudes have changed in three decades, which is certainly part of the history such a book should be conveying. And then, too, an awareness of the dis-pute might encourage readers to be a bit more skeptical of the some-

times very partial and even rather moralistic judgments that are propounded with such an air of authority in this book, particularly as its chronological timeline draws nearer to the present.

That timeline itself, in any case, quickly shows itself to be as much of a convenient fiction as the book's veneer of collective authorship. Let's take a look at some of those pages on Matisse I mentioned. Matisse first enters the narrative near the beginning, in one of the two chapters headed with the year 1900: "Henri Matisse visits Auguste Rodin in his Paris studio but rejects the elder artist's sculptural style," reads the legend below the date. What follows is essentially a survey of Matisse's sculpture—a survey that gains a good deal from being framed in terms of the younger artist's debts to and differences from the elder (I owe the alliterative formulation to Bois). And through this dialectic Bois is able to throw off, like so many sparks, compare-and-contrast references to Brancusi, Cubism, and much more of early-twentieth-century sculpture—and even to the sixteenth-century Mannerist sculpture of Michelangelo and Giambologna—that allow the particularity of Matisse's achievement to emerge with great clarity. These are pages that, given the careful reading they deserve, would make a better introduction to modernist sculpture than a great many laborious tomes. But they have very little to do with the year 1900, and one suspects that their sense would have been even more perspicuous had they been framed as a section of a single chapter en-

tirely devoted to Matisse, references to whom have instead been scattered here and there, in chapters headed 1900, 1906, 1910, and 1944. While this dispersal helps show Matisse as part of the broader context of his time rather than as an isolated genius, it makes it hard for readers to get a real overview of his achievement in all its complexity. Moreover, it allows Bois to ignore those moments in the artist's career that might fit less comfortably into his view of what Matisse should have been. It's hard to imagine, for example, that any assessment of Matisse's work—or of European art in the postwar era in general—could overlook his chapel at Vence, which would be an equally fascinating case whether one judges it a failure or a triumph. This book does. While it makes sense to press the traditional protagonists of an art-historical narrative—namely individual artists, movements, and national cultures—a bit further into the background, the timeline structure offers nothing to replace them with; it provokes a merely tactical dispersal of them into puzzle piece-like fragments.

Another problem is that, even with four authors representing diverse positions and interests, the combined fragments may not form a whole. The book's first half, spanning the years through 1945, covers what is by now the traditional canon of modernist art produced in Europe and the United States. But the rest of the world is out of the picture. Even the Mexican muralists enter only by way of the scandal over the censorship of Diego Rivera's work for Rockefeller Center. Pre-World War II Africa and Asia are apparently entirely outside

history, as far as this book is concerned. Likewise, any form of artistic endeavor outside the boundaries of the professional art world counts only as an influence, never as a reality in itself. The discovery of the art of the insane and other "outsiders" can be mentioned insofar as it fascinated Paul Klee and Max Ernst, but the fact that figures like Adolph Wölffli, Martin Ramirez, and Bill Traylor produced oeuvres of considerable artistic value and presented substantial problems to criticism is nowhere registered. Popular arts, too, are excluded; no matter how many painters may have admired the work of George Herriman, the creator of Krazy Kat, he remains beneath notice. These omissions are nowhere explained; for all their methodological scruple, the authors never theorize about the constitution or boundaries of their field of study. On the other hand, whereas until now the history of photography has always been considered a separate subject from that of the traditional arts of painting, sculpture, and drawing, with only the occasional painter/photographer like Man Ray to link the two, *Art Since 1900* substantially integrates them. This is the one truly groundbreaking aspect of the book.

If the first half of the book is stolidly conventional though finely executed, the second half is likely to be more controversial. The geographic boundaries begin to open up with the emergence of the Gutai group in Japan and the Brazilian Neoconcretists in the 1950s, though the book never shakes the sense that modernity is something

that emerges from Europe and North America, without real roots elsewhere. But what's most striking about the pages covering the late '40s and '50s is the virtual erasure from the story of Abstract Expressionism. Yes, substantial pages are devoted to the crucial work of Jackson Pollock and Barnett Newman, but they are strategically detached from their lived context. And when the other Abstract Expressionists can't be ignored, they are assassinated: what Willem de Kooning made of Pollock's innovations was "a kiss of death"; the movement as a whole is to be disdained as "a half-romantic, half-petty-bourgeois" version of the Cartesian *cogito ergo sum* and infected with "much vulgarity" to boot. Petty bourgeois!—now, that hurts, coming from a crew with such an impeccable class composition as the *October* editors. Here at last, they seem to speak with something like true unanimity: a formal analysis of Bois's sort delivered in Buchloh's strident tone but employing Krauss's favorite epithet, "vulgar."

Well, at least such passages have the energy of a good knockabout fight to them. And on through the chapters on the '60s and '70s, the élan of the authors' varied *parti pris* makes the book fascinating, however much one might disagree. In fact, the more one disagrees, the more one can learn from mentally arguing with these generally well-articulated positions. (The spluttering intemperance of the pages on Abstract Expressionism is a rare exception.) On the other hand, this hardly makes for a trustworthy textbook. But things

get worse as the last couple of decades loom. Suddenly, all fighting spirit seems to expire. Events on the timeline start becoming sparser just where the effect of perspective would normally make them more numerous—recent events tend to seem more important than they really are, after all. Here, they occur instead in a desultory fashion, as if the effort of finding artworks that would at once exhibit some sort of imaginative energy while at the same time lending themselves to the authors' strictures on historical necessity were no longer worth the effort.

Bois's introduction on formalist and structuralist methods rightly concedes their limits, their affinity for certain very particular types of oeuvre, which are serial and systematic in nature (like Picasso's Cubism or the mature work of Mondrian), yet Bois rightly claims that "the heuristic power of structuralist and formalist analysis, especially with regard to the canonical moments of modernism, need not be discarded." But to have to judge one's own method as merely heuristic— preliminary, exploratory, destined to be replaced by something more solid—seems modest to the point of pessimism, all the more so if it is something to be reserved for "canonical works" rather than the living art of today. The other authors are equally frank about such matters. Buchloh has to admit that the social history of art is truly revealing only under special circumstances, "those historical situations where actual mediations between classes, political interests, and cultural forms of representation are solidly enacted and therefore relatively veri-

fiable." But where these are ambiguous or, as with the twentieth-century avant-gardes, actively contested, then "social art history's attempts to maintain cohesive narrative accounts often emerge at best as either incongruent or incompatible with the structures and morphologies at hand, or at worst, as falsely recuperative." All the more so, perhaps, in a volume such as this, in which actual historical events outside the art world are kept strictly offstage, political position-taking becomes difficult to distinguish from mere attitudinizing.

What these scrupulous admissions indicate, though the authors of *Art Since 1900* barely register this possibility, is that scholarly attempts to form coherent methodologies, ostensibly in order to put their efforts on sounder scientific footing, are fundamentally something else altogether: expressions of taste. Scholars develop working methods that derive in part from the kinds of art they prefer—structural analysis is not merely something that Bois "applies" to Cubism, Cubism is already a "structuralist activity"—and that aid them in fathoming and intellectually appropriating it. This preference, this taste, is always the fundamental thing. Yet somehow the subjective, perhaps even irrational or arbitrary foundation of each author's activity is something that all four of them—even Foster, with his emphasis on psychoanalysis—are anxious to disavow. As if one's repulsion at the inevitable vulgarity of the self were enough to expunge it.

Just as these writers wish to disavow the subjective bases of their own positions, their tendency is to repudiate subjectivity in the art

they write about. Perhaps this accounts for their extreme animus against the Abstract Expressionists. A good thing about this book's timeline structure is that pinning everything to a specific date is conducive to the use of telling anecdotes. There are a good many famous stories included, but one of the most famous anecdotes of modern art gets left out. The date is 1970; the place, Marlborough Gallery in New York. Abstract Expressionist painter Philip Guston—another member of the *Art Since 1900* blacklist, mentioned only as a possible influence on the Neo-Expressionism of Georg Baselitz, though the influence might well have flowed in the opposite direction—returned after several years of soul-searching with a new group of paintings in which figuration had suddenly reemerged, but of a starkly grotesque and disenchanted sort, like a cross between late Goya and the cartoons of Robert Crumb. The response from his old friends, the artists of his generation, was stony silence, complete rejection. With one exception. De Kooning threw his arms around Guston, saying he understood what it was all about: freedom. It's a word that doesn't get much play in this book.

GRAPHOLOGICAL GIFTS

Walter Benjamin's Letters

What is missing when we read a book of letters is, after all, the letters themselves: the envelope with its stamps, postmark, its address, and return address (or mystifying lack thereof); then the act of opening it (along the top? the side?), the paper on which the letter is written—its weight and texture; above all the handwriting with its precise indications of the writer's state of mind, like tone of voice in conversation. Trivia? Not to Walter Benjamin, who had particular tastes in writing paper and often alludes to his choice in the text of his let-

Theodor W. Adorno and Gershom Scholem, eds. *The Correspondence of Walter Benjamin*, trans. Manfred R. Jacobson and Evelyn M. Jacobson (Chicago: University of Chicago Press, 1994).

Richard Wolin, *Walter Benjamin: An Aesthetic of Redemption*, 2nd ed. (Berkeley: University of California Press, 1994).

ters. As for handwriting, his friend Gershom (at that time still Gerhard) Scholem recalled Benjamin's "almost uncanny graphological gift of which I witnessed a good many instances. (Later on he tended to conceal this gift.)" At one point Benjamin even earned money by doing handwriting analyses, and one of his last letters (October 12, 1939, to Gretel Adorno) describes a dream about death and graphology. In another, urging the photographer Gisèle Freund to write more often (November 2, 1939), he reports that "the number of my joys is very limited, and your handwriting heralds a few of them." That verb, to herald, is precise: handwriting as messenger, an angelic function. Scholem once wrote of Benjamin's underlying intention:

To present in the briefest literary utterance something complete in itself. The same trait was manifest in his handwriting which manifested that extreme bent toward smallness, yet without the slightest sacrifice of definition or accuracy in his minutely shaped characters. It was his never-realized ambition to get a hundred lines onto an ordinary sheet of notepaper. In August 1927 he dragged me to the Musée Cluny in Paris, where, in a collection of Jewish ritual objects, he showed me with true rapture two grains of wheat on which a kindred soul had inscribed the complete *Shema Israel*.

Letters, for Benjamin, had "aura." The mechanical reproduction of the same writings by their reduction to typographic form and then printing in numerous copies should undermine that aura, which is a

form of distance, something like a taboo, by abstracting from the letters their uniqueness, their physical and temporal singularity, and making them available for mundane use. This line of argument will sound familiar to readers who know—and who by now doesn't?—Benjamin's famous essay on "The Work of Art in the Age of Mechanical Reproduction." That essay has become the rallying point for the contemporary cult of the "anti-aesthetic" (to borrow the title of Hal Foster's 1983 anthology), the view that, under contemporary conditions, the specificity of artistic aims has been or should be dissolved in favor of their subsumption under broader and more pressing social-political concerns: that art should be "critical" and "effective."

This is not the place to explore the problems with the anti-aesthetic position as such, but certainly any view of Benjamin's "Mechanical Reproduction" essay that considers it in the context of its author's intellectual development shows how one-sided it would be to take the views expressed there as his settled position. The problem is that it is still so difficult to get access to that context for American readers. Benjamin's writings have come to us in a rather haphazard and piecemeal manner, and a great quantity of them remains untranslated. Although there has arisen a vast secondary literature around Benjamin, as a whole this raises more problems than it resolves. One relatively early scholar noted that "merely to sift through the controversy that has surrounded Benjamin's name in the past decade would be a task of considerable proportions," and if the industrious Martin Jay was

already daunted in 1973 (the words are from *The Dialectical Imagination*, his pioneering study of the Frankfurt School), how much more so must today's reader be, two decades on.

Surprisingly, considering Benjamin's fame and the dramatic story of his life, there exists no biography, which might, in the best of cases, plot his intellectual development while relating it to his involvement with the social movements of his time and his intense and deeply influential friendships with such contemporaries as Scholem, Theodor W. Adorno, and Bertolt Brecht. The broad outlines of Benjamin's life are well-enough known: born in 1892 to a wealthy Jewish family in Berlin, Benjamin lived the privileged childhood of which we read in his "Berlin Chronicle." Like many of his generation, Benjamin reacted strongly against the rationalist complacency of assimilated German-Jewish society. World War I was cause for even greater disillusionment, especially when it was supported by such previously admired figures such as Martin Buber and Gustav Wyneken, the radical educational theorist in whose Free German Youth Movement Benjamin had been a leader during his student years. Some of Benjamin's peers found a solution in Marxism, others in Zionism. Benjamin lived the dilemma more deeply, both through an immersion in the metaphysical and hermeneutic implications of esoteric Jewish tradition (Kabbalah, which Scholem reclaimed for serious study) without the comfort of either religious belief or nationalist ideology, and eventually in a commitment to communism neither theoretical or pragmatic but fundamentally ethical.

Benjamin's relations with his family were always difficult, but a severe break with his parents occurred in 1921, the same year his marriage effectively fell apart. Benjamin listlessly pursued an academic career—mainly in hopes of retaining financial support from his parents—but this direction was closed to him when in 1925 he was forced to withdraw his *Habilitationsschrift* (a kind of second dissertation) on *The Origin of German Tragic Drama*, after it became clear that it would otherwise earn him a humiliating rejection by the faculty of the University of Frankfurt on the grounds of its obscurity. (It was nonetheless published as a book in 1928.) Accordingly, Benjamin remains a sort of patron saint for all those intellectuals who have suffered righteous defeat at the hands of graduate school.

After this defeat Benjamin lived a precarious existence as a freelance writer and translator (of Proust, among others). His supporters included not only the up-and-coming radical scholar Adorno, but the likes of Hugo von Hoffmansthal, Austria's preeminent man of letters (Benjamin's letters to Hoffmansthal may be the only ones he wrote with any trace of obsequiousness). In 1924, Benjamin had met and become infatuated with Asja Lacis, a Bolshevik militant from Latvia. Under her influence he became deeply involved with the communist movement, although he never seems to have seriously considered joining the party, and through her he later met Brecht. With the Nazi takeover of Germany, Benjamin settled in Paris, where his position became ever more difficult. After it became impossible to publish in Germany even under pseudonyms, he subsisted mainly on a small

stipend from the Institute for Social Research (relocated from Frankfurt to New York), but with which his intellectual relations were often difficult. His time mostly given over to quantities of day-to-day journalism (at one point Benjamin tried working by dictation in order to speed up production), he spent more than a decade on the never completed *Passagen-Werk* or *Arcades Project*, a vast manuscript using nineteenth-century Paris as the setting for a "prehistory" of modernity centering around the figure of the poet Charles Baudelaire. One would like to know more about Benjamin's relations with the Parisian circle around Georges Bataille (to whom he entrusted his archive of manuscripts) and Pierre Klossowski (who translated the essay on "The Work of Art in the Age of Mechanical Reproduction" into French for its initial publication), but the letters are as frugal with this information as are the other available sources. After a period in a Vichy internment camp in 1940, Benjamin was among a group of refugees detained at the Spanish border at Port Bou while attempting to flee Nazi-occupied France. That night, believing that he would be turned back, Benjamin ended his life.

Lacking a biography, we should make the best we can of the raw materials for biography furnished by the newly translated *Correspondence*, supplemented by Scholem's various writings on Benjamin (his memoir, *Walter Benjamin: The Story of a Friendship*, and two essays in *On Jews and Judaism in Crisis*), and by Richard Wolin's *Walter Benjamin: An Aesthetic of Redemption*, still the most thorough-going

attempt to provide a synthesis of Benjamin's thought in English. First published in 1982, Wolin's book has been reprinted with a new introduction as part of a useful series of volumes on the culture of Weimar Germany from the University of California Press. But these materials only take us so far. Wolin's book is dependable, but it is not very well organized, and he tends to use language loosely, without the scrupulousness Benjamin calls for; an example is furnished in the very subtitle, for if there is not to be a fatal contradiction between the claims of "aesthetic" and those of "redemption," between the realms of sense and spirit, their relation must be carefully explicated, and this Wolin never attempts.

Neither is the *Correspondence* what it might have been, and it can be less easily recommended than an earlier collection, *The Correspondence of Walter Benjamin and Gershom Scholem, 1932–1940*— even though many of Benjamin's letters in the earlier book, and a few of Scholem's, are included in the new one. Although the book's editors, Adorno and Scholem, chose to include a handful of (extremely important) letters from themselves to Benjamin, this should really be called *The Letters of Walter Benjamin*. Unlike that previously translated volume, this does not represent a true collection of correspondence, insofar as that implies a full exchange rather than just one side of it. It is the translation of the 1978 German edition published by Suhrkamp Verlag (an earlier one had appeared in 1966). Despite the time that has passed and the vast difference in intended read-

ership, no new annotation has been added. (As an example, names that perhaps needed no editorial information for German readers over a generation ago may be completely obscure to American readers today.) Thus, this book is at best a stopgap, and the University of Chicago Press might have done better to pass on the project until such time when it could have been better done.

And yet who would willingly renounce possession of the treasures half-buried here? Although they retain the imprint of Benjamin's extraordinary personality, they also bear witness to an entire spiritual realm which no longer exists, that of the German-Jewish bourgeois intellectual during the years leading up to the time the very existence of this category would be annihilated. The intense earnestness of the student activist Benjamin, for instance, is simply unimaginable today. And there is something almost ridiculous about the philosophical scrupulousness and formality of Benjamin's July 1916 letter rejecting Buber's invitation to contribute to his journal *Der Jude*, yet the heart of the letter could stand as representative of Benjamin's position to the end: "I can understand writing as such as poetic, prophetic, objective in terms of its effect, but in any case only as *magical*, that is as un-mediated. Every salutary effect, indeed every effect not inherently devastating, that any writing may have resides in its (the word's, language's) mystery. In however many forms language may prove to be effective, it will not be so through the transmission of content, but rather through the purest disclosure of its dignity and its nature."

What is extraordinary is not so much this insistence on language as the disclosure of its own nature, but rather Benjamin's paradoxical solution to the question of how this disclosure might manifest itself:

It repeatedly seems to me that the crystal-pure elimination of the ineffable in language is the most obvious form given us to be effective within language and, to that extent, through it. This elimination of the ineffable seems to me to coincide precisely with what is actually the objective and dispassionate manner of writing, and to intimate the relationship between knowledge and action precisely within linguistic magic. My concept of objective and, at the same time, highly political style and writing is this: to awaken interest in what was denied to the word; only where this sphere of speechlessness reveals itself in unutterably pure power can the magic spark leap between the word and the motivating deed, where the unity of these two equally real entities resides. Only the intensive aiming of words into the core of intrinsic silence is truly effective.

Recall that this letter precedes by five years the publication by Benjamin's great contemporary, Ludwig Wittgenstein, of the *Tractatus Logico-Philosophicus* with its gnomic equation of ethics and aesthetics, and its claim that both reside in silence. The parallels are telling, but more important may be the contradiction between Wittgenstein's quietist conclusion and Benjamin's native aspiration to activism. In any case, Benjamin's faith in the power of the unspoken remained with

him throughout his life. Thus, for instance, his praise of Brecht's "Five Difficulties in Writing the Truth" for having "the dryness and therefore the unlimited durability of classic texts" (May 20, 1935, to Brecht).

The unmediated effectiveness of which Benjamin speaks is structurally identical to the potential unmediated appearance of the Messiah in the *Jetztzeit*, the "now-time" which is every second, of which we read in Benjamin's last (and greatest) essay, the "Theses on the Philosophy of History." In that profoundly disillusioned meditation on the brink of disaster, marked by the shock of the Hitler-Stalin pact of the previous year, Benjamin denounces "the politicians' stubborn faith in progress, their confidence in their 'mass basis,' and, finally, their servile integration in an uncontrollable apparatus." Benjamin goes on to speak of "the high price our accustomed thinking will have to pay for a conception of history that avoids any complicity with the thinking to which these politicians continue to adhere." One might observe the justice in Benjamin's use of the first person here; such thinking was indeed his among others, and one might be tempted to cite the "Mechanical Reproduction" essay, as well as others dear to the "anti-aesthetic" position such as "The Author as Producer" as examples of his deviation in this direction. But that would be too simple, just as is the opposing viewpoint represented by, for instance, Hal Foster's lament (in *Recodings*) over Benjamin's "turn from revolutionary prognosis to a melancholy messianism." Benjamin's "materialism" was never a deviation from the "theology" with which his career began

and ended, but it was never what most materialists mean by materialism either. Rather, Benjamin's attempted "elimination of the ineffable" was always and consistently, in his eyes, the most radical way of making silence appear and be effective. Benjamin's apparent derogation of autonomous art cannot be attributed solely to a progressivist deviation, as Adorno tried to show in his essay "On the Fetish Character of Music and the Regression of Listening" (some of Wolin's best pages unfold the contention between Benjamin and Adorno). Benjamin's "revolutionary prognosis" was more correctly though severely characterized by Adorno as "the crossroads of magic and positivism" (November 10, 1938, Adorno to Benjamin). Though seen by both Adorno and Scholem as a violation of what was truest in his thought, it is of a piece with Benjamin's effort to drive the ineffable back to its most extreme, most imperceptible, and *therefore* most effective stronghold. (His obsession with concealment recalls that of the conservative political philosopher Leo Strauss, later of the University of Chicago, with whom Benjamin enjoyed a friendly acquaintance. As Wolin reminds us, Jürgen Habermas has pointed out Benjamin's fascination with reactionary thinkers such as J. J. Bachofen, Ludwig Klages, and Carl Schmitt, while Scholem notes his awareness of "the strange interplay between reactionary theory and revolutionary practice.") Since theology, as we read in the "Theses," is "wizened and has to keep out of sight" if it is to operate "the puppet called 'historical materialism,'" one might conjecture that Benjamin would be

at his most cryptic and hermetic precisely in those works that present themselves as most vulgarly materialistic. Thus, as we read in "The Author as Producer," "it is in the theater of the unbridled debasement of the word—the newspaper—that its salvation is being prepared." By contrast, today's opponents of autonomous art lack not only Benjamin's acutely dialectical reason, but also the promise of a genuinely oppositional mass movement as an alternative basis for culture.

Benjamin made, in fact, a most peculiar fellow traveler, one for whom "Communist 'goals'" are "nonsense and nonexistent" (May 29, 1926, to Scholem) and who had little use for "the cult of the Great Revolution" (October 13, 1936, to Max Horkheimer) but who nonetheless saw his politics as "a drastic, not infertile expression of the fact that the present intellectual industry finds it impossible to make room for my thinking, just as the present economic order finds it impossible to accommodate my life" (May 6, 1934, to Scholem). Someone once referred to him as a "Marxist rabbi," and his materialist politics are best seen as a vehicle for his theology, or rather an ascesis imposed for theological motives, rather than as a displacement of it. Both were ways of confronting an utterly fallen world, the very one he had spoken of in *The Origin of the German Tragic Drama*. It is amazing how early, even before Hitler actually took power, Benjamin foresaw the coming disaster; and later, precisely when his tone is most apocalyptic, he seems to read clearly what in his last letter to Scholem he called "the arrangements made by the zeitgeist, which has set up markers

in the desert landscape of the present that cannot be overlooked by old Bedouins like us" (January 11, 1940). It was as much from reading Kafka as from reading the newspaper that, before the Final Solution, before Hiroshima, Benjamin knew himself to be living in "an epoch that is preparing itself to annihilate the inhabitants of this planet on a massive scale" (June 12, 1938, to Scholem; their exchange on Kafka constitutes a high point in modern literary thought). There are many reasons to read Benjamin generally, and many reasons to read his letters, but foremost among them is to approach a mind that lived more clearly than almost any other the tragedy of Europe in the twentieth century. You can do this more easily by reading the previously published Benjamin-Scholem correspondence, but having done so, you could do worse than to move on to this broader selection of Benjamin's letters.

A letter always reaches its destination. And yet the person who knew him best told Walter Benjamin that, "given how your life is constituted, it is certain that you, more than any other person, will always arrive somewhere other than where you intended" (February 20, 1930, Scholem to Benjamin). Something in him resisted the efforts of friends who would have helped rescue him from Europe before it was too late, either to Jerusalem or to New York. Today, when history is once again producing refugees in vast numbers, I'd like to imagine an alternative history in which the academic misfit Benjamin ends up a pro-

fessor at Columbia University (Meyer Schapiro was one of those who made efforts on his behalf), perhaps nursing a detached sympathy for the "angelheaded hipsters" who would arrive there shortly—and yet I can't. The lucid isolation of this man who had so great a capacity for intellectual and spiritual contact is matched only by that of his hero in failure, Franz Kafka. One of the eternal outsiders, Benjamin, through his evasion of any assimilating context (even the unique one that produced him), has made it possible for the potential availability of his life's work to maintain itself indefinitely. For all its fame, this life and this work are still in arrival. The *Correspondence* contains some of its brightest signals.

A BENJAMINIAN VIEW OF COLOR

One of the greatest problems and greatest pleasures of painting is the one named *color*. You can't see painting without seeing color; you can't think about painting without thinking about color. But it's hard to think about color in a way that really illuminates and enriches your engagement with painting. Art historical studies of color usually turn out, in my experience, to be arid and technical and fundamentally tangential to the activity of looking at, understanding, and enjoying a painting.

My own fascination with color, as it has been directed by my engagement with painting over the years, has been intertwined with what I suppose would be called a philosophical question related to the classic topos of the one and the many: my experience is of a multiplicity of different colors, yet all these different, distinguishable, and

sometimes clashing colors all point me back to a kind of unity of color, what I might even call the fundamental coloredness of the world. Color exists as an unbroken continuum, but the language that directs our perception breaks this continuum down into distinct areas that are red, orange, yellow, green, and so on.

Among the few places where I've read thoughts about color that have helped me further these stray ruminations has been in the early writings of Walter Benjamin. It might seem surprising to invoke Benjamin's name in a discussion of painting. He wrote some important essays on photography and film but not much on painting, and his essay most often cited in art contexts, "The Work of Art in the Age of Mechanical Reproduction," is typically seen as supporting the foreclosure of interest in an "auratic," autographic, handmade art like painting in favor of camera-based and reproducible art forms.

But while reflections on painting and its constituent elements are scarce in Benjamin's mature thought, they are absolutely essential to his early work—fragmentary and scattered as with so many of his projects. If you look at the first volume of the English translation of Benjamin's selected writings edited by Michael W. Jennings, you will find a number of fragmentary texts, all unpublished during Benjamin's lifetime, that have titles like "Aphorisms on Imagination and Color," "A Child's View of Color," "Painting and the Graphic Arts," "Painting, or Signs and Marks," "Perception is Reading," "On Perception," and "Notes for the Study of the Beauty of Colored Illustrations in Chil-

dren's Books," that have a definite bearing on issues related to painting and the role of color in it. There are also several other relevant texts that have not been translated, whose titles can be rendered as "Reflection in Art and in Color," "The Rainbow: A Dialogue on Phantasie," "The Rainbow or the Art of Paradise," and "On Painting." All these texts date from the period between 1914 and 1921 and according to Howard Caygill—the only scholar to have written on them in depth, as far as I know—they were essential to Benjamin's philosophical program of those years: a critique of the Kantian notion of experience.

Caygill finds a kind of encapsulation of Benjamin's concerns in this period in the lapidary statement that begins one of these fragments, which says, "Perception is reading." That may sound like Paul de Man talking, but Benjamin was not a premature deconstructionist. Gershom Scholem was later to recall that Benjamin "occupied himself with ideas about perception as a reading in the configurations of the surface—which is the way prehistoric man perceived the world around him, particularly the sky." In other words, the "reading" that takes place in perception, as Benjamin understood, is a kind of divination, of soothsaying. It is "to read what was never written," as Benjamin put it in his late essay "On the Mimetic Faculty."

Benjamin was interested in the duality of an inscription and the surface on which it appears, a graphic duality that functions in both writing and drawing. At times, in these writings, Benjamin seems to

think the same duality exists in painting, saying that "the surface and not colour is the essence of painting." Painting does not begin from color, "but from the spiritual and the creative, from form"—that is to say from the outline. Elsewhere Benjamin says that, because of its subsumption to form, "painterly colour cannot be seen for itself, it is in relation, is substantial as surface or ground, somehow shadowed and related to light and darkness," that is, to the duality of the graphic inscription.

But must this necessarily be so? Is there no possibility of manifesting color as such in painting? I would suggest that such a possibility emerges clearly with abstraction, where color need not support a representation of something other than its own presence. A clear instance of this would be a yellow painting, called *Yellow Painting*, by the American painter Joseph Marioni. It shows color as a single yet complex thing; its yellow appears not as something that is added to a surface, like the graphic sign, but as an articulation of the surface. As Benjamin says, "color is first of all the concentration of the surface, the imagination of infinity within it." He sometimes refers to this "concentration of the surface" as a mark, in contradistinction to the sign that is added to it, giving examples such as stigmata or blushing and describing them as effects of rather than on the surface of the skin. Is a blush something we see on someone's face or in it? The face is marked by it, though it is not a sign on the face like a tattoo.

Caygill's study is important not simply for explicating some of

these writings on color but that he shows how they underlie Benjamin's subsequent, and much better known, writings on language, particularly on translation. In "On Language as Such and on the Language of Man," Benjamin describes translation as "removal from one language into another through a continuum of transformations. Translation passes through continua of transformation, not abstract areas of identity and similarity." As Caygill glosses this, "the word in translation functions analogously to the color in configuration, having no fixed meaning but existing in a state of continual transformation according to its relationship with other colors." The reverse, I've come to think, is true as well: colors function as vehicles of translation. So my first Benjaminian theme is color as translation.

The best way to approach the notion of color as translation may be anecdotally, and by referring to a very familiar painting. In 1911, soon after Henri Matisse completed *The Red Studio*, he was visited by a Danish painter and art historian named Ernst Goldschmidt, who wrote about his first encounter with the painting: "'You're looking for the red wall,' Matisse said to me as I gazed at the objects depicted in the painting and mentally compared them to what I could see in the studio."

Imagine Goldschmidt seeing the painting still sitting in the very studio in which and of which it had been painted, and his face showing some puzzlement over the fact that whatever resemblance there was

between the motif and the painting did not extend to the aspect that would have been most important to Matisse, namely color. Goldschmidt continues to quote Matisse: "That wall simply doesn't exist. As you can see here, I painted the same furniture against a completely blue-gray studio wall. These are experiments, or studies if you will. I am not happy with them as paintings. Once I had discovered that red color, I put these studies in a corner, and that's where they'll stay. Where I got that red from I couldn't say. [...] I find that all these things—flowers, furniture, the commode—become what they are for me only when I view them together with that red."

Now if you go to the Museum of Modern Art in New York and look at *The Red Studio* I think you'll see that this very rich red that dominates the painting is not a clear, clean, transparent red, but a dense, heavy one that is somewhat impure. Very distantly, the red still has something of the blue in it. In any case, what I want to focus on here is the idea that Matisse was trying to express a visual sensation that had come to him in the form of a blue-gray, and that by paying close attention to what happened in his process of articulating that sensation pictorially he discovered that it could only be communicated by transforming it into a hue that would normally be considered completely opposite to it, into red. In order to express the sensation carried by the blue-gray, he had to translate it into a red.

As if to give further emphasis to this point, Matisse goes on to say something similar about another painting that was in his studio at the

time, a landscape with two female nudes. Here's Goldschmidt relaying Matisse's words again: "In Collioure I take walks every day in the hills along the shore, and that's where I saw the landscape you find so beautiful. I found it impossible to paint. I made many attempts, but I found the paintings I produced to be trivial, they didn't say anything. There were many more paintings in what I was seeing than in what I was painting."

For Matisse, the painting is already to be found somewhere out in the world and the essential problem is to translate it into pictorial form. "The color yellow came to me one day when I was trying, in vain, to paint those hills. So I painted the canvas over again, this time painting the whole of the landscape in relation to the yellow color I gave the nude bodies in the middle of the picture, and I think I can say that it is only because of that yellow that the landscape turned out such that you venture to call it a good painting."

Once again, a kind of translation of a coloristic sensation away from its naturalistic origin makes the painting possible, that is, makes the painting on the canvas an acceptable realization of the potential painting glimpsed out in the world—a translation possible through a color that Matisse has to say that he "gave" the painting, not one that he found.

That's Matisse ninety years ago. Does what he said still bear some relevance to what painters are doing today? I can't help but think of something the young Frank Stella said, back in the 1960s—that he

wanted to keep the paint on the canvas as good as it was when it was in the can. So coming a little closer to the present, there was still for Stella this notion that the painting was already out there, and the problem would just be to translate it into pictorial form—though of course there is a world of difference between thinking of this to-be-translated painting as existing in the natural world, as Matisse did, and thinking of it as existing in the industrially manufactured realm of one's own working materials, like Stella. Moving right up to today, I found very striking something that the British painter Gary Hume told me when I visited his studio. I noticed a painting of a yellow grid containing black squares, basically a kind of strange window frame, and asked him about it. He said,

I've been wanting to do a window painting for ages. When you go to Portugal, or lots of places, when they fill in a window for some reason or another they always paint the outside black rectangles with white lines and I've always loved seeing that. I've been trying to paint that for ages. I've done many of them, all totally unsuccessful, which is ridiculous because there's nothing to it. That's the first one that's worked because I've been painting the frame white and it took me ages to realize I could paint the frame any color I like!

Sounds just like Matisse, doesn't he? Befuddled at his sense of this incredible discovery that he could paint what he'd seen as white by means of yellow, I said, "Well, of course, it's your painting," and he

responded, "It's my painting, it's my window, and just like your home, you can paint your window frame any color you want. When I painted it yellow it all made sense, visually and linguistically: What's the window? Where is the window? Am I looking out? Am I looking in? It's the yellow that managed to make that. White, it was entirely diagrammatic." And then he added, "I could probably do a white one now and it wouldn't be diagrammatic."

The feeling engendered by the white and black window could only be translated pictorially by a yellow and black one—at least in that moment. Now that he's seen how this particular translation functions, his options have opened up somewhat. But like Matisse, Hume is profoundly convinced that his paintings already exist. "Everything's found," he told me. "I recognize it as my painting and then I paint it." And also: "I'm not Expressionist. I do all the looking and then I paint it. I look and then I paint. I look again and then I paint again. I'm not expressing myself, I'm expressing the painting"—that is, translating the painting he sees in the world, which is less Matisse's world of nature or Stella's world of manufactured materials than the world of media imagery.

Of course, if Matisse or Hume hadn't happened to give us their accounts of it we might never have realized how this act of translation had made their paintings possible. But I know of at least one case of a very interesting contemporary painter who really seems to make this act of translating color into the subject of her painting, so we can

just look at the paintings and work out the fact that this is what has happened without our needing to be told about it. Maria Morganti is an Italian painter whose work I've been following for quite some time. Typically, each of her paintings is dominated by single large color area that almost fills it, almost turns the painting into a mono-chrome like Marioni's—yet never does. The edge of the shape always coincides with the bottom of the canvas and sometimes, at least in part, with another edge as well. The areas along the top and sides of the painting that have not been covered by the dominant color show traces, not of a single "background," but of numerous other colors. And the rounded-off yet somewhat angular shapes of those slivers of colors, which more or less echo the contours of the dominant color-shape, suggest the temporality of the painter's process. It seems there have been several attempts to satisfactorily fill this canvas with color as rich and commanding as the one that now possesses it, but they were seen to be unsatisfactory and therefore painted over, though incompletely. A blue painting might easily have been green, red, pink, purple, and so on, just as a green one could have been red, purple, blue, or perhaps simply a different green. One color unfolds into another, not as arbitrary change but as explication. Strangely, an experience first evoked by a given red may only be fully articulated by a particular green. A brilliant hue may ultimately find itself rendered by one several shades more somber.

The second aspect of Benjamin's thinking about color that has come to seem valuable to me as a way of understanding color in contemporary painting has to do with what he called "a child's view of color." This is another way of understanding color as a mark rather than as a sign. In the essay titled "A Child's View of Color," Benjamin writes: "The rainbow is a pure childlike image. In it color is wholly contour; for the person who sees with a child's eyes, it marks boundaries, is not a layer of something superimposed on matter, as it is for adults. The latter abstract from color, regarding it as a deceptive cloak for individual objects existing in time and space." (As I would put it, the adults disregard the essential coloredness of the world to the extent that they see this as irrelevant to the object-quality of its contents, intuited by way of the Kantian categories.)

Color is single, not as lifeless thing and a rigid individuality but as a winged creature that flits from one form to the next. Children make soap bubbles. Similarly, games with painted sticks, sewing kits, decals, parlor games, even pull-out picture books, and, to a lesser extent, making objects by folding paper—all involve this view of color.

Children like the way colors shimmer in subtle, shifting nuances (as in soap bubbles), or else make definite and explicit changes in intensity, as in oleographs, paintings, and the pictures produced by decals and magic lanterns. For them color is fluid, the medium of all

changes, and not a symptom. Their eyes are not concerned with three-dimensionality; this they perceive through their sense of touch. The range of distinctions within each of the senses (sight, hearing, and so on) is presumably larger in children than in adults, whose ability to correlate the different senses is more developed. The child's view of color represents the highest artistic development of the sense of sight; it is sight at its purest, because it is isolated.

There are interesting parallels here to the later exaltation of the purity of the medium and of opticality by formalist critics like Clement Greenberg and Michael Fried; tracing their significance would take another essay altogether. Let me just go on with one more quotation from this brief fragment of an essay: "In this respect, coloring-in has a purer pedagogical function than painting, so long as it makes transparent and fresh surfaces, rather than rendering the blotchy skin of things. [...] Children's drawings takes colorfulness as their point of departure. Their goal is color in its greatest possible transparency, and there is not reference to form, area, or concentration into a single space."

We can see this "child's view of color," once again, in some of Gary Hume's work—most obviously in his sculptures of snowmen. The motif itself alerts us to see a childlike quality, but there's something else. I referred to them as sculptures, because they are obviously three-dimensional, free-standing entities, but I see them more as

paintings, in fact three-dimensional paintings, three-dimensional and, because rounded, completely continuous expanses of painted color. You can just look and look and walk around and around them and you never come to an end of the color they are. In this way, childlike, they elude "reference to form, area, or concentration into a single space," as Benjamin put it.

A different way in to this child's view of color might be through the paintings of Monique Prieto. Here, by contrast, the decal-like crispness of the shapes evokes a child's play with color. These shapes don't seem fixed, evoking instead the haphazard results of moving a mouse around on a mouse pad—the motor activity of a hand on a horizontal surface, which children delight in today just as much as they ever did drawing with crayons. The sheer quantity and as it were insistence of color tends to be more important than the particular shape that arises. For Prieto, each color remains distinct; each painting, a discursive sequence of intensities. Think of children's drawings, where the sky is always a detached band of blue at the top of the paper and a tree trunk is a brown column on top of, never within, the green of the landscape.

Benjamin's respect for the child's delight in coloring would have been rewarded by some work done by Glenn Ligon in 2000. The artist gave copies of pages from coloring books from the Black Power era, the late 1960s and early '70s (which is to say the time of his own childhood) to a group of kids to color, then "translated" the re-

sults into large-scale paintings of his own. The effort brought out a wildness and intensity that had not previously been admitted into this artist's work, for instance in the painting in which Malcolm X is endowed with red cheeks and pink lips. What emerges is the antithetical nature of what Benjamin called "the pedagogical function" of coloring, since it must encompass both that might be called the manifest content of the imagery—in this case, pride in the various manifestations of Black culture—and the latent content of an experience of color that is indifferent to all categorization. With these paintings, Ligon leads his viewers to the difficult period when innocence and experience begin to exist simultaneously in a child's mind. He points us back to a child's view of color and then back to an adult view, enabling us to see each differently.

FEVER CHARTS

Jack Tworkov on the Ethics of Art

Almost any fable of the artist's life could take its title from the novel about the life that Balzac wrote, and that stands as a model for the rest: *Lost Illusions*. Yet Balzac may have been too optimistic. Showing his would-be poet Lucien Chardon seduced by his social ambitions and undefended by any strength of character, a man who throws away his talent by selling out, Balzac implicitly defends those who labor with integrity as heirs to greatness—and its rewards. So we all hope. But experience teaches that greatness is rare, and perhaps no less so among the upright than among those of questionable character. A sadder novel than Balzac's could have been written about the lost illusions of those who with patience and determination remain

Mira Schor, ed., *The Extreme of the Middle: Writings of Jack Tworkov* (New Haven, CT: Yale University Press, 2009).

true to their intuition of the artistic absolute yet attain little inner certainty of their achievement or even scant public acclaim for it. But how much recognition would be enough anyway? In exchange for its near-extinction in the exigencies of form the ego demands twofold repayment. The artist's demands on his public are typically as unappeasable as those he makes on himself. Although the pleasures of Jack Tworkov's writing are many, *The Extreme of the Middle* is a book I'd recommend to aspiring artists as a warning: this is how depressing it can be to be a serious, successful artist.

I don't mean to nominate Tworkov as the hero of a neo-Balzacian novel in which the artist who stays true to his calling ends up a tragic failure. Nothing could be further from the case. Tworkov, one of the original Abstract Expressionists whose mark on the history of painting is inexpugnable, accomplished a great deal in a long and rich life, not only as an artist but as a teacher and a mensch. And his writings are a considerable contribution to the art history of his time. Their subject is not so much aesthetics or form as the ethics of art. But his was a life deeply shadowed by, among other things, his resentment at never having been accorded the worldly status of friends like Willem de Kooning, Franz Kline, and Mark Rothko. Repeated insinuations that he'd been too heavily influenced by de Kooning particularly rankled, and were not always wrong.

He was born Yakov Tworkovsky in Biala, Poland, in 1900. It might have been said of Tworkov, when he arrived in New York in 1913,

what he would later write in an essay on Chaim Soutine: "The journey he made [...] from the mediaeval Lithuanian ghetto village to Paris has to be measured not only in hundreds of miles but also in hundreds of years." Yet more than a journey in space or in time, it was the immeasurable journey from a culture that disregarded the image to one in which the art of painting had a noble history and also, perhaps, a great future. But much had to be sacrificed for that journey to be undertaken. Tworkov speaks from the heart when, comparing Soutine to one of his predecessors, he says, "I envy Cézanne living out his manhood in the same village where he was born. [...] I am sorry for Soutine living in a foreign land. He could never exorcise the terrors of his childhood, and so they possessed him all his life."

As for his own home town, Tworkov never did see it again. In one peculiar way, though, it always stayed with him, as the adopted name of his younger sister, who was the first to encourage him in his art and who herself became a painter of considerable stature. Unlike her brother, Janice Biala spent much of her life in Europe, first as the companion of the writer Ford Madox Ford from 1930 until his death in 1939, and then again after the war. Despite the long periods of separation, it is clear from his letters that Tworkov remained devoted to her to the end of his life, and that she and her husband, the painter Daniel Brustlein (whose illustrations for the New Yorker were signed Alain, the name by which Tworkov always addresses him) were his most trusted confidants—with the possible exception, it seems, of Ilya

and Resia Schor, New York artists now little remembered except among connoisseurs of Judaica, who are also the parents of the book's editor, Mira Schor. On Ilya's death Tworkov said, "I had told Mira long ago that she had better adopt me as an uncle since I had already adopted her father as my brother." Her long and sensitive introduction repays any avuncular debt.

A sense of being hobbled by some inborn weakness rarely seems to have left Tworkov for long. He constantly reflects on his neuroses, his diffidence, his social anxiety—which honestly never seem anything beyond the norm, but then what could be more neurotic than believing you're more neurotic than you really are? Of course, it's possible that the artist's journals are misleadingly one-sided, as he himself felt on rereading some of them in 1955 when he remarked, "They are like fever charts. I almost never write when I feel normal." Fair enough; he was not a writer by profession. But with well over 400 densely packed pages of journals, diaries, and letters as well as published writings and lecture notes, the heft of this collection suggests that the painter felt abnormal often enough. Schor does not indicate what percentage of his private writings are represented here, but her statement that Tworkov "wrote incessantly, compulsively" suggests there could be much more; at minimum, she has not included a small book written in 1935–36 but then abandoned, Social Meaning of Art, described by the curator of Tworkov's posthumous 1987 retrospective

at the Pennsylvania Academy of the Fine Arts as "a fifty-page typed and edited manuscript."

It would be interesting to know if the typescript illuminates Tworkov's political views at the time. Later these would be deeply entwined with his sense of personal malaise. A Jewish immigrant intellectual in New York in the '30s was a natural socialist. The fact that Tworkov had collaborated with John Dos Passos at the New Playwrights Theatre in the late '20s gives some indication of his radical sympathies at the time. The earliest writings included in *The Extreme of the Middle* are letters to the artist's wife, Wally, composed during brief separations in 1936 and 1937. In them, demonstrations and union meetings are as important as high culture, the word "comrade" is a normal part of his vocabulary; he writes as both an artist and an activist. So it comes as something of a surprise that when Tworkov's writings recommence ten years later, his attitude to politics is very different: disillusioned to the point of pessimism. "The left in American letters, art, and politics," he advises his daughter Hermine, a college freshman, in 1958, "has become a cesspool of bad and stagnant thinking." It is a point he returns to again and again: revolutionary movements are merely symptomatic of the sickness and rot of the civilization they pretend to oppose.

Between 1937 and 1947 something happened to profoundly shake Tworkov's faith in political action. Nothing in this book gives the reader any glimpse into what occurred—and yet the depth of his

disgust, and the consistency and vehemence with which he expresses it, suggest that there must have been some definite event, or perhaps a series of them, rather than a gradual drifting away. But what distinguishes Tworkov from so many others—his erstwhile comrade Dos Passos, for instance—was that his loss of faith in the left did not lead him to the right. When asked at a public forum in 1960 what he considered to be the most important cultural activity in America, he answered "the Negro sit-downs in the south." Though professing himself "emotionally sad but placid" about the Vietnam War, he supported Eugene McCarthy for president and felt that "under Reagan it's America that has become the greatest danger to the world, not even less than what Hitler was." One of his last diary entries, six months before his death from cancer in 1982, notes a meeting "to organize a committee to organize visual artists against nuclear armaments."

Tworkov had not renounced his ideals. But he'd lost hope in the fight for them, and this loss was directly related to his ongoing sense of unease with himself and others. "Revolution of whatever kind," he felt, "leads to authoritarianism, to suppression, to dictatorship. Inevitably everyone must serve the revolution or be regarded as its enemy—thus no one can speak, reason, think or paint who does not directly serve the revolution. [...] The word has come to fill me with disgust." Tworkov's tone in this letter to his sister and brother-in-law, its personal yet categorical note, suggests that he'd met revolutionary demagoguery in person and felt in it a threat to his very existence

as an artist. In any case—as this book's rather unattractive title, taken from one of the artist's journal entries, suggests—Tworkov was allergic to any form of extremism or intellectual absolutism. Thus his animosity towards Ad Reinhardt, whose pose of sublime certainty and exclusive possession of the truth must have been infuriating; Reinhardt's statement, "Art is art. Everything else is everything else" seemed to leave all his colleagues on the side of everything else. "He thinks there is a kind of Chinese wall between experience and painting," Tworkov complained, publicly, in Reinhardt's presence; in his private notes he added, "It is obnoxious to take a position that leaves you the only artist around." All the more so since, as Tworkov had declared years before, "No artist is by himself an artist. He is an artist only by virtue of the fact that he voluntarily permits other artists to act on him and that he has the capacity to react in turn. [. . .] There could no more be one artist than there could be one human being."

More broadly, Tworkov was repulsed by all self-conscious avant-gardism as well as the cult of genius or any insinuation that art might somehow be beyond good and evil. In his eyes, revolutionary politics and the nihilism of an all-consuming aesthetic mirror each other: "Pure esthetics, like pure sociologies (Utopias) lead to pure (without guilt) murder." And elsewhere: "Picasso is the first of the modern artists who treated art neither like one treats a beloved or a mother who nourishes, but like a land to be conquered even if it had to be burned or

destroyed. He prefigures the ruthless dictator." Both exemplify the "aristocratic pretensions" of all who claim "the autonomous character of the individual who is a law to himself." For this reason, Tworkov felt sure that the extreme avant-gardes, clinging to aristocratic values against the bourgeoisie, were actually reactionary and antimodern.

What's curious is that despite his professions of anti-avant-gardism and anti-extremism, Tworkov was extremely attracted to certain avant-garde grandees of his time—most notably, John Cage, "one of the most intelligent people I have ever met." Perhaps it was the composer's ability to embody a nonviolent, playful avant-gardism that beguiled Tworkov, although he shrewdly remarks that while "Cage associates himself with Zen and the absence of ego, [...] an egoless Cage is unthinkable to me." Despite his ostensible quietism, "in a conversation Cage uses you as if you were an instrument from which to fetch a sound." In the end, Tworkov classified Cage's work as farce.

Tworkov was equally attracted to two younger painters who were close to and much influenced by Cage, Robert Rauschenberg (whom he met during a brief stint teaching at Black Mountain College in 1952) and Jasper Johns. He even bought a small early flag painting from Johns, but he never really warmed to the work of either of them. "John's [sic] Flag was a subject that posed a paradox: Was it an object? Was it a painting? The paradox is literature. As such it was interesting but soon exhausted." (Around 1961–62, Tworkov would

paint his own variations on the American flag, retaining its colors while, in contrast to Johns, distorting its composition—"perhaps unconsciously an ironic comment," he mused, on his own "growing patriotism.") Rejecting avant-gardist pretensions to operate in what Rauschenberg famously called "the gap between art and life," let alone to heal that breach, Tworkov was even more disdainful of modernist claims to strict aesthetic autonomy as articulated by Reinhardt or by Clement Greenberg. On the other hand, as an abstractionist he refrained from an art that approached reality as something to be represented. True, his first abstract paintings, in the early '50s, had been full of figurative reminiscences, but from the middle of that decade on he tried to eliminate them—not always successfully in his own eyes, since even as late as 1963 he was still telling himself, "I've never quite been able to shake off figurative elements, but I must."

Still, he never ceased to envy representational painters from afar. In part this is accounted for by his intense admiration for his sister and her husband, both of whom pursued a modern form of stylized representation in the École de Paris tradition. He seems always to have wondered if he'd made a mistake but was convinced—in contradiction to Greenberg's view that modernism was essentially a distillation of what made for quality in the painting of any time—that between abstraction and representation he had crossed a radical divide. He even speaks of being "trapped" in abstraction. Recalling to Alain the exaltation he'd felt in the Prado, he had to admit, "I cannot associate

my experience in front of these paintings with what engages me in the studio." Seeing the work of younger representational painters, he remarked, "I shared not one thing with them except canvas, brushes and paint and the desire all artists have to fill their lives with something meaningful." In both spirit and technique, they might as well have been practicing different arts altogether.

Perhaps this is why, as critical as Tworkov could be of his colleagues among the Abstract Expressionists, he had to be acutely skeptical of succeeding generations of artists. Having with great difficulty and considerable regret made what he saw as a fundamental break with tradition, it must have been galling to find himself cast in the role of a traditionalist whose revolution had not been thorough-going enough after all. Having the paid the price of that revolution, the successive ones must have looked cheap and facile. It's a problem that the critic Leo Steinberg was talking about in the early '60s. Although the article he devoted to it was called "Contemporary Art and the Plight of Its Public," he meant the plight of its makers just as much as of its viewers—that is, of the artists who might continually feel themselves in danger of being left behind. Steinberg evoked his own feeling, on first encountering the work of Johns: "The pictures of de Kooning and Kline, it seemed to me, were suddenly tossed into one pot with Rembrandt and Giotto." The reason, according to Steinberg, is that by comparison with Johns they all seemed equally "painters of illusion." A few years later, Johns was to be shown up as an illusionist by Donald Judd,

and then Judd, a few years after that, by Mel Bochner. It was a period in which illusion was found to be bottomless, since more of it could always be discovered retroactively through a process of elimination. Steinberg goes on to report the responses to Johns of two unnamed Abstract Expressionists: "If this is painting, I might as well give up," said one; "Well, I am still involved with the dream," said the other. Both those painters could have been Jack Tworkov.

It's somewhat surprising that a man so prone to curmudgeonliness should have been a good teacher, but apparently Tworkov was, most notably at Yale, where he chaired the art department from 1963 through 1969. A journal entry deliberately paints his decision to accept the position in the worst possible light. He was driven, he accuses himself, by "hurt self-esteem. The attacks in the press on my status as a painter, my failure to win the support of any important writer, the lack of interest in my work by the leading museums, the narrowness of my circle of supporters, the failure of my exhibition. [...] The Yale job then seemed for the time being to salve some of my hurt." Needless to say, these are the worst possible reasons for becoming a teacher, though common enough.

Yet Tworkov thrived as a teacher because it appealed to his latent idealism. Years before, teaching one summer at Black Mountain, he had experienced something like the ideal anarchist community of which he'd secretly dreamed always: elders and youth, men and

women working together in freedom and self-defined responsibility, without authority or hierarchy, squaring the circle of community and individualism that had always confounded him. "A bully could not exist here, everybody would allow that he has the right to be a bully, but no one would be bullied by him." One gathers that Tworkov would have liked to cultivate a similar ethos at Yale—the more fool he, albeit a holy fool. One can only wonder—from the perspective of today, when universities are assiduously burdening the world with a doctorate for artists—that in an Annual Report for the Academic Year 1965–66 he raised the issue of abolishing the MFA in favor of "a school for advanced study where the student genuinely comes for just that and feels entirely responsible to himself"—no grades, no degree, just work for its own sake.

Tworkov had experienced something like this hoped-for community of individuals once before, in the early days of the Artists Club, sometimes known as the Eighth Street Club or simply the Club, which (together with de Kooning and Kline, among others) he helped found in 1949. "I cannot remember any period in my life that so went to my head," he wrote. Here, everything was up for debate, and the sometimes pugnacious attitudes of the participants had a paradoxical effect: "The enthusiastic clash of ideas [...] destroys, or at least reduces, the aggressiveness of all attitudes. [...] There is a strong sense of identification. I say to myself these are the people I love, that I love to be with. [...] How dull people are elsewhere by comparison." It

wasn't to last. One of the saddest things about Tworkov's diaries, as he grows older, is his growing distance from the artists with whom he shared those years, the sense that these massive egos (his own no less than the others, despite his veneer of gentility) could no longer share the same space.

For Tworkov, painting was the cipher of this ideal community he had briefly glimpsed but could never hold onto. His life story was filled with episodes of failed identification. First came the loss of his home in Poland, though it had offered not even the protective warmth of the shtetl as he imagined Soutine had known it; since Tworkov's father was a tailor serving the officers of a Russian army regiment, the family lived in the gentile part of town: "I don't remember being at ease in either the Jewish or non-Jewish sections," he recalled. Then there was the comradeship of the '20s and '30s including a stint on the WPA Federal Art Project, when he believed he could assert political agency as part of a larger social movement; and the Club, where a movement of artists "as fruitful and revolutionary as the Impressionism of 1870" was heralded. Both finally left him more isolated than before. The only freedom he'd discovered was one not worth finding, as he wrote the year before his death, the freedom "to be spiritually homeless."

When Tworkov was in his late '60s his art began to undergo a change nearly as drastic as the one that had happened some twenty years before when he'd worked his way toward abstraction: eschewing the impulsive gesture of Abstract Expressionism as he'd earlier es-

chewed the recognizable image, he introduced a geometrical arma-
ture on which to hang a dense field of smaller, less dramatic marks.
In his essay on Soutine, who, as Tworkov asserted, looked on the sur-
face like more of a traditionalist than he really was, he spoke of
how his predecessor had managed "to liquefy the building blocks of
Cézanne's art" to create "an art of movement" with "temporal over-
tones." This is not a bad description of what Tworkov himself would
go on to do in his late work, which is when, I would argue, he finally
came into his own as artist. He uses his geometrical substrate for the
same reason that Soutine used the simple everyday things he painted,
to "set free his energies for a full and uninterrupted flow into his
painting," such that the entire temporal process of its making be-
comes evident. It's one way to paint one's time, after some of its illu-
sions have passed.

RESISTANCES

Meyer Schapiro's
Theory and Philosophy of Art

The first three volumes of Meyer Schapiro's *Selected Papers* were published in 1977, and his lucid yet quietly impassioned essays on *Romanesque Art*, *Modern Art*, and *Late Antique, Early Christian, and Medieval Art* have continued both to instruct and to inspire. Fifteen years passed before the appearance of the fourth, *Theory and Philosophy of Art*. Schapiro, famous not only for his writings but for teaching at Columbia University, his political involvements in the 1930s, and his support of the Abstract Expressionists in the 1950s, has been one of the few academic art historians to fuse historical perspective with contemporary commitment, scholarly specialization with theoret-

Meyer Schapiro, *Theory and Philosophy of Art: Style, Artist, and Society* (New York: George Braziller, 1994).

ical breadth, empirical probity with interpretive bravura. Because Schapiro's legend—and of how many of his colleagues could one legitimately use that word?—includes a reputation for fanatical, even neurotic retentiveness and rigorous attention to detail, those awaiting this promised fourth volume concerning theoretical questions had reason to fear that its definitive abandonment (in Valéry's sense) might not come in its author's lifetime. Instead, the book happily appeared in time to honor Schapiro's ninetieth birthday.

Many of the essays collected in the volume were already well-known, despite the sometimes out-of-the-way places in which they appeared. The essays on "Style" and "On Some Problems in the Semiotics of Visual Art: Field and Vehicle in Image-Signs" are bibliographical staples, however little their skepticism toward premature generalization has been taken to heart in subsequent work. "The Still Life as a Personal Object: A Note on Heidegger and van Gogh," published in a 1968 *Festschrift* for Kurt Goldstein, is known to a readership beyond the ranks of art historians as the starting-point for a far-reaching deconstruction in the final section of Jacques Derrida's *La vérité en peinture*. (Schapiro does not deign to remark on Derrida's critique in the newly appended "Further Notes on Heidegger and van Gogh," but given Schapiro's passion for sobriety, one can understand his unwillingness to be drawn into the eddies of Derrida's *dérive*). Still, the gathering of these essays from the 1950s and, predominantly, the '60s, along with a few previously unpublished ad-

denda such as the one on van Gogh, allows for a fuller understanding of Schapiro's position in his maturity.

Schapiro's famous resistance to publication, it gradually becomes clear, is more than a simple psychological quirk. It is a by-product of the project implicit in his very style as a writer. This project is a surprisingly Hegelian one, and a literal impossibility: it intends to render everything explicit. There are to be no approximate statements, nothing merely evocative. Figurative language is so rare and so subdued here that it comes as a deep shock—the shock of recognized truth—when we suddenly read of Eugène Fromentin that "he really bites into things with his eyes." Even when something must be passed over in silence, either for practical reasons or for lack of information, this omission must be made explicit; thus, speaking of a typical posture in Egyptian art, Schapiro specifies that "whether the choice of the left leg depends on a superstition concerning the first step in marching or on some natural disposition, I cannot say." Likewise, Schapiro's exhaustive examination of theories of style ends with a deferral of theory, the call for no less than "a deeper knowledge of the principles of form construction and expression and for a unified theory of the processes of social life" as the ineluctable prerequisites for the theorization of style—a humbling demand indeed.

Thus, Schapiro's resistance to publication is not unrelated to what W. J. T. Mitchell has called his "resistance to theory." This latter has been the cause of a certain quiet unease among those who believe,

and not without reason, that among the big problems with the practice of art history has been precisely its innocence of theory, which they see as a measure of the backwardness of the field in comparison to neighboring disciplines such as the study of cinema or literature. Mitchell is to be commended for bringing this tacit conflict out into the open. Acknowledging Schapiro to be "without question the eminent living American art historian," he nonetheless dismisses *Theory and Philosophy of Art* as outmoded: "Generations of young art historians, emboldened by his example, have expanded the boundaries of art history so broadly that Schapiro's pioneering gestures now seem routine and familiar," he wrote in the April 1995 issue of *Art in America*. Pity the poor Moses who will not enter the Promised Land!

Mitchell is "depressed" (the word is his) by the way Schapiro uses "facts" to criticize "theories," as in his essay on Sigmund Freud's analysis of Leonardo and especially the one on Martin Heidegger's use of van Gogh in his treatment of "The Origin of the Work of Art." Schapiro just misses the point, Mitchell believes. "Freud was engaged in speculative play," while Heidegger's text "is underpinned by the entire tradition of the 'theory and philosophy of art' on which Schapiro's own discipline is built." It seems that theory may be either too light to be affected by Schapiro's "factography," or too heavy, too well founded; it is fact-proof either way.

Perhaps Schapiro's scrupulousness does remain tangential to Freud's and Heidegger's very distinct projects, as Mitchell believes,

and leads Schapiro to fall into what he himself calls "the most common and inexpugnable error of criticism," which is to "impose the conventions of his school as the prerequisite of all good art" or, in this case, scholarship. But then, Schapiro has a point too, which Freud missed, which Heidegger missed, and which Mitchell—relying perhaps on the great prestige of those masters—seems bent on missing as well. For while Mitchell assures us that Schapiro's sin, in his eyes, lies not in any lack of "respect" for the grand position of the theorist or philosopher, he fails to recognize that what Schapiro disdains is the theorist's lack of respect for the work of art. "Does Schapiro really believe," Mitchell asks, "that Heidegger's 'error' about van Gogh invalidates his more general philosophical arguments about the nature of art"— as though it were somehow inconceivable that one could believe such a thing. But if Heidegger's arguments connect to the reality of art, that can only be by way of connecting to the facts of the art it connects to, unless we are to accept that there is some ideal reality to which we can have access without the mediation of mere humble, dirty facts—which I believe is the opposite of what Heidegger himself wants to urge on us with the maxim that "what art is should be inferable from the work."

A peculiar shift occurs in the course of Heidegger's essay. As he begins to speak of the "equipmental" qualities of, for instance, a peasant woman's worn shoes, he calls upon a painting by van Gogh which he believes to represent such shoes simply "to facilitate the vi-

sual realization of them"—to provide a handy mental image. But as Heidegger continues, he raises the possibility that "perhaps it is only in the picture that we notice all this about the shoes," referring, it appears, not to any particular picture, not even van Gogh's painting, but to a faculty of picturing in general, the distancing function of reflection that allows us to construct an image of an activity, indeed, of a life, that the person involved partakes of unself-consciously ("the peasant woman [...] simply wears them"). Yet soon enough Heidegger is claiming that "only by bringing ourselves before van Gogh's painting" are his insights into "equipment" possible. It is painfully clear, however—even aside from Schapiro's assertion that the depicted shoes are in no case those of a peasant woman but rather the artist's own—that Heidegger's description is a fantasia, a "work of reverie," to borrow a phrase Schapiro uses in another context, and owes little to van Gogh's picture. For all the philosopher's concern to explicate the distinction between objects of use and the work of fine art in which truth is disclosed, he has in fact reduced the work to a merely useful prop for his text, like Marcel Duchamp's suggestion for a "reciprocal readymade" that would be a Rembrandt used as an ironing board. As with Duchamp's Rembrandt, the result is a notable flattening of the work's texture.

Schapiro's point, fundamentally, would be that Heidegger fails to follow through on his own maxim—that, rather than inferring "what art is" from the artwork, he has (like Freud) allowed himself to twist

his account of the work to make it accord with what he already thought it should be. One need hardly be a dogmatic empiricist to see why this might be a problem. The very theorist from whom Mitchell borrowed the phrase "resistance to theory" could have shown him as much. In compositing his searching critique of "Heidegger's Exegeses of Hölderlin," Paul de Man insisted above all on the difficulty and importance of the most basic philological choices in interpreting the poet, whereas Heidegger, by contrast, "reduces philology to a subordinate position, although he does not hesitate to call upon it when his cause requires it"; that is, Heidegger uses philology opportunistically. De Man does not overemphasize this; in a gesture that anticipates Mitchell's, he writes that "the strictly philological objections" raised against Heidegger "are without merit, for it is manifestly by design that Heidegger goes against the established canons of literary scholarship." But de Man makes this concession knowing that he can raise the stakes. The very nature of the philosopher's thought makes necessary "*the fact that Hölderlin says exactly the opposite of what Heidegger makes him say,*" since Heidegger requires a witness and only Hölderlin speaks of that of which Heidegger means to speak, the possibility of speaking Being, although Hölderlin asserts this possibility in a negative sense, that is, as an impossibility.

It is true that, rather than holding Heidegger's philological faults as immediate grounds for dismissal of his philosophical reading of poetry, de Man engages in a tandem reading of Hölderlin and

Heidegger that is at once philologically and philosophically nuanced to a degree that Schapiro does not deem necessary. But this reading still centers on matters of literary and rhetorical fact, whereas Heidegger's high-handedness with small and large facts reveals itself as symptomatic of his anticritical agenda, the "blind and virulent passion with which Heidegger treats his texts," as de Man says, and—we might add with Schapiro—his images. Far from dismissing philological studies (for the equivalent of which Schapiro stands in the field of art history), de Man recognizes that, "as a control discipline, equally scornful of arbitrariness and pseudo-science, philology represents a store of established knowledge; to seek to supersede it, and it is far from obvious that it is possible, is without merit."

De Man's warning should alert us to how ill-conceived it is to criticize a work like Schapiro's on the grounds that he should get with the program that now goes under the name of theory. Schapiro's book is proof—and through this earns its title—that one can do theoretically consequential work without doing what looks like theory. Schapiro the theory-resistant and de Man the theorist find common ground in their insistence on what de Man calls *reading*—that is, close attention to the particulars of the work of art—as the only possible ground for theory. "It turns out that the resistance to theory," de Man writes, "is in fact a resistance to reading, a resistance that is perhaps at its most effective, in contemporary studies"—and here, although de Man has particular forms of semiotics in mind, all those who would

do theory without attention to the facts of particular works should take heed—"in the methodologies that call themselves theories of reading but nonetheless avoid the function they claim as their object." It is no accident that Schapiro and de Man both tend to emphasize undecidability, although de Man theorizes it whereas Schapiro cites it as an obstruction to theory. In both cases, doing theory turns out to mean working on the difficulties of or resistances to theory. With this view, to want to do away with Schapiro's resistance to theory is tantamount to wanting to do away with theory.

Because in principle everything relevant to a discussion must be mentioned in order to be taken into account, the purely enumerative function of Schapiro's prose—the systematic laying of cards, one by one, on the table—distends and threatens to overwhelm his argument's discursive framework. Although Greenberg once imputed Schapiro's "strain to leave nothing unsaid" to a lack of "humility," we should not see it as a weakness, an indulgence, but rather a method: for theory is called upon to measure itself against all examples. Schapiro's is for this reason a constructivist prose. The "Field and Vehicle" essay ends by "indicat[ing] briefly the far-reaching conversion of [...] non-mimetic elements into positive representations"—in other words, ways in which artistic practice has compelled its media of representation to signify. But the essay has no real conclusion or summation, just the telling image of Piet Mondrian's continuation through nonrepresentation of "the conception of the picture-field as corresponding in its en-

tirety to a segment of space excerpted from a larger whole [...] a model of one aspect of contemporary thought: the conception of the world is law-bound in the relation of simple elementary components, yet open, unbounded and contingent as a whole." The essay ends where its own form arrives at a deep accord with its subject.

This accord finds its fullest and most sustained form in the 1963 essay "Eugène Fromentin as Critic," originally published as the introduction to an English translation of *Les Maîtres d'autrefois*. It may seem surprising that a scholar, a socialist, and a champion of modernism such as Schapiro would find a kindred spirit in this aesthetic and political conservative who wrote that he wished to be read as a "pure dilettante." Yet Schapiro is, like Fromentin, a "profoundly objective" critic, though, for all that, a moralist or psychologist more than a pure formalist. For both men, art is both a personal and a social achievement. They feel that "the highest human values are involved in a patch of color, the bend of a line"—or in a sentence. Schapiro shows how, for all his orthodoxy as a painter, Fromentin was in the avant-garde as a writer of prose, "among the first to introduce into art criticism the standards of observation and expression of sentiment" being developed by the most advanced French poets and novelists of his day, availing himself of a new directness and immediacy closely attuned to the Impressionist treatment of "what had formerly been regarded as only a preparatory note or sketch" as "self-sufficient and valid." Yet no more for Fromentin than for Schapiro would this be an excuse

for whimsy or mere enthusiasm. Schapiro speaks for himself as well when he catalogues the virtues Fromentin found in Dutch bourgeois life: "probity, patience, devotion to a task, reasonableness, and regard for reality."

The literalism Schapiro demands of himself he does not, in contrast to Fromentin, require of the artist. He admires in Rembrandt what horrified Fromentin: the inner liberty that "dared to transfigure the real world." Yet this is akin to what offends Schapiro in Heidegger and also in Derrida, of whom Schapiro once complained, in a conversation reliably reported to me, that he lacks "*mésure*"—precisely what Rembrandt lacks in the eyes of Fromentin. We may be permitted to wonder about Schapiro's own unrealized desire to transfigure reality through politics. For all that *Theory and Philosophy of Art* tells us about Schapiro's work in the 1950s and '60s, it contains none of his more overtly Marxist, politically engaged writings of the 1930s. There is undoubtedly much in those writings that Schapiro would later, and with reason, consider naive and, as Fromentin might have said, chimerical. But asked toward the end of his life, in one of the rare interviews he granted, if he bore any regrets, he replied, "I regret the failure of Socialism"—as though he were taking personal responsibility for this failure. Fromentin, as Schapiro remarks, might not have been such a great critic had he been a stronger, more daring painter; Schapiro may have felt that his accomplishments as an art historian came at the expense of the political activist he might have wished to be.

MODERN LOVE

Clement Greenberg among the Gentiles

Everything Clement Greenberg wrote as an art critic was exactly what Baudelaire said criticism should be: partial, passionate, political—embodying "an exclusive point of view, provided always the one adopted opens up the widest horizons." It couldn't have been fun for artists to find themselves athwart Greenberg's exclusivity, though not many had to face judgments he'd been storing up for years, as Georgia O'Keeffe did when he reviewed her retrospective at the

Alice Goldfarb Marquis, *Art Czar: The Rise and Fall of Clement Greenberg* (Boston: MFA Publications, 2006).

Caroline A. Jones, *Eyesight Alone: Clement Greenberg's Modernism and the Bureaucratization of the Senses* (Chicago: University of Chicago Press, 2005).

Museum of Modern Art in 1946: "The lapidarian patience she has expended in trimming, breathing upon, and polishing these bits of opaque cellophane betrays a concern that has less to do with art than with private worship and the embellishment of private fetishes with secret and arbitrary meanings." And that was one of his more sympathetic comments on O'Keeffe. She sounds like Laura Wingfield polishing her glass menagerie. How things have changed in sixty years—the very qualities Greenberg invoked to bury O'Keeffe would now more likely be used to praise an artist's work.

Yet his criticism remains alive, because of a rare ability to do two things at once: to deliver a clear, coherent, and seemingly authoritative synthetic overview of art's development through time and even (or so he imagined) into the near future—a view so forcefully argued that it served either as a guide or as a lightning rod for dispute—and to articulate intimate aesthetic experiences with acute vividness. His attack on O'Keeffe, for instance, is imbued with a pungent sensuality, suggesting that his revulsion is rooted in an intense sensitivity to what the art really is; even those who adore O'Keeffe's work might learn something about why they love it, as well as about why someone else would hate it. Indeed, Greenberg could anticipate what some would hate in the contemporary painting he loved best, Jackson Pollock's: "I already hear: 'wallpaper patterns,' 'the picture does not finish inside the canvas,' 'raw, uncultivated emotion,' and so on, and so on," he wrote in a 1948 review for *The Nation*. Yet he was sure he

knew better, and startlingly enough, he was also sure that he would know better still before long: "I am certain that *Phosphorescence*, whose overpowering surface is stalagmited with metallic paint, will in the future blossom and swell into a superior magnificence; for the present it is almost too dazzling to be looked at indoors." Greenberg was a past master at taking with one hand in order to give with the other, thereby assuming an air of prophetic wisdom even when acknowledging his own limitations.

The son of Eastern European Jewish immigrants who had arrived in New York not very long before his birth in 1909, Greenberg was a slacker full of sexual frustration and inchoate ambition well into his twenties. Irregular employment meant all the more opportunity to read intensely—poetry, fiction, German philosophy—and to frequent New York's few modern galleries. Yet there was nothing to suggest that he had any calling for art criticism or indeed any calling at all. For all his drawing and versifying, his only notable accomplishment was his supreme confidence in his own judgments, especially negative ones: letters of the early '30s declare the Whitney Museum "rotten" and O'Keeffe, already, "lousy, by the way."

But a knack for such judgments can hardly have looked like a way to make a living. After working here and there around the country for his father's chain of stores and falling into a short-lived marriage in California, Greenberg ended up with a civil service job back in New York, where he mingled with writers and artists in Greenwich

Village. He immersed himself in the ideas of Leon Trotsky and became friendly with Lionel Abel, a literary critic for *Partisan Review*, and Harold Rosenberg, who would also later emerge as a famous art critic—and as Greenberg's despised rival. Through Rosenberg he met a young painter named Lee Krasner, who invited him to lectures by her teacher, the German émigré painter Hans Hofmann. Although Greenberg's fantasies of becoming an artist himself never led anywhere, Hofmann's ideas remained a constant reference.

As war loomed in Europe, then, Greenberg was nothing more than one of the multitude of Village dilettantes and hangers-on. It was a letter to *Partisan Review* (where he had already published a brief book review) that launched his career. Just why he felt the need to take exception to the boilerplate statement, in an essay on the Soviet cinema by Dwight Macdonald, that "Western art has for centuries lived without associations with the masses," may never be known, but in doing so he must have been expressing ideas that had been stewing in him for a long time: "It must be pointed out that in the West, if not everywhere else as well, the ruling class has always to some extent imposed a crude version of its own cultural bias upon those it ruled," he wrote. "Chromeotypes, popular music and magazine fiction reflect and take their sustenance from the academicized simulacra of the genuine art of the past. There is a constant seepage from top to bottom, and Kitsch (a wonderful German word that covers all this crap) is the common sewer."

Kitsch made Greenberg's reputation. Invited by the magazine's

editors (and encouraged by Macdonald) to work his ruminations up into publishable form, he produced "Avant-Garde and Kitsch," which appeared in *Partisan Review*'s fall 1939 issue. Immensely ambitious, the essay opened up a vast perspective: Greenberg put the dialectic between formal and popular cultures at the center of cultural history: mass art, kitsch, made itself out of the remains of moribund cultivated forms, but the motor of high art's development was in its recoil from the condition of kitsch, the potential fate of its own efforts. Greenberg's references ranged brashly across centuries of history and shuttled with no less confidence from poetry to painting to music. The prose was pithy, forceful, punctuated with memorable formulations: "If the avant-garde imitates the processes of art, kitsch, we now see, imitates its effects"; to the ruling class, avant-garde art "has always remained attached by an umbilical cord of gold." Most important of all was Greenberg's political perspective, a fusion of Marxism and modernism. Part of the essay's appeal must have been its tone of disillusioned realism even as it guardedly evoked the possibility that socialist revolution could preserve high culture. But in retrospect the essay's realism doesn't seem to go much deeper than its tone. In particular, it turns on the fantastic notion of an imaginary Russian peasant asked to choose between Picasso and the Russian academic painter Ilya Repin—a rhetorical ploy that mainly serves to show that Greenberg had never met a peasant. But while painting the masses as incapable of producing any real culture of their own, he reserved

his strongest scorn for a ruling class that was abandoning its putative role as patron of high culture.

Greenberg's next big essay, "Towards a Newer Laocoon," developed at length one of the subsidiary themes of "Avant-Garde and Kitsch"—a theme whose formulation he specifically credited to Hofmann, that of the modernist artist's resort to his own medium as his work's subject and inspiration. Here, painting came to the fore, yet Greenberg's broad argument continued to take in poetry and music on equal terms. Over the next couple of years he wrote brief reviews of exhibitions by Miró, Léger, and Kandinsky, as well as an essay on Klee, but otherwise one would have assumed literary criticism to be Greenberg's main concern. It was only in 1942, when he began reviewing exhibitions regularly for *The Nation*, that he became an art critic in the narrow sense of a reviewer on the beat, and for the next few years his art reviews were still interspersed with essays on writers as diverse as Stefan George, Anthony Trollope, and Sholem Aleichem.

This last name in particular reminds us that Greenberg always wrestled with the question of "what the West now knows as the Jew." It was never easy. Alice Goldfarb Marquis, in her new biography of Greenberg, can quote any number of anti-Semitic barbs littered through his early correspondence. "Squalling Jew bastards from the very best homes in Long Island" is how he described the kids he had to look after as a teenage camp counselor; Hollywood was "a lot of

sporty looking little Jews and fairy scenario writers and high school girls." Much later, Greenberg would reminisce about taking the subway alone from the Bronx to Manhattan—getting out and seeing "the crowds of gentiles—and it was liberating." One might wonder whether Jewish self-hatred could be a key theme in the critic's life, were it not that he could be equally disdainful of the goyim, discerning in his ex-wife and mother-in-law, for instance, "a mean Gentile quality ... so cold, so just, so sensible." Besides, for an anti-Semite to have earned his living from 1944 to 1957 as an editor for the *Contemporary Jewish Record* and its successor, *Commentary*, would have taken an iron constitution, something the hypersensitive Greenberg never had. Considering the topic in a 1950 essay, Greenberg quoted the idea that "'group pride' and 'self-hatred' seem inextricably mixed." A critic for whom Sholem Aleichem "goes deeper than Dickens" is not one given to underestimating his people's accomplishments. His own verdict was that "a quality of Jewishness is present in every word I write," and in his published writings, Greenberg could be a sensitive and subtle examiner of the dilemmas of Jewishness, always with an autobiographical undertone. When he speaks of Kafka's "apprehension" about "the outside world—the world of officials and of strangers on the street, of janitors and peasants and coachmen," one feels that he might be thinking of himself at twelve emerging from the subway into the gentile world of Manhattan. The sense of the unknown is the same, whether experienced as threatening or liberating. And when he at-

tributes Kafka's difficulties with the world to his complex relations with his father, the impression of identification is even stronger: the Jewish world that Greenberg didn't want to be a part of was that of the "barbarian" *shmatte* merchant who had thrown his son's drawings away and spent "sleepless nights over the fear that [... the boy] may turn out to be a weakling in life."

Greenberg's propensity to articulate his deepest desires for art in terms of classical Greece thus takes on a very particular coloring—from the declaration in "Avant-Garde and Kitsch" that "it's Athene whom we want: formal culture with its infinity of aspects, its luxuriance, its large comprehension" to the later demand, in "The Present Prospects of American Painting and Sculpture," for "a bland, large, balanced, Apollonian art." Greenberg was a sort of latter-day Hellenistic Jew, attempting to reconcile Hebraic particularity with cosmopolitan (not to say Arnoldian) sweetness and light. In contrast with this enviable cosmopolitan breadth, he felt, Jews in Europe and Asia, having "lived self-absorbed in the midst of alien peoples," had grown "fundamentally uninterested in the social and cultural life that surrounded it on every geographical and political side." Such was the cramped and blinkered outlook his parents had brought with them from the land of the czars, and from which he sought to liberate himself. Get clear of it he certainly did. But if Greenberg viewed one side of the wider surrounding gentile culture through the prism of Apollo and Athena, he never lost sight of the culture's shadow side,

represented by the idea of the peasant, who, though powerless like the Jew, had a stronger "relation to the sources of power in a feudal society" and thus impunity in his brutality toward Jews.

What's best remembered now about Greenberg's years as art critic for the *Nation* is his campaign on behalf of Pollock, who by then had married the critic's old friend Lee Krasner. It's one of those rare instances of a critic staking a daringly long position on a contemporary and turning out spectacularly right. Greenberg's quondam girlfriend, Jean Connolly, had already picked Pollock out of a group show as one to watch in a review she had published, but only Greenberg was ready to pronounce the work in Pollock's first solo exhibition as "among the strongest abstract paintings I have yet seen by an American." The inner workings of Greenberg's response to Pollock are sifted in great detail and with some surprising results in *Eyesight Alone*, a massive new study by Caroline A. Jones, an art historian at MIT who has already made a considerable impression in the field with her first major (and equally unwieldy) book, *Machine in the Studio*, an examination of the changing sense of what artistic work might be in the American art of the '60s. But what's probably most important is how, in hailing Pollock's work, Greenberg struggled to reconcile the antithetical tenets of his criticism: on the one hand, the need to experience the artwork as a self-contained aesthetic fact; on the other, the question of whether the work is historically progressive,

i.e., the extent to which it shows awareness of "the direction in which the pictorial art of our times must go in order to be great." For Greenberg that direction ran toward purity of medium and elimination of subject matter; in painting this meant the dismantling of pictorial space. He came to depend greatly on the distinction between "major" and "minor" art as a way of finessing the tension between autonomy and history. A formidably agile rhetorician, he turned his contradictions to advantage. As critic Hal Foster once put it, "When Greenberg was challenged on questions of history he would defend his judgment as a matter of taste, and when contested on taste he would appeal to history."

By 1949, though, with "a bellyfull of reviewing in general," Greenberg gave up his beat. In the '50s this led to a series of important essays on individual modernists from Cézanne through Soutine and Léger to Pollock and David Smith. Beginning with "'American-Type' Painting" in 1955, and continuing with "Modernist Painting," "After Abstract Expressionism," and others, he also began to rethink "the direction in which the pictorial art of our times must go in order to be great." These efforts became all the more concerted as it became clearer that the direction taken by much of the most notable art from the late '50s onward—the "Neo-Dada" of Johns and Rauschenberg followed by Pop, Minimalism, Conceptual art, and so on—could never lead, in Greenberg's eyes, to greatness. These artists had learned from modernism to seek the borderline between art and non-

art but did so not by rigorously purifying a medium but by arbitrarily mixing media in search of "the merely odd, the incongruous, and the socially shocking." Greenberg's preferred tendency—the "color field" painting of Jules Olitski and Kenneth Noland and the welded steel sculpture of Anthony Caro—seemed secondary at best to the art world at large; to some, they were not avant-garde but kitsch. And yet despite his aversion to much of the new art of the time, the publication in 1961 of *Art and Culture*, a selection of his essays, gave Greenberg new authority in the eyes of an emerging generation of critics like Michael Fried and Rosalind Krauss. This is the Greenberg who fascinates many art historians today—the one who engaged in ideological battle with the suddenly emergent Duchampian tradition and struggled to theorize an art he could not abide. By the end of the '80s, Greenberg declared that taste had not so much declined as "just gone away." No wonder that after the 1967 piece with the self-explanatory title "Complaints of an Art Critic," Greenberg's written work thins out drastically. From then until his death in 1994, his criticism consisted mainly of lectures delivered at museums and universities around the world (he was now freelancing for the State Department, having defected to conservatism like many ex-Trotskyists) and conversation in the studios of a chosen band of sympathetic artists. It's a particular loss that Alice Goldfarb Marquis, Greenberg's latest biographer, has little to say about Greenberg as a studio visitor. Apparently she did not interview Olitski, Noland, Caro, or any

of the other artists who were close to him from the late '50s on. There will never be a definitive biography of the critic without some account of what transpired in their studios.

This is not to say that Marquis (the author of biographies of Alfred H. Barr, Jr. and Marcel Duchamp) adds much to our knowledge of Greenberg in any other way. She's hardly done more than repeat a story already told in the 1997 biography by Florence Rubenfeld, while embroidering it with material from Greenberg's correspondence between 1928 and 1943 with a college buddy, Harold Lazarus, published in 2000 as *The Harold Letters*. Rubenfeld's biography was not without problems of its own, but at least she'd had the benefit of lengthy interviews with her subject. Whenever Marquis uses a phrase like "he told an interviewer," a glance at the back matter will confirm that the "interviewer" was the biographer who got there first. Marquis may have lowered Rubenfeld's sensational tone down a notch or two, but that's not necessarily a virtue when contending with a figure whose private life was as messy—some would say vile—as Greenberg's.

Readers who want a better understanding of what Greenberg wrote and why, and above all of why what he wrote was so significant, would in any case be better off if they ignored both biographies and did the harder but more rewarding work of reading Jones's dense, indeed sometimes maddeningly verbose, "critical history." Like Marquis, Jones leans on biographical material culled from Rubenfeld and *The Harold*

Letters along with Greenberg's own writings as well as the reactions to (and against) Greenberg by the art critics and historians who followed in his footsteps; but she brings to all this an analytical intensity, an almost ferocious determination to dig into the text, that makes the biographers' declarative flatness seem dull by comparison. The hundred pages she spends analyzing Greenberg's writings on Pollock—minutely sifting the critic's words through her own searching reexamination of the paintings he had in view—are alone worth the price of the ticket. As Jones's title suggests, her subject comes from the attachment to medium that Hofmann had revealed to Greenberg back in 1938 and that had been a constant of the critic's thought from "Avant-Garde and Kitsch" to the end of his life—the notion that painting could be a purely "optical" art. For Jones, Hofmann's articulation of this idea was central to Greenberg's influence because it fed into and accelerated a larger historical process that she calls "the bureaucratization of the senses." It's a suggestive point, yet it remains strikingly undeveloped, particularly for a writer as attentive to detail as Jones. (She's the sort of writer who finds it necessary to gloss Greenberg's jibe at Alfred Stieglitz's circle of artists—"Too many of the swans in his park are only geese"—with a paragraph outlining the significance of the swan as a symbol in Western culture.) She never properly defines bureaucratization, nor does she engage with the large sociological literature, from Max Weber onward, that deals with the development of bureaucracy as an aspect of modernization.

More oddly, given Greenberg's immersion in Trotskyite thought in the late 1930s and early '40s, she never discusses Trotsky's critiques of the Soviet Union as a degenerate bureaucracy. Even allowing Jones's point that "art forms were positioned as elements of a system whose function was to regulate feeling (rather than merely 'show' it)," there should be some explanation of why bureaucratization in particular should have been the great social force at work in this system, especially when artists themselves were unlikely to have much firsthand experience of it—unlike more traditional themes of the social history of art, such as class. Still, the strength of Jones's book is the sense of how complicated a thing it was for Greenberg to become Greenberg. While the kind of art viewer Greenberg seemed to be calling for was not, as Jones says, "a dallying subject, a daydreaming subject, a narrativizing subject, a distractedly scanning subject," a bureaucratized viewer would have been nothing like the ne'er-do-well who wrote "Avant-Garde and Kitsch."

USE AS MEANING

E. H. Gombrich on Image History

"History of art" or "visual culture"? The conflict between them may be rife in academe, but in the temperate pages of these essays, whose publication on March 30, 1999, coincides with their extraordinary author's ninetieth birthday, the two distinct but competing projects seem easily reconciled. Still, forced to choose, one would have to admit that while Ernst H. Gombrich is the author of a widely used textbook in art history, his real contribution has been as a forerunner of the study of visual culture even in his best-known works, *Art and Illusion* and *The Sense of Order*, whose subtitles both refer, not to culture, but to psychology. On the very first page of the first essay

Ernst H. Gombrich, *The Uses of Images: Studies in the Social Function of Art and Visual Communication* (London: Phaidon, 1999).

of *The Uses of Images*, on the development of mural painting in the Renaissance, Gombrich is quite explicit about being concerned with "the history not of art, but of image-making." And yet the study of art may owe just as much to Gombrich, after all, as the study of image-making does.

This is particularly clear in the rather cohesive set of five essays with which *The Uses of Images* begins. Their titles signal the way Gombrich intends to examine paintings, sculpture, and so on in terms of their purposes or destinations: "Paintings on Walls," "Paintings for Altars," "Images as Luxury Objects," "Pictures for the Home," and "Sculpture for Outdoors." What the bluntness of the titles doesn't catch is the subtlety or ambition of the tasks Gombrich has set up for himself in the essays to which they are attached. "Paintings on Walls," for instance, is really a meditation on one of the grandest themes in art history, namely on the reasons for the emergence of Renaissance art out of the disintegration, as he calls it, of the very different but "grand and consistent" canon of representation that had served the Middle Ages. Gombrich's answer has to do with "the increasing demand for what I have called the dramatic evocation, the return to the desire not to be told only *what* happened according to the Scriptures, but also *how* it happened, what the events must have looked like to an eyewitness." In other words, it has to do with the replacement of a visual rhetoric of simple representation by one bound to an idea of verisimilitude.

To a reader like me, more deeply involved with contemporary art than with that of the Middle Ages or the Renaissance, what is striking here is Gombrich's observation that, "at first, sculpture was more pliable to these new demands than was painting," but that with the need to place the now fully-realized figures of, say, Nicola Pisano on "a convincing stage, a consistent spatial setting," painting became more serviceable. In this century, the demand for verisimilitude has again been reformulated, or rather a new formulation has come into circulation to compete with existing ones, and this newer sense of artistic credibility is centered on objectivity. The curious thing is that, mirroring the one that led to the Renaissance, this reformulation occurred first in and through painting, but the corresponding "need of a convincing stage" for it has led to the development of the new genre of three-dimensional work known as installation. What Gombrich's analysis suggests, though, is that, just as there was no final resolution to the problem of mural painting in the Renaissance because "decoration, sequential narrative, and dramatic evocation each demand a different way of looking," so the conflicting or inconsistent demands on today's art will undoubtedly impede any ultimate synthesis and for that very reason will continue to generate new forms. "Taken to its logical extreme," writes Gombrich, "the principle [that a frescoed wall should be treated as a fictitious window] must in fact deny not only the wall but the room itself, which is what Giulio Romano did in Mantua, in a sensational showpiece which is not, perhaps, the height

of stupidity, but the height of folly, when regarded as a room—precisely because it is the ultimate in dramatic evocation, the equivalent of a 3-D horror film." And the image of the collapsing room with toppling columns in the Sala dei Giganti will evoke, for some of us, nothing so much as Chris Burden's *Samson* (1985), an installation contrived so that each visitor, entering the gallery through a turnstile, places added pressure on its walls so that, if enough people had come to see it, the work would have destroyed its setting. More commonly, of course, installation art seeks to displace its site by means of illusionism, as in Ann Hamilton's *myein* at the 48th Venice Biennale.

Is it legitimate to make such comparisons, though Gombrich himself does not? According to his way of seeing things, nothing could be more natural, for evolution of artistic tasks is something that happens over the *longue durée*, and "even the artist today [...] owes his predicament and his joy to the demands made on his predecessors some 700 years ago." The four succeeding essays are similar to "Paintings on Walls" in their historical sweep, and in having implications even broader than Gombrich's own extensive erudition might necessarily reach. Gombrich's history of artistic tasks (a term whose significance he borrows from Jacob Burckhardt, from whom Walter Benjamin too must have borrowed it, however different his use of it in "The Task of the Translator") is not really, as he seems to claim in his introduction, a history of suppliers' reactions to or even influence on the "market force" of demand unless demand be understood in a

very broad way indeed, for it is clear that the "demand" for a fresco is of a very different nature than the demand that a fresco be understandable as an Albertian window. The demands that interest Gombrich are essentially formal and ideological, not economic, which is why his work offers so much to the history of art, not just of image-making, and why it has contemporary implications that Gombrich himself may not necessarily care to follow.

The six final essays are harder to sum up, and are mostly of more specialized interest. Essays on visual symbolism in the French Revolution, on pictorial satire, and on pictorial instructions (e.g., the diagrams found in airplanes showing how to fasten your life jacket, which I too have always found amusing) are really studies of visual culture in the strict sense, since they involve images with no artistic claims whatsoever, and for the non-specialist are as suggestive as the explanation for a joke you didn't find funny. The most stimulating of these essays, for me, was "Pleasures of Boredom," a meditation on doodles, again in part because of the subject's relation to twentieth-century art, though Gombrich himself is concerned to minimize this. But he notices how the influence also goes the other way: "The license enjoyed by contemporary art has encouraged many doodlers today to follow the suggestions of their dreaming minds much further" than they did in the past.

GHOSTLY PRESENCE

Hubert Damisch's and James Elkins's
Conflicting Perspectives

"Linear perspective," as Martin Kemp wrote in opening his own discussion of the subject in his book *The Science of Art*, "is a beguilingly simple means for the construction of an effective space in painting." Kemp's use of the word "effective" seems to firmly place the function of perspective in the realm of a sort of pictorial rhetoric; on this view, it has to do with a certain "effect" in the eye and mind of a painting's beholder. But the effect which is the aim of rhetoric is never something

Hubert Damisch, *The Origin of Perspective*, trans. John Goodman (Cambridge, MA: MIT Press, 1994).

James Elkins, *The Poetics of Perspective* (Ithaca, NY: Cornell University Press, 1994).

purely self-contained; rhetoric is meant to be convincing, and so the effect it seeks is a truth-effect. The problem with perspective—"the firmest link," as James Elkins writes, "between paintings and the measurable world known to physics"—has to do with knowing how to take its implicit claim to truth. Its "origin," to use Hubert Damisch's loaded term, at the intersection of optics, mathematics, and painting—of empirical science, pure analytic thought, and art, or (in Kantian terms) of practical reason, pure reason, and judgment—has made it difficult to disentangle its conventionality from its supposed ability to provide demonstrably correct representations of the visual world.

Moreover, there is something about the "beguilements" of perspective that threatens to draw us into all sorts of traps. The headlong rush of perspectival recession seems to pull vision toward an infinite distance from which it can never return—or only by a jolting break with the representational fiction of the painting—while the intricacies of perspective construction, forbiddingly dry and austere to the non-initiate, seem calculated to seduce the specialist into the coils of a diabolical obsession. Not only are science, mathematics, and art implicated in Renaissance perspective, there is also about it a faint aura of magic, a suspicion of that Faustian lust for occult knowledge, for "things kept secret since the foundation of the world," that is also a part of our image of the Renaissance.

Thanks to the development of perspective in Renaissance Italy, it has been said, "space rather than the objects in it came to have increasing importance" not only in painting but in an entire worldview

or visual culture; but in the process, "space was robbed of its substantive meaningfulness to become an ordered, uniform system of abstract linear coordinates [...] less a stage for a narrative to be developed over time than the eternal container of objective processes." Such is the image of perspective taken for granted in much contemporary thought outside the specialized purview of Renaissance art history, as in those quoted passages from *Downcast Eyes*, Martin Jay's investigation of the attitude toward vision in modern French thought —the prejudice, one might say, of what turns out to be a ubiquitous "anti-ocularcentric" tradition according to which the "scopic regime" of Cartesian modernity centered on a perceiving subject conceived of in the image of "a monocular, unblinking fixed eye (or more precisely, abstract point), rather than the two active, stereoscopic eyes of embodied actual vision." While "making a strong case for a causal relationship between the invention of perspective and the rise of capitalism may be problematic," as Jay says, their simultaneous rise has engendered suspicion that a common regime of rationalization for the sake of domination unites them. (I am surprised that more has not been made of the fact that Leon Battista Alberti, whose *De pictura* is the ur-document for the Florentine development of perspective, is also the author of four *Libri della Famiglia* in which Werner Sombart, for one, and after him Fernand Braudel, recognized the beginnings of a new mentality which can be identified as capitalist—well before the advent of that "Protestant spirit" that Max Weber considered an essential precondition for the development of capitalism, let alone

the industrialization that Marxist thought sees as crucial.) In modern thought, certainly, perspective has not been in very good odor, as both Elkins and Damisch acknowledge early on in their recent books on the subject. "There has always been something a bit philistine about the perspective lines that art historians add to paintings," Elkins admits ruefully, reflecting perhaps the broader problem that "perspective as a whole has become a backwater, no longer central to our painting or our imagination." His French colleague follows the more typically American wisdom of Vince Lombardi, who taught that the best defense is a good offense: Damisch relentlessly trashes "the imprecise definitions, the crude simplifications, not to mention the outright errors and misunderstandings, that are the stock in trade of those, their motives often suspect, who parrot formulations that no longer even have the merit of novelty."

Against such broad and invidious assumptions, Elkins offers a detailed and convincing account of perspective practice that appears calculated to revise our understanding of it in ways that might render it more agreeable to postmodern ideologies. As he announces at the beginning of his book, "Renaissance authors and artists thought there were many compatible perspectives, so that their writings evince a 'pluralist' approach in strict contrast to the monolithic mathematical perspective we imagine today." As a result, in the present, "perspective is not fully at home in any one discipline," and "no canonical site, no single definition or description [...] can provide an adequate or

standard account of what it is." This pluralist, interdisciplinary, downright rhizomatic perspective becomes an irresistible challenge to the rather "fossilized" understanding of perspective that Elkins contends has overtaken contemporary writings on the subject (including the legacy of Erwin Panofsky, whose celebrated essay *Perspective as Symbolic Form* could be taken as the precursor text for a Bloomian analysis of the anxiety of scholarly influence that afflicts not only Elkins and Damisch—who devotes some challenging pages to Panofsky's work—but most others workers in this field) as well as its place in artistic practice.

Elkins's proclaimed pluralism does not make his work easygoing, however. To fully follow his arguments involves working through numerous proofs and diagrams, often confusing or even incoherent, from old treatises. These proofs, according to Elkins, involve not only logic but expression, and are typically "neither elegant nor rational but unnecessarily ornate and intricate"; he accords their "poetics" as much attention as he gives to renowned paintings like Masaccio's *Holy Trinity* (1427–28), Piero's *Flagellation of Christ* (1455–60), or Pontormo's *Visitation* (1514–16). Both *The Poetics of Perspective* and *The Origins of Perspective* are most interesting for the way they challenge casual assumptions and unquestioned conventions about how art history should be done, and in both books it is the "technical" side of perspective that provides the monkey wrench to be thrown into the gears of unreflective scholarship. The difference is that Elkins's

method involves an effort—questionable in principle but in practice enlightening, thanks to his discriminating application—to stick as closely as possible to the reconstructible self-understanding of the early practitioners of linear perspective. In other words, he aims to avoid overlaying later metaphorical or mathematical interpretations onto their terminology, in contrast to the elaborate interpretive armature derived from structuralist linguistics and Lacanian psychoanalysis that Damisch brings to bear. Curiously, the latter too announces his intention to give "a reading that, if possible, is more naive (in the phenomenological sense), less *anticipatory*, but also more literal, more respectful of the texts, than those previously proposed." If it's harder to accept this at face value than Elkins's cognate professions, it is just as true that with Elkins the impulse toward "literalism" threatens to degenerate from a methodological postulate into the kind of historical positivism Damisch rightly decries, and which is equally at odds with what is most consequential in Elkins's work.

"The Renaissance painters made perspective pictures without the benefit of a concept of space," Elkins reminds us, meaning the modern concept—inherited from Descartes, Newton, and Kant—of pure, abstract space prior to any contained object. This is almost impossible for us to come to terms with today. Not having a concept of space suggests a completely alien mentality, as Benjamin Lee Whorf suggested the Hopi had, and our sense of cultural continuity with the Renaissance will not easily allow that. One would rather hypothesize, for

instance, that it was the inception of perspective that made the concept of space possible, and that for this reason the concept would only become explicit subsequently, in its wake. There is probably some truth to this, but to assume an implicit concept of space in early perspective pictures would be to obscure much that is strange and striking about them. "The artists were concerned with making objects," Elkins concludes, and not "with excavating space," and Damisch seems to agree, although couching his acknowledgment of this in a less definite form.

In fact, Damisch and Elkins have more in common than one might have gathered from the severity with which the latter refers to *L'Origine de la perspective*, which Damisch first published in 1987 and then revised for the 1989 edition which John Goodman has translated. Elkins's diffidence is easy to understand. A product of the late efflorescence of Lacanian/Derridean post-structuralism, Damisch's style can be infuriating. The "warning" in his preface that "the pages that follow will have their share of trying passages and repetitions and will not be devoid of obscurity" turns out to be an understatement but also, I'm afraid, a boast. Damisch's sometime obscurity is willful, and it extends from a tortuous syntax to the seemingly arbitrary structure of the book as a whole. All of this is unfortunate because *The Origin of Perspective* contributes a genuine philosophical bearing to issues of perspective, which is not exactly missing from *The Poetics*

of *Perspective*, since Elkins's bracketings constitute a philosophical stance as well, but which is only tacit there, and not as deeply considered as it might have been. The complexity of Damisch's arguments, the shrewdness of his critical analyses, the impressive reach of his erudition would have been demanding enough without the rhetorical baffles. A more deeply rewarding frustration would have resulted simply from the way Damisch constantly defers resolving or foreclosing issues on which he carefully canvases all the received opinions, leaving the really broad questions about perspective up in the air—most notably, how can we perceive and represent something that is not an object of perception and representation but a constitutive structure through which these take place?

Yet there is a second book, shapelier and more compact, folded into this unwieldy monster, though one could never divine it from the sibylline table of contents. This more tightly focused book-within-a-book is an analysis of three paintings, horizontal panels of uncertain date and attribution now in Urbino, Baltimore, and Berlin, representing depopulated (or nearly so) urban settings. While Elkins complains that Damisch here "ends up by reducing an eloquent array of specific constructions to a lumbering play of abstractions," it is hard to understand how one could fault his loving attention to specific detail or his urge to make them tell their own hidden tales. While there is certainly now a dated feeling to Damisch's structuralist schematisms, and it is clear that they need not have been so elaborate, the fact is that these interpretive Rube Goldberg machines eventually pay off in commu-

nicating a more concrete sense of how perspective works in particular paintings. In any case, Damisch's method is a closer match to the "ornate and intricate" workings Elkins claims are typical of the early perspectivists.

Both Damisch and Elkins imply, without showing how this would work itself out, that the issues produced by the study of perspective are not simply historical, but have some bearing on artistic issues in the present. Elkins begins by acknowledging the common wisdom that "contemporary art has largely abandoned" perspective, or rather, "the founding of modernism was bound up with a rejection of perspective," but some intriguing hints occur at the end of his book, where he points broadly to the possibility that perspective "remains a ghostly presence throughout modernism." He suggests that a fuller understanding of Analytic Cubism would account for this presence, enabling a more detailed understanding of the foreshortening that sometimes does and sometimes doesn't affect Cubist faceting. One could wish for these points to have been further developed, and—recalling Elkins's opening statement that his book concerns pictures "with a high complement of geometric forms"—for an examination of the tacit relationships between the planar, geometrically simple structures of "geometrical abstraction" and the more elaborate structures in depth we find in perspective. And then it would have been worth the trouble of examining some of the contemporary painters of various generations who have attempted to use perspective in ways that are neither academic nor simplistic, among them Al Held

and Mel Bochner, not to mention the most vital manifestations of figurative painting from Francis Bacon to Kerry James Marshall, and the more "conceptual" reflections of an artist like Giulio Paolini. Elkins speaks mournfully of perspective having become a fossil, which can only happen when something is dead; but cultural forms, unlike the people who make them, can never really die. They can lie dormant, but may always be rediscovered and revivified should there arise sufficient need for something of their kind. The interest of artists like those I've mentioned, and of writers like Elkins and Damisch, suggests that there may once again be arising needs to which perspective alone can answer. Lay readers like me will be dismayed and enlightened in turn by both of these books—with differences in ratio between the two reactions dependent more on intellectual taste than anything else. Elkins seems more persuasive and perhaps more immediately useful, though Damisch may have more resonance in the long run. The value of these books will be less for particular propositions about perspectives such as will give specialists matter for learned dispute, and more for what one hopes will be their influence on historiography—not so much for the effect they may have on the study of art as on our sense of the trajectory of European civilization as a historical (or better, anthropological) construct. Paradoxically, they can only do so by showing us that we cannot hope to map the broad features of this construct without thorough readings in detail of the historical evidence as supplied by treatises and paintings.

OUT OF SIGHT

Jacques Derrida on Drawing Memory

Over the years Robert Morris has produced an extensive series of "Blind Time" drawings and prints, executed while blindfolded. Sophie Calle, in her work *Les aveugles* (1986), juxtaposed photographic portraits of blind people with texts in which they explain their idea of beauty and images of what they described. Any number of artists have incorporated Braille into their work in recent years, among them L. C. Armstrong, Miguel Barceló, and Leone & MacDonald, a collab-

Jacques Derrida, *Memoirs of the Blind: The Self-Portrait and Other Ruins*, trans. Pascale-Anne Brault and Michael Naas (Chicago: University of Chicago Press, 1993).

Martin Jay, *Downcast Eyes: The Denigration of Vision in Twentieth-Century French Thought* (Berkeley: University of California Press, 1993).

oration between Hillary Leone and Jennifer MacDonald. Vik Muniz and Klaus Ottmann have organized, for the Zilkha Gallery at Wesleyan University, "Shooting Blind," a photography show on the theme of blindness, and among those whose work is included is Evgen Bavčar, a photographer who is himself blind. (What, I wonder, is the nature of the pleasure he takes in his work?)

Clearly, the idea of blindness is a resonant one in contemporary art. Why? Are signifiers of blindness employed for their sheer pathos? Do they signal the aspiration to some more inward form of knowledge or perception, one undeceived by illusion and surface? Or is it just that any investigation of vision must eventually determine the nature of its absence? All of the above, no doubt, and more. The reasons for visual art's fascination with the absence of vision may be as numerous as the artists affected by it. But two recent books should stimulate a more pointed investigation of art's romance with blindness.

Perhaps the author's name alone is sufficient explanation for why Jacques Derrida's *Memoirs of the Blind*, a book ostensibly about drawing, turns out to be another installment in the celebrated French philosopher's ongoing elaboration of the activity of writing, of textuality. This is the translation of *Mémoires d'aveugle: l'autoportrait et autres ruines*, published in 1990 as the first volume in the "Partipris" series from the Louvre, publications accompanying a series of exhibitions selected from the museum's drawing collections by prominent nonspecialists. (However, the translator's preface warns us, cryptically,

that "the text presented along with the drawings and paintings at the exhibition was not the same as that found here.")

Martin Jay's *Downcast Eyes*, a compendious charting of "the denigration of vision in twentieth-century French thought," fills in some of the intellectual context for Derrida's reflections on blindness in drawing. Jay's book is long, dense, and massively documented. He shows the distrust of vision to be a constant theme in modern philosophy in France, from Jean-Paul Sartre on "the look" and Jacques Lacan on "the gaze" to Michel Foucault's "panopticon" and Guy Debord's "spectacle." Admitting that his attempt at a synoptic view would violate the strictures of most of the thinkers he discusses, Jay perhaps overestimates his degree of removal from his subject, his attainment of a "totalizing vantage point." In fact, Jay plunges so deeply into his subject that it becomes difficult to gain perspective. What *is* this "denigration of vision" Jay has charted? Denigration with regard to what? On the one hand, insofar as sight has been seen as "the noblest of senses," it is partly a question of undermining its place at the pinnacle of a certain epistemic hierarchy (as, for instance, the German hermeneutic tradition, with its emphasis on dialogue, can be said to give pride of place to the sense of hearing). But on the other hand, it turns out to be more about the denigration of a certain *idea* of vision, namely the Cartesian idea, which is to say an idea that was dominant in French intellectual history for centuries. In explaining how the mind works, as Jay points out, René Descartes "tacitly adopted

the position of a perspectivalist painter using a camera obscura to reproduce the observed world"; his was a vision modeled on that of a single disembodied eye inspecting entities positioned in a neutral and infinitely extendable space. This model of vision and, by extension, of knowledge in general, which Descartes generalized from the practice of Albertian perspective in painting, is what Jay calls "the dominant scopic regime of the modern era," and it is really this "scopic regime" that is the target of most of the thinkers Jay considers, Derrida among them. Thus, as Jay admits, the subject of his book is not only a rejection of the primacy of vision but the "recovery of a subordinate, heterodox, and virtually obliterated visual practice—that of the baroque—from the initial moment of the modern era."

The "clear and distinct" ideas that were the desiderata of Cartesian thought, modeled as they implicitly were on the clear and distinct forms of Renaissance painting, had a profound influence on the French understanding of language as well, and stand as the ultimate guarantors of the confident presumption, quoted by Jay, of the eighteenth-century author of De l'universalité de la langue française, Antoine de Rivarol, that "what is not clear is not French." If de Rivarol's statement comes as a shock to the many readers who remain leery of what is often considered the hermetic and impenetrable language of modern French philosophy and critical theory—what Donald Kuspit recently called "that whole involuted self-questioning writing, what I call solipsistic language, [which] is dreadful, very wrongheaded, and very

specifically French"—it only goes to show how deeply the reaction against Cartesian perspectivalism has permeated the very syntax of the writers with whom Jay is concerned. The tortuous line of Derrida's "ruminations on visual issues, characteristically impossible to reduce to a simple valorization or condemnation of the eye," as Jay notes— its mixture of playfulness and manipulation, aphoristic brilliance and enigmatic obscurity—constitutes a typically baroque literary rhetoric, parallel to the anamorphoses and other destabilizing devices that express the baroque resistance to the scopic regime of modernity.

I have said that Derrida's book is more about writing than its ostensible theme of drawing, but I don't mean to imply that Derrida fails to discuss drawing. He does so with accustomed subtlety, brilliantly connecting it with such apparently far-flung themes as those alluded to in his title and subtitle: memory, blindness, self-portraiture, ruins. Derrida's prose is a remarkable literary invention, at once massive and dispersed, fractally self-replicating and confoundingly plural. It is the very medium of paradox. In this case, it is as paradoxical to connect blindness with self-portraiture as with ruins, for how could one portray oneself without having seen oneself, and is not the ruin precisely a form of spectacle? But, according to Derrida, "at the origin of the *graphein* there is a debt or gift rather than representational fidelity. More precisely, the fidelity of faith matters more than representation, whose movement this fidelity commands and thus precedes. And faith, in the moment proper to it, is blind." So the activity

of drawing always contains some moment of blindness in it; the hand is faster than the eye, as the magician says. And just for this reason, for Derrida, "every time the draftsman lets himself be fascinated by the blind, every time he makes the blind a *theme* of his drawings, he projects, dreams, or hallucinates a figure of a draftsman. [...] He begins to *represent* a drawing potency [*puissance*] at work, the very act of drawing."

The self-referential, even autobiographical nature of the projection of blindness as a theme in drawings must be what evokes yet another blindness at work here, "a double infirmity: to this day I still think that I will never know *either* how to draw *or* how to look at a drawing." Derrida's modesty is not apparently false, for he but rarely attempts to guide us in looking at the drawings he has chosen, any more than he wants to speculate on just how they came to be drawn. His concern is more with the relationship between the drawings and the texts they illustrate, the narratives they evoke. His exegeses convoke citations ranging from Plato and the Bible to St. Augustine and John Milton, Charles Baudelaire and Jorge Luis Borges. Derrida's own discourse in *Memoirs of the Blind* concludes where a surprising number of the narratives of blindness end, in the veiling of sight in tears, in the intimation that "deep down inside, the eye would be destined not to see but to weep. [...] It neither sees nor does not see: it is indifferent to its blurred vision." And this blurred vision, which is specifically human ("But only human eyes can weep," as Derrida quotes Andrew

Marvell), is assigned by the history of European drawing to women: blind men, weeping women. Jay interprets Derrida to suggest that "only a feminism that knows the value of the veil of tears [...] can preserve the insights provided by such blindness. Only women who resist mimicking the dominant male scopic regime can avoid merely inverting the hierarchy that it supports," reminding us that even as he has held feminism at a distance, Derrida's work has been crucial for the development of feminist theory in France—though there is something queasy in this *larmoyant* feminism, reminiscent of a certain eighteenth-century sensibility.

In the end, Derrida—following up on the work of Paul de Man—does not exactly "denigrate" vision in the way that many of the other authors discussed by Jay do; one might say that for Derrida, vision does not exist, or rather that the attempt to examine vision itself, to render vision visible—as art so often does—"ruins" it, shows how what we take to be vision (in the sense of a direct intuition) is somehow an attempt to compensate for a fundamental blindness. To counter the young Frank Stella, what you see is never what you see. "Vision" is a prosthesis, a ruse.

But there may be an even deeper level of autobiography in *Memoirs of the Blind*, an ulterior blindness in operation—a blindness that is equally a silence. The clue comes in the first word of the book's title, for these are not Derrida's first *mémoires*. In 1984, Derrida delivered the René Wellek Library Lectures at the University of California

Irvine. Derrida's friend and colleague de Man had died a few weeks before, and the lectures were titled *Memoires for Paul de Man*. These lectures, which like the present *Memoires* include a confessional dimension (the first lecture begins with the admission, "I have never known how to tell a story") and which likewise evoke the topos of tears ("We weep *precisely* over what happens to us when everything is entrusted to the sole memory that is 'in me' or 'in us'"), were published in book form in 1986. The following year, it came to light that in the early 1940s de Man had contributed to collaborationist journals in his native Belgium—contributions that individually, for the most part, might have seemed innocent were it not for their venue and the concomitant perspective of a generalized acceptance of German hegemony, but also including several that were (to put it as generously as possible) highly compromised, among them one under the title "*Les Juifs dans la littérature actuelle*." Derrida quickly responded with an essay, "Like the Sound of the Deep Sea within a Shell: Paul de Man's War," published first in the journal *Critical Inquiry*, then in a collection of *Responses: On Paul de Man's Wartime Journalism*, and finally as an appendix to a new edition of *Mémoires*. Reading one of these articles by the twenty-two-year-old de Man, Derrida was to find, among other things, "an irony whose pitiless lucidity, alas (too much lucidity, not enough lucidity, blindly lucid), spares no one, not even de Man almost half a century later."

What have those earlier *Memoires* to do with these more recent

ones? In the first instance, they start us on a curious connective thread: from a book about blindness (in which the name of Paul de Man occurs just once, at the end of a long footnote) to one about de Man, whose first and best-known book was precisely *Blindness and Insight: Essays in the Rhetoric of Contemporary Criticism*, a work whose title picks up a theme developed most closely in a chapter called "The Rhetoric of Blindness: Jacques Derrida's Reading of Rousseau," an analysis of a chapter from Derrida's *Of Grammatology*. In that chapter, tellingly, de Man makes the remarkably blunt and non-ironic observation that "Rousseau's text has no blind spots." Rousseau, "an author as clear-sighted as language lets him be," anticipates the necessity that his text will be misunderstood. In *Memoires for Paul de Man*, Derrida cites an admission made by de Man in the foreword to the second edition of *Blindness and Insight*, an admission which it has become possible to read retroactively as a sort of confession: "I am not given to retrospective self-examination and mercifully forget what I have written with the same alacrity I forget bad movies—although, as with bad movies, certain scenes or phrases return at times to embarrass and haunt me like a guilty conscience."

As its title suggests, "Like the Sound of the Deep Sea," Derrida's first attempt to come to terms with the unhappy legacy of de Man's early writing, is a text more concerned with figures of hearing than of vision, a plea for a listening which has the differentiating potency of reading, or for a reading with the empathetic tenor of listening.

Yet after reading *Memoirs of the Blind*, I wonder whether the fidelity of drawing might not be something like Derrida's fidelity to the memory of Paul de Man, a mournful fidelity that no doubt returns obsessively to one's blindness to a friend's profound moral failings. The question of blindness and its paradoxes would be related to questions like the one about how the young de Man's blindness through too much lucidity could have become a source for the older man's insight through acceptance of blindness.

While the debates touched on by Jay and Derrida have a profound bearing on issues that are important to the world of contemporary art, one thing these books will not give is much of a clue as to how the terms of discussion translate from one field to the other. Nor is this review the proper vehicle for such a transposition, but I can offer at least a couple of suggestions. The first is to remember that the philosophical discussion of the visual and anti-visual does *not* translate into painting versus Conceptual art, even though the former may appear as obviously visual as the latter does anti-visual. The besetting sin (if sin it be) of Conceptual art is precisely its "Cartesian" assumption of the artist as disinterested observer, its stance of detached mastery, which, however removed from actual physical vision—or rather because of that removal—reveals its dependence on the perspectival visual model, while the painter, whose product Marcel Duchamp once denounced as "olfactory masturbation," is precisely the artist with "dirty hands." Another suggestion is that it is

just where vision is engaged most passionately that the ambivalences toward and resistances to it may develop most fully.

Unfortunately, one must also denigrate the vision of the editorial staff at the University of California Press. I might not have bothered to mention this were it not that *Downcast Eyes* has been designated a "Centennial Book [...] an example of the Press's finest publishing and bookmaking traditions." If so, then it is a shame that the book is marred by so many typographical errors, particularly with regard to names and titles—so that the great Mallarmé scholar Robert Greer Cohn is given the middle name Green instead, the artist Daniel Buren becomes Burin, or Bataille's essay "*Le 'jeu lugubre'*" is rendered "*Le 'jeu lububre'*" instead—a lububrious situation indeed.

REALISM REVISITED

Linda Nochlin on Courbet and After

The idea of realism may not have much currency in contemporary American art criticism; but if it has any at all, that is due mainly to the efforts of Linda Nochlin. At the same time, she can be seen as the progenitor of an approach that has had considerably more success: art history from a feminist perspective. Two new books offer an opportunity to reflect on Nochlin's career as an art historian: one gathers her writings on Gustave Courbet, published between 1965 and 1986, along with one previously unpublished text, while the other collects the Norton lectures she gave at Harvard in 2003–04. The Norton lectures are six wide-ranging inquiries into the representation of the

Linda Nochlin, *Courbet* (London: Thames & Hudson, 2007).

Linda Nochlin, *Bathers, Bodies, Beauty: The Visceral Eye* (Cambridge, MA: Harvard University Press, 2006).

body in nineteenth and twentieth-century art, especially but not exclusively women's bodies; they range from Pierre-Auguste Renoir's impossibly pneumatic young bathers to some "horrific yet seductive" photographs of an extremely old woman taken in 2001 by Alex Francés.

Born in 1931, Nochlin was raised in a left-wing Jewish family in Brooklyn; the class song at her graduation from the Brooklyn Ethical Culture School was "Hail the Hero-Workers"—though her own family seems not to have been working class but instead rather well-to-do. This was a world where political consciousness and cultural striving went hand in hand, a world Nochlin once recalled as both entirely secular and entirely Jewish: "Basically we didn't know anybody who wasn't Jewish except for maids who were either Polish, Irish or black. [...] When I went to Vassar, it was a definite culture shock." From Vassar, she went on to Columbia University and then to the Institute of Fine Arts at New York University, where she is now Lila Acheson Wallace Professor of Modern Art. The Institute's tone had been set by the great European scholars who had found refuge there; "Hitler shakes the trees, and I pick up the apples," its chairman had observed. Among the apples were Walter Friedlaender (on whom Nochlin based on an unpublished novella), and Horst W. Janson, who (along with Robert Goldwater) directed her dissertation, "The Development and Nature of Realism in the Work of Gustave Courbet: A Study of the Style and Its Social and Artistic Background." But probably the greatest single

influence on Nochlin's early work came not from any of her teachers but from Meyer Schapiro, whose 1941 essay "Courbet and Popular Imagery" provided the model for much of her writing on the artist, as Nochlin acknowledges. Finding the visual source for Courbet's *Meeting* (1854) in a popular print illustrating the legend of the Wandering Jew, for example, she discovers a "compositional and iconographic framework for Courbet's conception of his relation to his patron," the painting's underlying subject. Yet in Nochlin's hands, like those of a contemporary such as Robert L. Herbert, the social history of nineteenth-century art resembles a new form of Panofskian iconology, treating the work as a text to be interpreted by way of other texts; in the previously unpublished "Courbet and His Territory: How Landscape Means," she tries to textualize the physical and tangible *Oak of Flagey* (1864) by attaching it to various contemporary writings about the tree, and to contemporary symbolic associations with oak trees in general—a legitimate aim as long as one can find one's way back to that "sense of the oak's imperious quiddity," as Nochlin puts it, which is the painting's true burden. Likewise, the fourth lecture in *Bathers, Bodies, Beauty* makes extensive use of late nineteenth-century tourist literature to situate Claude Monet's *Hôtel des roches noires. Trouville* (1870).

In 1969 came Nochlin's road-to-Damascus experience, the discovery of feminism; that same year she began teaching (at Vassar) what is said to be the first undergraduate art history course concerning

women, "The Image of the Woman in the Nineteenth and Twentieth Centuries." In 1971 she published a groundbreaking essay, "Why Have There Been No Great Women Artists?" which proposed feminist critique as a lever to transform the study of art, "to reveal biases and inadequacies *not merely in regard to the question of women artists, but in the formulation of the crucial questions of the discipline as a whole* [...] probing the most basic and 'natural' assumptions, providing a paradigm for other kinds of internal questioning." Yet at least as far as her readings of Courbet go, the grounds of feminist critique remain quite limited, and precisely to the issue of "the image of the woman." (In 1999 she would publish a book called *Representing Women*.) In "The '*Cribleuses de blé*': Courbet, Millet, Breton, Kollwitz, and the Image of the Working Woman," first published in 1980, Nochlin implicitly praised Courbet for depicting females free of the "mythology of resignation, piety or natural submission to the given order of things" and endowed with a "confident muscular expansiveness" hitherto seen only in images of males at work—though still lacking in "energy, self-assertion, and power" compared to a later work by Käthe Kollwitz.

As an analytical instrument, Nochlin's particular kind of feminism remains quite limited in comparison to the revolution she seemed to be calling for in 1971. The longest and in many ways the strangest of her essays on Courbet, a 1986 analysis of his most elaborate painting, *The Painter's Studio: A Real Allegory Summing Up Seven Years of My Artistic and Moral Life* (1855), sheds some light on the reason for those limits. Nochlin begins by "wrestling with the mean-

ing" of this problematic work while summarizing the history of its interpretation—until, suddenly pulling back from the stance of scholarly neutrality, she reports "a twinge of annoyance" at finding herself in "a position of intellectual distress. It would seem that the more I know about *The Painter's Studio*, the less access I have to collaborating in the production of its meaning." Although admitting that this closure of meaning is "necessary from the vantage point of art history," she then attempts a divergent approach, using the unfinished state of Courbet's "real allegory" as license for treating it instead "as a field of uncertainty" in which meaning remains unfixed; she isolates the shadowy figure of an Irish beggar woman as the locus where "the would-be allegorical connection between thing and meaning is really fumbled" in order to use the "room for doubt" within the work, not as a problem to be solved, but as a stimulus to interpretive creativity.

But then there's another turn: in the essay's second section, Nochlin moves beyond this deconstructive unraveling of Courbet's meaning to assert a new kind of interpretive authority, an authority underwritten by none other than "me reading it as a woman." Now it is "crystal clear" that *The Painter's Studio* is an assertion of male domination in which "Courbet goes so far as to cross out the woman in the Lacanian sense." (In fact, it was not "*femme*" but rather the universalizing article "*la*" that the French psychoanalyst had crossed out in explicating his contention that "*la femme n'existe pas*," woman does not exist" or "*il n'y a pas la femme*," there is no such thing as woman.) Yet the focus

114

of her animus is, as much as Courbet himself, a competing interpreter of Courbet's work, Michael Fried, whom Nochlin takes to have asserted precisely the force of the artist's empathy with the women he depicted, "his ability, as it were, to enter into the bodies of his female subjects." This supposed empathy, according to Nochlin, is simply another version of the privilege of male genius to appropriate all forms, including the female body, "transgression as usual" leaving the laws of gender untroubled. As usual, "the artist is male and active, his model is female and passive." Differently from her earlier article on *Les cribleuses de blé (The Wheat Sifters,* 1854), Nochlin views Courbet as politically and aesthetically progressive in every way but one, his gender politics.

It is entirely plausible that Courbet's attitudes toward women were more typical of his time than one might wish, but there's something disquieting about the way Nochlin conducts her analysis. With her apparent acceptance of a wholly conventional view of what is "necessary from the vantage point of art history" even as she swerves wildly away from it, Nochlin's opposing interpretive personae—a "normal," neutral, and empirical one, and another, more assertively "partial, passionate, and political," as Charles Baudelaire once put it—remain at odds. In Nochlin, the "dutiful daughter" who won prizes for her good work, always mindful of the border between "the realm of speculation and wishful thinking" and that of "empirical evidence and visual analysis," coexists uneasily with the self-proclaimed rebel.

She has the integrity to register explicitly the difference between "reading as a woman who happens to be an art historian" and "reading as an art historian who happens to be a woman," but she never succeeds in synthesizing these two perspectives.

This ambivalence leads Nochlin to shrug off as a "jeu d'esprit" what is, though hardly her most substantial art-historical work on Courbet, certainly her most energetic and challenging piece of writing on him—her 1986 essay on his most notorious work, that "beautifully-painted 'beaver shot,'" as she calls it, *L'Origine du monde* (1866). At the time, the painting had never been publicly exhibited. Its very location and even continued existence were shrouded in mystery. The painting was little more than a rumor, really, "known to us only as a series of repeated descriptions or reproductions—an *Origin*, then, without an original." Rummaging through all these clues, descriptions, judgments, and cold trails, Nochlin arrives at a pessimistic conclusion, that "art-historical practice is itself premised on the notion of originality as repetition, an endless rehearsal of the facts which never gets us any closer to the supposed 'truth' of the object in question." Yet instead of using this indictment of the field as the starting point for a thoroughgoing critique of her discipline, Nochlin shrugs her shoulders: "It is a practice in which almost all of us who work with reproductions must inevitably engage." By this point the logic of her argument would suggest that anything, even an "original," is also a reproduction, if only of the ideas and perceptions that already circulate around it.

Today, you can see *L'Origine du monde* whenever you want at the Musée d'Orsay, which is now its home. But it is apparently still, in Nochlin's view, no more than an improved reproduction of the photographic pornography from which it derives.

Nochlin tries out two distinct voices in "Courbet's Real Allegory" but she has trouble orchestrating a plurality of voices whether they are her own or others'. In her lecture on Renoir's bathers, she collages a number of other readings into her own, disavowing "a unified reading of the painting in which I, the speaker, lay out the task with the understood assurance that from my position of superior knowledge I will pull it all together." Yet she does assume a position of superior knowledge, and undoubtedly with justification, when she patronizes the "endearing lack of historical accuracy" exhibited by the psychoanalyst Elisabeth Young-Bruehl, just as she does when "as a feminist, as an art historian with the proper sort of critical training" she shares her "negative gut reaction" to the lyrical musings of the journalist Caroline Knapp. Being both a feminist and a proper art historian is a difficult undertaking that doesn't seem to leave much room for other points of view.

When asked about the choice of subject for her dissertation, Nochlin told Moira Roth, "I didn't love [Courbet] more than other artists—indeed, I would say Manet is really more my boy—but I was very interested in how art and politics got together, and what could

be better than Courbet as far as that was concerned?" The dissertation's title, "The Development and Nature of Realism in the Work of Gustave Courbet," makes clear that her study was articulated on two levels: It concerns at once an individual artist and the broader phenomenon of style which that artist's work embodied. And it was the style, not the artist, that would become the subject of her first important book, *Realism*, published in 1971 in Pelican's "Style and Civilization" series and still a cultural history of great value. While it may seem self-evident to view the art of Courbet by way of a concept that he passionately espoused and that permeated the thought of his age, *Realism* represents a contrarian stance in relation to the art criticism of the '60s and '70s. At that time, Courbet—and Manet all the more—were celebrated primarily as precursors to a modernism that was understood to entail a "gradual withdrawal of painting from the task of representing reality—or of reality from the power of painting to represent it," as Fried put it in 1965. If Manet had been "the first in the decrepitude of his art," as Baudelaire said, Courbet was the last one on the other side of the divide, in the view of Clement Greenberg "perhaps the last great painter able to move forward without seeming to break the continuity of tradition." (For Walter Benjamin, too, Courbet represented the end of something, the last painter for whom "the solidarity which once existed between painting and public affairs [...] was highly developed.") What in Courbet counted for modernism if anything was his expressionism of the cor-

poreality of the medium—"realism" as an attitude toward subject matter and toward the artist's relation to his time was, in this view, secondary to what it made possible, a confrontation with the palpable stuff, the materiality of art itself. From the modernist view, his best heritage would not have surfaced in any contemporary realism implying, as Nochlin puts it, "recognizable views of people, things or places" but rather in an abstract art of the sort displayed, for instance, at the Museum of Modern Art in New York in 1968 as "The Art of the Real": a literalist and nonrepresentational art devoid of "metaphor, or symbolism, or any kind of metaphysics" (as E. C. Goossen described in the exhibition catalogue), notably that of the American Minimalist sculptors and color field painters.

In this context, Nochlin's reconstruction of mid-to-late nineteenth-century realism was not a purely academic task but a salutary updating of the narrow, reductive modernist sense of art's relation to reality. The idea of realism explored by Nochlin was not simply a focus on material sensation but rather a struggle for contemporaneity. And the art of the Impressionists, normally thought of as being on the other side of the divide separating "Manet's modernism" from "Courbet's realism" (to borrow the titles of two books by Fried), is part of this realism: "The 'instantaneity' of the Impressionists is 'contemporaneity' taken to its ultimate limits," as Nochlin wrote in *Realism*.

But if Nochlin's account of realism was an implicit challenge to the idea of modernism as a tropism toward abstraction, it was no chal-

lenge to modernist taste in nineteenth-century art—and this was un-
doubtedly part of its power. Although she was capable of showing
how realist ideals entered even the work of painters now seen as
wholly outside the great tradition of French art, these artists would
always remain bit players. Rather than proposing an alternate canon,
her focus remained fixed on Courbet, Manet, Edgar Degas, and the
Impressionists. Although a form of realism flourished throughout Eu-
rope, only some of its French exponents were able to give up a mor-
alizing or anecdotal treatment of subject and to attain a technique
imbued by the sense of immediacy, "capturing [...] the immediate
present with brushstrokes as fleeting and nonchalant as their motifs"
in the manner of the Impressionists. Yet this hardcore realism, in its
avoidance of any edifying meaning, was about to flip over into aes-
theticism, as can be grasped in George Moore's reaction in 1893 to
Manet's anomalous *Dead Christ with Angels* (1864): "His Christ is
merely a rather fat model sitting with his back against a wall, and
two women with wings on either side of him. There is no attempt to
suggest a Divine death or to express the Kingdom of Heaven on the
angels' faces. But the legs of the man are as fine a piece of painting
as has ever been accomplished." When Nochlin discussed the formal
consequences of the realist fixation on contemporaneity—the fasci-
nation with what Baudelaire called "the transitory, the fugitive, the
contingent"—her conclusions were congruent with late modernist aes-
thetics, and especially with the hostility to "composition" that was so

widespread at the time. When she speaks of Courbet's *Burial at Ornans* (1849–50) as "an additive, horizontal procession across the canvas—an arbitrary segment of what might indeed be an inexhaustible reality, since its boundaries are contingent and not set by any meaning, explicit or implicit" one might just as easily be reading about a stripe painting by Gene Davis or a sequence of boxes by Donald Judd. And if, in the first lecture of *Bathers, Bodies, Beauty*, Renoir's bathers are seen as aesthetically and politically dubious at best while those of Paul Cézanne are beyond reproach, this, too, is inherited modernist taste.

Yet stripes and boxes would never claim Nochlin's attention. Her first intervention into contemporary art had been an exhibition titled "Realism Now" at the Vassar College Art Museum in 1968. This was not MoMA's "Art of the Real," but a traditional painting representing recognizable people, places, and things. Like the nineteenth-century movement she was about to champion in her book, this contemporary realism was not a single movement. It ranged from the hardcore photo-realism of Malcolm Morley, with his meticulous transcriptions of found photographic imagery—a late descendent of the receptiveness to the random that was characteristic of French realism —to the Caravaggesque melodrama of Alfred Leslie. In 1970 her first essay on an individual contemporary artist was devoted to another of those in the show, Philip Pearlstein. The reproduction of his 1983 painting *Two Models on Kilim Rug with Mirror* on the dust jacket

of *Bathers, Bodies, Beauty* signals Pearlstein's continuing centrality for Nochlin. Pearlstein's is, as Nochlin says, an art of scrupulous empiricism, rejecting any sort of idealization: "anti-imaginative, antisociological, antisymbolic, antiexpressionistic"—precisely the character of Minimalists like Judd or Carl Andre, one might add. What distinguishes Pearlstein from the Impressionists even at their most extreme is that they applied their empiricism to everyday reality—the peopled scene of the street, theater, and café—while he assumes that it can only be exercised in the laboratory-like confines of the studio, where people lose their names, their class, their identities to become, simply, *models* participating in the structured artifice of the painter's setup. This is a realism of a sort, but one that's turned itself inside out after a hundred years of self-questioning.

Alice Neel, another painter praised by Nochlin for an "incisive realism," was not among those in the 1968 exhibition. All the social and psychological freight that Pearlstein has his models shed along with their clothes once they walk through the studio door is there in Neel's portraits; in this sense, she retains something of the full-bodied realism of the nineteenth century. What she leaves out is precisely the descriptive neutrality. Stylistically, she is as close to Expressionism as to Realism. This fraught, anxious style, enlivened by a caricaturist's ability to catch the essence of an expression on the wing and exaggerate it mercilessly, "has to do with the peculiar phenomenology of the human situation" of portrait painting—of the conflicted relation

between two people collaborating on a process of rare and intense scrutiny. In this way, like Pearlstein, Neel generated the subject of her work out of the actual process of its making. As desperately as Nochlin wants to retain an opening for realism in painting, her examples show that it can be preserved only at the cost of transforming it into something else, something nearly as unrecognizable as realism. Far from the wide-ranging anatomy of contemporary life that Courbet had envisaged, the works of artists as otherwise different as Pearlstein and Neel gains its intensity by narrowing its subject matter to a minimum, thereby betraying its contemporaneity with the abstraction and minimalism pursued by other artists of their time. Likewise, Morley's photo-realism, which proposed to describe some limited portion of the world through the rigorous transcription of an already existing and highly artificial image of it—a postcard of a cruise ship, for instance—preserved from the old realism only its aspiration to objectivity, but at the cost of any hope of spontaneous and direct engagement with life.

With modernism, it was less that reality became unrepresentable, as Fried implies, than that representational systems themselves became as crucial a subject as their ostensible contents. This is why representational painters like Morley and the rest could function within the same art world as painters whose work represents nothing beyond itself or indeed artists for whom media other than painting have seemed the best means to investigate representational systems and

thereby the realities being represented. Among the latter have been feminist artists who, since the '70s, have used performance, video, and photography to reconsider selfhood, the body, and the politics of appearance. Nochlin is well aware of these artists, as shown by the "Global Feminisms" exhibition she co-curated in 2007 at the Brooklyn Museum, but she has rarely written about them—yet it may be that theirs was the most penetrating realism in recent art. In Nochlin's career, realism and feminism seem to be subject and countersubject in a sonata that has yet to find its resolution.

MAKESHIFTNESS

Michael Fried on Menzel's Effort

Michael Fried, who is also a poet, writes a dense, self-questioning, fervent prose. Somewhat perversely he has, over the last three decades—that is, since his doctoral dissertation on Édouard Manet was printed as a special issue of *Artforum* in 1969—put this prose in the service of art-historical scholarship. It might have been otherwise. While still in his twenties Fried had become a leading critic of contemporary art, which may sound not much different from being an art historian, only less respectable. But from Charles Baudelaire on, an engagement with the painting of one's time had been formative of some of the greatest poets; and the best art critics, aside from

Michael Fried, *Menzel's Realism: Art and Embodiment in Nineteenth-Century Berlin* (New Haven, CT: Yale University Press, 2002).

those who were primarily artists, had always been imaginative writers who'd taken on art as a sideline. Even the rivals of American art criticism when Fried was a young man, Harold Rosenberg and Fried's own mentor Clement Greenberg, had started out wanting to be all-around literati before becoming something more like specialists in the fine arts; but Fried, who, along with Rosalind Krauss, Robert Pincus-Witten, and others was one of the first wave of art critics to have PhD's in art history, seems to have been the only one among them to have been tempted, however briefly, by the older model of the writer-critic rather than the academic.

Perhaps this accounts for the difference in tone between Fried's criticism and that of his peers. All of them were combative and polemical, but he was the only one to exhibit near-religious intensity, as though he wanted something from art, a sort of exaltation or transcendence, that criticism was hardly suited to express. That desire is most evident in what is probably the best known sentence Fried has written, the last line of his 1967 essay "Art and Objecthood": "Presentness is grace"—a line meant to be glossed by the citation from one of Jonathan Edwards's sermons at the head of the essay; and it is also evident in the Talmudic minuteness with which he would unravel the significance of stylistic features that to other observers seemed hardly so momentous. "Flatness" for instance—the annihilation of the illusion of deep space that had been the glory of classical art—was one of the big artistic issues of those days, and the artist-critic Robert

Smithson had great fun with Fried's finding that certain polychrome sculptures by the painter Jules Olitski consisted of surfaces that had the miraculous property of being "flat, but rolled."

Speaking of the American painters he championed in the 1960s—Olitski, Kenneth Noland, and Frank Stella—Fried observed that their work "not only arises largely out of their personal interpretations of the particular situations in which advanced painting found itself at crucial moments in their respective developments; their work also aspires to be adjudged, in retrospect, to have been necessary to the finest modernist painting of the future." In other words, the view of art that Fried espoused was fundamentally oriented toward its future history; the basic content of modern painting, he thought, was its concern with its own place in the advancement of art. Fried's sense of history was progressive: he understood the present as fundamentally oriented toward the future, rather than as self-contained. And by initiating his art-historical work with the study of Manet, who has always been seen as a crucial figure in the development of the very modernism of which his contemporary heroes—the painters I've mentioned or the English sculptor Anthony Caro—were the exponents, Fried seemed set to search out the anterior background to this progressive history.

But once in the academy, it's hardly surprising that Fried imbibed a different view of history, one that is properly historicist in the sense that it sees the past as self-contained, indifferent to the present that

had, in Fried's previous conception, been its future. In the lengthy and ruminative introduction to his collected criticism (also titled *Art and Objecthood*), written in 1996 and published two years later, Fried was careful to distinguish between the sort of thinking that goes into art history and the sort that goes into art criticism: history is not judgmental, while criticism is nothing but. Yet Fried concludes by expressing a faith that in his oeuvre "the poems, the art criticism, and the art history go together, that they share a single vision."

Fried's choice of Adolph Menzel as the subject of his latest book already implies that he has become a different sort of historian, with a different sense of what history is, from the young man who wrote on Manet and Stella. For Menzel has never been central to the history of modernism. There is good reason why the second section of Fried's book is called "Who Is Menzel?" providing a capsule biography and contextualization of a sort he had no need to provide in his writings on Manet or Gustave Courbet: few art lovers outside Germany know who Menzel is and, as Fried himself admits, "it is fair to say that his paintings have never really been seen to count in an essential history of nineteenth-century painting." The prominent early twentieth-century German critic Julius Meier-Graefe wrote about Menzel as he did about Cézanne, Vincent van Gogh, and others in the mainstream modernist tradition, but in order to salvage Menzel for his French-oriented vision of art history, Meier-Graefe had to rigorously distinguish between the progressive artist of the early "private pictures"

like the astonishing *Rear Courtyard and House* (1844) or *Balcony Room* (1845) and the conventional public artist whose elaborately worked up history paintings showed him to be merely a superior illustrator. This is not terribly different from the way historians of French painting used to distinguish, for instance, between the "private" Jean-Baptiste Camille Corot whose oil sketches looked forward to the Impressionists and the painter of elaborate salon pieces, sometimes embroidered with mythological subjects (Meier-Graefe again: "From fresh Impressionism came stale Romanticism"). But the trend in recent decades, as the modern tradition itself has become a historical artifact, has been to claim to see a painter like Corot as a whole—and therefore to judge him not insofar as his paintings were a necessary link to the best work of his immediate future but insofar as it fulfilled the demands of the moment. The closer to us any particular past development may be, of course, the more difficult it is to maintain this historicist commitment to the self-containment of the past: art historians still, for instance, cordon off the early Symbolist Piet Mondrian and the naturalist who continued to paint flowers all his life from the properly modernist one who reduced everything to primary colors and straight lines meeting at right angles.

Still, even Mondrian is becoming harder to break into good and bad bits. Menzel, too, is now to be restored to wholeness by Fried—both as a singular career and as a necessary part of some future synthesis of the history of painting in the nineteenth century. But who,

indeed, is Menzel? Why does it matter if we see him whole or otherwise? Fried, noting the paucity of interest in him outside Germany and the difficulty of accounting for him even there, nonetheless correctly remarks on the "widespread agreement that Menzel was one of the two foremost German painters of the nineteenth century, the other being Caspar David Friedrich." Unusually, he was an illustrator before turning to painting, and toward the end of his life he turned away from painting again, devoting himself mainly to drawing. A dwarf, born in Breslau in 1815, he grew up in the milieu of his father's lithography workshop, which was eventually moved to Berlin. When the elder Menzel died, the sixteen-year-old son took over the family business. He briefly attended the Academy of the Arts in Berlin, but quickly dropped out and went back to work. His fortunes changed in 1839 when he was commissioned to make four hundred illustrations for a history of Frederick the Great; drawing them and supervising their execution as wood engravings occupied him until 1842. He followed this with equally voluminous illustrations for books on *The Army of Frederick the Great and Its Uniforms* and *The Works of Frederick the Great*, projects that occupied him until 1857.

But in the meantime, Menzel was painting too. His first inspiration came, apparently, through exposure to the works of John Constable in 1839; within a few years he was painting the small studies of everyday urban sites that include some of his most renowned works but which only began to emerge from the artist's studio around the turn

of the century, just before his death in 1905. *Rear Courtyard and House*, for example, is all the more striking and memorable for the fact that it hardly seems to be a painting of anything in particular. The very vagueness of its title (whether or not attributable to Menzel himself) is significant. What it shows is hardly a *motif* in the sense that even an Impressionist would have recognized—just a seemingly arbitrary patch of terrain, rather unkempt and unlovely, that no more corresponds to one's usual image of the urban fabric than it represents any feeling of escape from the pressures of the metropolis. Instead, this yard, glimpsed at an odd angle from above, is one of those places where the city's built environment seems to peter out and go to seed; though crossed by fences and framed by the sides of buildings, it seems indifferent to any formal order. Fried speaks of a "sense of makeshiftness, of an entire environment having been put together, constructed, not in a spirit of permanence but rather in one of improvisation." But he goes on to stipulate, and this is more important, that it does not

seem quite accurate to speak of *Rear Courtyard and House* as sketch-like, as is often done, despite the rapid improvisatory play of the brush and also despite the sense in which the painting eschews not just traditional finish but all suggestion of finality. [...] On the level of execution as well as on that of the motif, *Rear Courtyard and House* presents us with an image of the sheerest makeshiftness, but just as the viewer is

not led to imagine a fuller description of the chosen motif, so there is nothing about the execution to suggest that if only the work of painting were carried further or started again in a more ambitious spirit we would have before us a more complete or definitive or in any respect superior version of the present canvas.

The passage brings out Fried's passion for precise expression and his determination to make close distinctions, such as that between the sketchlike and the improvisatory, that other writers would ignore; but it's worth developing a point that Fried implies here without quite articulating: that Menzel realigns our sense of the distinction, central to the disputes that shaped nineteenth-century French art and our response to it in the present, between a sketch and a finished painting. "Manet believes he is making paintings, but in reality he only brushes in sketches," as the proponents of the academy never tired of complaining; Fried himself explained the ethical force of Manet's rejection of academic finish by saying that "Manet's problem [...] was not so much to know when a given picture was finished as to discover in himself the conviction that it was now a painting." Even in paintings unintended for public exhibition, Menzel did not disdain the idea of finish so much as he redefined it.

As his immense productivity alone would attest (his memorial exhibition at Berlin's Nationalgalerie in 1905 included 129 paintings; 291 watercolors, gouaches, and pastels; 6,405 drawings; and 252

prints), Menzel was possessed of a fierce work ethic. His admonition to the gifted younger painter Max Liebermann was, "Your talent you have from God, I value in an artist only the effort." Remember that Menzel was essentially an autodidact, having fled the academy within months of his arrival, and the earnestness and concentration evident in every centimeter of *Rear Courtyard and House* are indifferent to the academic notion of finish (which, as Pierre Bourdieu once put it, by effacing all reference to the painting's pictorial and material specificity, aims at "transforming the painting into a literary work"). But the paintings are equally distant from the rising aesthetic of the unfinished, which based the judgment of an artwork only on the inward conviction of its fitness and not on any calculable degree of invested professional labor.

No other nineteenth-century artist painted like this. Menzel, at least in these "private paintings," represents not an eclectic synthesis, but a completely distinct solution to the problems of mid-nineteenth-century painting. Compositionally, *Rear Courtyard and House* is, as Fried says, anticlassical in a way that nineteenth-century French painting never was. But it is a peculiarity of Fried's insistence on Menzel's indifference to classical order that he never quite names what replaced it. The term "classicism" is always half of a dialectic; it might be classical and Baroque or classical and Romantic, or even classical and decadent. But none of these suit Menzel. His specificity is everywhere apparent yet difficult to name; perhaps this is why he lacked

great successors. Yet his paintings remain uniquely compelling and, indeed, strangely contemporary; the terms Fried conjures to describe them seem just as appropriate to the "makeshift constructions" of some of today's installation artists, such as Jessica Stockholder or Joëlle Tuerlinckx, whose work is always based on careful observation of what, even arbitrarily, happens to be there in a particular situation.

But Menzel didn't always paint like this. He became a history painter, gaining success for minutely detailed reconstructions of the past, and for a time he became something like an official court painter, though retaining his independence. An account of Menzel's work that really squared with his lived relation to his own time would have to take more thorough account than Fried does of stupendously detailed reportage, paintings like the *Coronation of King William I in Königsberg in 1861* (1861–65)—essentially a history painting of painstakingly accurate scholarship though set in the painter's present—with its more than one hundred detailed portraits worked into the crowd of dignitaries. Fried does not energetically contest the consensus that such a picture is more valuable as a document than as a work of art, but he does analyze at length a number of Menzel's later paintings, such as the dramatic scene of industrial labor, *Iron Rolling Mill* (1872–75) or the oneiric, almost surreal gouache, *Crown Prince Frederick Pays a Visit to the Painter Pesne on His Scaffold at Rheinsberg* (1861), which Fried sees as Menzel's allegorical reflection on his own art, comparable to Courbet's *The Painter's Studio* (1854–55), which was known to Menzel, or to Thomas Eakins's *William Rush Carving His Allegorical*

Figure of the Schuylkill River (1876–77)—both paintings on which Fried has reflected at length in previous books.

This gouache, which shows the prince surprising his court painter Antoine Pesne as, in the midst of executing a ceiling decoration, he stops to demonstrate a dance step to a model, is an apt choice for Fried's effort to show how the aesthetic of makeshift constructions that Menzel arrived at in the 1840s was still active in his later work; nothing in this picture seems stable, and as Fried notes, that includes the position of the viewer as well. Furthermore, he is able to make a clear case here for showing how this sense of the provisional is related to another of his key claims about Menzel, that his was an "art of embodiment" in the sense that it emphasizes what Maurice Merleau-Ponty once called the "lived perspective" (as distinguished from the mathematically constructed one central to Western painting since the Renaissance), which emphasizes the way human beings see things, not with a single all-encompassing glance from a fixed viewpoint, but rather in a series of glimpses caught by mobile eyes in mobile bodies. (Fried uses the term "embodiment" in many, sometimes possibly incompatible ways, but this seems to be its central sense for him.) Neither *Rear Courtyard and House* nor *Pesne on His Scaffold* is organized around a single center of interest; we have to take them in bit by bit rather than as already organized unities, and this means that the viewer who encounters them is evoked as an empirical body and not as an idealized eye.

Readers of Fried's writings on the art of the 1960s will undoubt-

edly raise their eyebrows at his current preoccupation with the whole body as a vehicle for pictorial perception, because it seems to contradict his insistence on "opticality" as a characteristic virtue of paintings such as Jackson Pollock's, and on the instantaneousness of one's perception of it. It also appears to conflict with his harsh criticism of what he called the "theatricality" of Minimalist sculpture, which turns out to mean its concern with the physical circumstances under which the viewer encounters it. Fried articulates this apparent volte-face in other ways, too: in his praise of Menzel, for example, for his ability to make painting express time, or to evoke "different sensory modalities" such as hearing or touch. Fried has to strain to make this last point. Does the mysterious violist in *Pesne on His Scaffold* really lead us "to imagine the music he makes filling the space," as Fried claims, or does it rather make more palpable the silence inherent in all painting, as it seems to me? This strain makes it clear that there are ulterior investments in this line of interpretation beyond the explication of a particular painting or oeuvre.

But then a willingness to strain credibility has always been part of Fried's critical method—as Smithson gleefully realized so long ago. He has always been aware that any truly productive interpretation must go beyond verifiable fact—that it is, in fact, a wager. What's amazing is that as an art historian he can still work the same way, as in his well-known analysis in his 1990 book *Courbet's Realism* of the French painter's *The Wheat Sifters* (1854), which turns the image of

peasant women sifting wheat into a metaphor for Courbet himself applying paint to canvas. Such passages must have had his more sober-sided colleagues tearing their hair out, but it also made his brand of art history a continuing inspiration for critics of contemporary art, who know they have to make risky interpretive leaps in approaching works whose meanings have not yet been stabilized. Now, though, going out on a limb seems to make him nervous in a way that would have been incomprehensible to his combative younger self. This book is littered with "I know, but" gestures that seem designed to ward off his colleagues' chidings, half-embarrassed acknowledgements of how shaky his interpretations can be: "Not that there is any warrant for associating [...] but those affinities [...] are sufficiently compelling"; "again, I stop short of calling this a self-portrait [...] but the image is"—two examples drawn almost at random from a single page. Similarly, Fried is continually seeking to buttress his reading of Menzel's works by drawing parallels with the concerns of cultural authority figures ranging from Søren Kierkegaard and Franz Kafka to Walter Benjamin and Ralph Waldo Emerson. These comparisons are invariably resonant, yet often feel poorly integrated. One would have liked them either to be more punctual and suggestive or else more elaborately developed. *Menzel's Realism* is a passionate book, at times touching in its very awkwardness, but as a makeshift construction it's not quite as workable as Menzel's own.

WORDS FOR ART

Mel Bochner and Language as Art

"Borges speaks of a labyrinth that is a straight line, invisible and unceasing," wrote Mel Bochner and Robert Smithson at the beginning of "The Domain of the Great Bear" (1966), their picture-essay pastiche on the Hayden Planetarium at the American Museum of Natural History, from which the title of Bochner's new and long-awaited collection of writings and interviews is taken. (Apparently, it was a real piece of signage in the old planetarium.) The name of that labyrinth is, perhaps, language.

Mel Bochner, *Solar System & Rest Rooms: Writings and Interviews, 1965–2007* (Cambridge, MA: MIT Press, 2008).

Liz Kotz, *Words to Be Looked At: Language in 1960s Art* (Cambridge, MA: MIT Press, 2007).

For centuries, it seems, art lingered near the mouth of that labyrinth; some of its adventures there, from the appearance of Annunciation scrolls in late medieval art through the use of newspaper fragments in Cubist collage, were traced by Michel Butor in his book *Les mots dans la peinture*. In the 1960s, though, art plunged deeper into the maze, and it has yet to emerge. This tropism toward language is inextricable from the emergence of Conceptual art, with which Bochner's protean early work is usually classified but is not simply synonymous. For art historians, the crux of the matter is this: did Conceptual artists usher art into the realm of language (or language into the realm of art) or, on the contrary, did the fact that art had already become linguistic allow certain artists to constitute a practice that could be called Conceptual art?

In the past, the assumption that Conceptual art was part of the heritage of modernist painting and sculpture made it reasonable to see the movement following in the footsteps of the highly discursive practices of late modernists like Jasper Johns and Robert Rauschenberg. Thus, in 1971, Bochner said of Johns that "most essentially he raised the troubling question of the relationship of language to art" —but not in the sense that he began a process of reducing one to the other, as certain Conceptualists were to imagine they should do. Instead, Bochner explains, "His paintings demonstrated that neither was reducible to the other's terms." Likewise, in the earliest scholarly book to approach the theme of language in contemporary art, *Art*

Discourse/Discourse in Art, author Jessica Prinz focuses first on Johns before going on to discuss the work of Joseph Kosuth, Robert Smithson, and Laurie Anderson. A different thesis was put forth by Peter Osborne in his book *Conceptual Art*; for him, John Cage was the key precursor, thanks to the composer's reconceptualization of the notion of a musical score. Osborne thereby not only connected Conceptual art to a lineage outside the visual arts but also gave new weight in this story to the importance of what we can broadly term Fluxus. The Fluxus artists were generally denigrated or ignored by the Conceptualists and their admirers. Johns and Rauschenberg, though, were quite connected to Cage, and works like George Brecht's *Event Scores* of the late 1950s and '60s and Yoko Ono's *Instruction Pieces* (1961–62) arguably went deeply into the linguistic nature of art, well before canonical Conceptualism.

Liz Kotz, in her book *Words to Be Looked At: Language in 1960s Art*, implicitly follows Osborne's lead while rejecting Prinz's narrative, though she does not mention either one; her book is weakened by its limited scope of historiographical reference. On the other hand, she has delved into the sources, and as a result she gives the picture Osborne sketched out much greater substance and nuance. Like him, she takes the idea of the score as her starting point, beginning her book with a comparison between the several versions of the score that Cage produced over the years for his notorious silent composition *4′33″* (1952). Kotz shows how, as the composer's understanding of

the piece developed, he progressed from a version using conventional staff paper through a graphic notation to a written text. She then traces the consequences of this development in a number of language-based works from around 1960, in particular by Brecht and by the composer La Monte Young. Next, she turns her attention to Cage-inspired poetry by John Ashbery and Jackson Mac Low before going on to examine the relationship between the poetry of Carl Andre and Vito Acconci and their better-known works as artists. Finally, the confrontation between Fluxus and Conceptual art emerges as Kotz stages a compare-and-contrast of Brecht's *Three Chair Events* (1961) and Joseph Kosuth's *One and Three Chairs* (1965). Surprisingly, the fundamental difference Kotz discovers between the two lies in their relation to photography—in a turn "from participatory aesthetics to representational media"—which helps to explain the fact that Brecht and other artists of his milieu rarely incorporated photography into their work while Kosuth and other Conceptualists did so readily.

Having shown the linguistic turn in art to have been an accomplished fact well before the emergence of Conceptual art, however, Kotz uses this idea of a representational turn to "save" the originality of the movement by positing a "larger shift from the perception-oriented and 'participatory' post-Cagean paradigms of the early 1960s to the overtly representational, systematized, and self-reflexive structures of Conceptual art." This shift accounts for the difference between works such as Brecht's "events," which take varied forms of

realization based on a score, and those that allow for varied forms of representation based on an idea. Kotz's diminution of the significance of language for Conceptual art is a novel and challenging move, all the more so because Kotz views this "larger shift" dialectically, aware as she is that it brings cognitive losses as well as gains: "If Brecht is programmatically unable to recognize the extent to which the indexicality of the 'events' structurally aligns them with the photograph, Kosuth's *Proto-Investigations* rest on an unacknowledged relation to something like 'performance.'" Photography had only a subsidiary role to play in Fluxus but became central to Conceptualist practices as "a result of the fact that the 'work of art' has been reconfigured as a specific realization of a general proposition." She goes on to argue that the "indexical" use of photography as a "seemingly neutral means of recording information" in turn influenced the linguistic usage of Conceptual art, as seen in text-plus-photo works by Douglas Huebler and Victor Burgin. As a logical but hard-to-swallow conclusion, she presents Andy Warhol's rarely-read and little-appreciated *a: a novel* (1968), a transcription of two days of conversations between Warhol and Factory denizen Ondine, as the apotheosis of this indexical esthetic.

Kotz's readings are richly exploratory but very selective; one sometimes wonders if she isn't generalizing from too few examples. Among the many artists who are less crucial to her study than might be expected is Bochner. Reading through his criticism, statements, and

interviews from a period of more than forty years, one is more impressed than ever with the power of his restless mind, so ready to stake everything on an extreme view yet equally able later to calmly reconsider and revise the view so passionately espoused. The principle Bochner never gives up on is that of self-criticism. Reading Bochner with Kotz's analyses of representational modalities in mind, it is interesting to notice that not only does his book include, as one would expect, various genres of writing (exhibition reviews; critical, speculative, and historical essays; collages of quotations; notes; interviews; etc.) but also various modes of representing those writings visually, and it mixes them up in a canny and unconventional way. Writings here may be newly typeset (with or without illustration); they may be reproduced as facsimiles of the original layout of a publication, pictorially preserving its illustrations and typography; or they may be presented as photographs of handwritten note cards or notebook pages. Moreover, texts may be presented not as "texts" but as "illustrations" (e.g., *Self-Portrait*, 1966, one of a series of ink-on-graph paper text "portraits" that Bochner made using *Roget's Thesaurus*). By mixing these various modalities, Bochner is continuing to do what he has been doing all along: questioning the relation of language to representation and the manifold ways language can be a medium for artistic work.

In a stunning passage in his first extended piece of published writing, a consideration of the 1966 "Primary Structures" exhibition at

the Jewish Museum in New York, Bochner announces that "such words as 'form-content,' 'tradition,' 'classic,' 'romantic,' 'expressive,' 'experiment,' 'psychology,' 'analogy,' 'depth,' 'purity,' 'feeling,' 'space,' 'avant-garde,' 'lyric,' 'individual,' 'composition,' 'life and death,' 'sexuality,' 'biomorphic,' 'biographic'—the entire language of botany in art—can now be regarded as suspect. These words are not tools for probing but aspects of a system of moralistic restriction." This could be read as nihilistic posturing, but only to say that sometimes nihilistic posturing is right: concepts that might have been useful at one time or another—and may become useful again—are always threatening to become restrictive contrivances. Bochner's strength is that he has never hesitated to cast them off. Over time, his writing has naturally tended to become more retrospective in character, but he has been no more willing to take his own earlier ideas on faith than those of others.

Already in 1973 he writes, "Baffled, I discover my art opaque to the very mind which postulated it. This reveals the absurdity of faith in 'ideas,' which are merely artifices of the mind devised to protect itself from itself." Among the most fascinating of Bochner's writings is a series of reconsiderations of modernist precursors—Henri Matisse, Pierre Bonnard, and perhaps most surprisingly Pierre-Auguste Renoir, among others—which rigorously eschews the dead-end words of "moralistic restriction" he had earlier derided. But when he speaks of Paul Cézanne's "refusal to smooth out the gaps between thought and perception," the sense of identification is patent—and earned.

The issues raised by Bochner's work always resonate beyond the work; he makes you question things you never questioned before. Speaking about his measurement pieces in a previously unpublished interview from 1969 with Elayne Varian, the artist explains, "The way things are contained physically and mentally is an important issue to me. For example, the measurements that are marked on the wall around the sheet of paper read 36" x 48". However, to measure the entire work you must include the 2" width of the numbers, which makes the actual measurement of the piece 38" x 50". In other words, in order to contain the boundaries you must inevitably enlarge them, *ad infinitum*." Having been infected by Bochner's fascination with the ever-receding nature of boundaries, I wonder about something that Kotz never explains or considers in her forty-five pages on John Cage: if 4'33" is a work in three movements, of (in one of its versions) 33", 2'40", and 1'20", how can the work as a whole be only 4'33" long? Because if there are three movements, there are also two pauses between the movements—unscored silences between the scored silences, the times during which David Tudor, in the work's first performance, closed and then reopened the keyboard to indicate the end of one movement and the beginning of another—and those two intervals must have increased the work's actual length beyond that indicated in the title. Here, time is the infinite labyrinth. If time and silence are essential to Cage's piece, why isn't the actual length of 4'33" an issue? I'm just asking.

SEEING PAST THE GORGONS

Peter Schjeldahl, Critic as Aesthete

Peter Schjeldahl is the only currently practicing art critic whose style I envy. He can do things with words on which other critics can only look with wonder—though he sometimes does them too often or too flashily, so that reading seventy-five of his pieces at a go can be too much of a good thing. Still, the very title of his collection of reviews from over the last decade shows his finesse. What lightness of touch! Just two little monosyllables—contracted from three, admittedly—yet how much they tell us about the writing they somehow summarize. They take the form of an invitation, one without condescension or formality, for they assume an "us" that includes writer and reader as equals. And the invitation, mind

Peter Schjeldahl, *Let's See: Writings on Art from* The New Yorker (London: Thames & Hudson, 2008).

you, is to see, not just to look, which is to say that they assume we can not only search but find. But as to what there is to be found, there is no foregone conclusion: "I don't know—let's see." Schjeldahl never writes as an authority, just as a particularly energetic, quick-thinking, and vocal member of a club of art lovers of which the reader is also assumed to be a member.

Schjeldahl's band of aesthetes is hardly an embattled remnant, but neither, surprisingly, is the art world, with its institutions entirely dedicated to fulfilling its needs. "Art lovers are a disorganized minority constituency in the conduct of the art culture," Schjeldahl once told an interviewer. "We are like selfish children; all we're interested in is art. And we learn to ... we have our improvised guerrilla tactics. Getting in, getting past all the gorgons, and educators, and labels, and getting what we want and then going home." Schjeldahl's generation of art critics, now in their mid-sixties, mostly created bases for themselves as art historians working in universities—among them Rosalind Krauss and Michael Fried. But Schjeldahl was "one of those sixties college dropouts you hear about," he admitted, and, without having a chip on his shoulder about it, he makes his autodidacticism a point of pride and of solidarity with readers who are assumed to be smart if not erudite.

An aspiring poet when he arrived in New York City in the mid-'60s, Schjeldahl got his start as a critic in publications like Art in America and ArtNews but eventually found his real niche writing to a broader public when he became the critic for the short-lived weekly Seven Days and then

for the *Village Voice*. His move in 1998 to the *New Yorker*, however, may have been an even bigger leap. The *Voice* shares with the specialized art press a premium on contemporaneity, whereas the *New Yorker* has licensed Schjeldahl to turn his eye toward the cultural summits; yes, you can read about painters-of-the-moment like John Currin, Neo Rauch, and Lisa Yuskavage in *Let's See*, but more of it is devoted to classics like Johannes Vermeer, El Greco, and Peter Paul Rubens—the blockbusters for whom crowds have lined up at the Met.

Meanwhile, what happened to Schjeldahl the poet? Poetry "gave up on me in the early 1980s," he explains. "I never had a real subject, only a desperate wish to be somehow glorious." Feelings, one suspects, are much rawer, and find a socially acceptable form in the guise of humility; "subject" may be another way to say "will to persist in the face of the indifference most poets have to contend with." But poetry lurks within Schjeldahl's prose, and when poetry is lacking there's still something nearly as good: the bracingly dialectical rhetoric of epigram. Speaking of a sculpture by Alexander Calder, Schjeldahl notes that it's "grand but so affable you forget to be impressed." One of his great talents as a critic is that he also consistently forgets to be awed by artists even grander and much less affable than Calder—the "congenitally ag-grieved" Paul Cézanne; the "glowering" Jackson Pollock, "whose ruling emotion was fear"; the "truly barbarous" Jean Auguste Dominque Ingres. Even when Schjeldahl advises that "it is good to be on amicable terms with Chardin," one suspects a hidden threat. "I've discovered a reward-

ing way of looking at sculptures by Alberto Giacometti," he announces at the beginning of one piece, inconspicuously acknowledging that he might not have found them very rewarding before. What makes Schjeldahl a good writer on the classics is that, without pretending not to recognize them as such, he likes to bring out the awkwardness, irritability, and riskiness in their work.

Contemplating the art of the Aztecs, Schjeldahl thinks, shows that "a civilization based on slaughter steadied and inspired human genius." It's a sobering thought, but the very concreteness with which he imagines Aztec brutality ("Sights and smells of gore attended normal life in Tenochtitlán—children must have grown up liking them.") testifies to the depth of his need to check his own aestheticism. The lesson is clear: art is good—Schjeldahl has no doubt of that—but not necessarily good for you. A persistent warning note is sounded: "beauty isn't nice." That's not too hard to disagree with, but how about "beauty can be a kind of murder"—this, apropos not of the Aztecs but of, again, Jean-Baptiste-Siméon Chardin? For Thomas Eakins, less dramatically, "the dignity of art may have stood in an inverse relation to the nobility of its motive." An inquisitor painted by El Greco seems "repellently cruel," but the painter "regards severity as part of the man's important job and a good thing for everybody." In short, art is always capable of going against the grain of socially sanctioned good and of supporting socially sanctioned cruelty.

One reason Schjeldahl needs to reiterate this insight is to defend art from its credentialed defenders, all those "gorgons" and "educators"

whose jobs in art's "sentimentally celebratory institutions" depend on showing that it is personally edifying and socially constructive—philistines *sans le savoir* in their attempt to harness art to utilitarian agendas of improvement. Whether in the museum hall or the seminar room, they must seem in his eyes a bit like Mrs. Beale in *What Maisie Knew*, who exclaimed of some lecture, "It MUST do us good—it's all so hideous." But there's more to it than that. He's fascinated by the danger in art for its own sake. He's a little like a connoisseur of fugu, the Japanese blowfish whose liver contains a deadly poison; if a nonlethal amount of the toxin remains in the fish after preparation, it is said to impart an especially desirable tingling sensation. It's a good *frisson* to feel in the vicinity of old master painting, which can so often be made to seem boringly worthy.

In retrospect, it's a bit surprising that Schjeldahl held out as a denizen of the contemporary art scene for the three decades before he was taken up by the *New Yorker*—or at least that he retained his enthusiasm instead of setting up shop as an accredited curmudgeon. His taste has never exactly been mainstream. Minimalism he acknowledges as "the dominant idea in art of the past forty years." He respects it and regrets it, and if he hasn't warmed to it by now he's never going to—not to its works, which "succeed by occasioning, rather than communicating, bleak epiphanies," and not to the milieu that formed in its wake, "waves of academically trained artists, curators, and critics" who could happily see the point of an art that would be "boring, on purpose." If Schjeldahl did have a moment when he appeared to be in sync with the zeitgeist, it would have been the era of what was wrongly called Neo-Expressionism. Looking

back on "the early 1980s revival of painting and public sensation," he acknowledges, "I saw great promise in the moment and a role for myself in promulgating it. Its disintegration taught me a lesson in humility." Rarely has "humility" been such a transparent euphemism for "disappointment." What's sad is Schjeldahl's diffidence about continuing to make a case for the artists he championed in the early '80s. It would be interesting to know what he thinks now of David Salle, for instance, but mum's the word. Jean-Michel Basquiat is here, but he's an easy case if it's true that, as Schjeldahl says, he made really good work only in the single year of 1982—in that case you can uphold him and dismiss him by turns. Cindy Sherman is a special case among the stars of the early '80s: she's a photographer rather than a painter but also one of the few cases in which the taste of those "academically trained artists, curators, and critics" who now define the consensus links up with Schjeldahl's enthusiasm.

Without the oxygen of what he calls "public sensation," Schjeldahl would choke. "Your criticism is about the studio," he once told me, "mine is about the opening." By "opening," he meant, I think, not so much the party, the social occasion, but rather the moment when a work first emerges in public view, as yet uncategorized and uninterpreted. At the time, I understood him to be subtly and perhaps rightly taking me to task for misunderstanding my role as a critic—to be saying that if there's a side to be taken, it's that of the public, not that of the artist. Schjeldahl and I are both admirers of Charles Baudelaire, who wrote of his art criticism that "as for techniques and processes ... neither public nor artists will find anything about them here. Those things are learned in the studio

and the public is interested only in the results." But at the same time, I now see Schjeldahl was revealing his own limitation as a critic, a need, not to be at one with the crowd, but nonetheless to be where the crowd is. This weakness—if that's what it is—is inseparable from one of his great strengths as a critic, a sensitivity to the importance of what might be called the group mind in art.

Consider this passage: "In the early twentieth century, influential artists and intellectuals in Europe and America agreed to exalt Cézanne's obstreperousness as the echt modern mind-set, thereby instituting a cultural oligarchy of experts which even now, though with mounting self-doubt, stands against popular taste." Most curious, and indicative of Schjeldahl's fineness of touch, is his choice of the verb "agree." He's gently poking fun at what Harold Rosenberg called "the herd of independent minds" by pointing to a contingency verging on arbitrariness in the self-appointed experts' election of Cézanne as their totem. But if you think Schjeldahl is aiming to debunk the cultural consensus—to suggest that somehow it would be better if we could all just forget the whole thing and go back to some form of untroubled pre-modernist representation—forget it. He respects the social nature of opinion formation as much as he understands its fragility. He reminds us that there is no objective basis to the judgments that have become tokens of cultural belonging, like that of Cézanne's greatness, but that it can become nearly impossible to judge otherwise. And so it's just the case that "you can't say something bad about Cézanne in the discourses called 'modernist' any more than you can gainsay Jesus with language from Christian liturgy."

But that doesn't mean that praising Cézanne is enough to make you a modernist any more than praising Jesus is enough to get you into heaven. Maybe in religion there's wiggle room, but in art, salvation definitely lies in works, not faith, as shown by the fascinating case of Norman Rockwell, to whom Schjeldahl devotes some pages of beautifully calibrated assessment. Remember that when Schjeldahl started out, it would have been impossible for an art critic—as opposed to, say, a highbrow critic of mass culture like Leslie Fiedler—to attend seriously to a figure like Rockwell. It would have been—to give Schjeldahl's analogy with religion another turn—like allowing fair response from Beelzebub in *The Book of Common Prayer*. Yet as Schjeldahl points out, Rockwell rated Picasso "the greatest," and his famous image—you see, I hesitate to call it a painting!—of an old fellow trying hard to make heads or tails of a Pollock painting "expresses Rockwell's perplexed admiration for an avant-garde that he seemed never to resent for scorning him." Schjeldahl doesn't scorn Rockwell. He'd like to like him and finds much to admire, both in his painterly chops and in the lessons his art was devoted to broadcasting. "Most of them," Schjeldahl says of Rockwell's works, "play variations on the theme of tolerance." The problem is that, in the eyes of a critic who spent his boyhood, as Schjeldahl did, in the kinds of small heartland towns that are the inevitable settings for these pictures, Rockwell "got everything right—except the confusion that flowed in and through every jot of my own experience"—except, that is, its soul. He left out the poison that gives art and selfhood (not unlike fugu) their savor.

Still, Schjeldahl thinks, even to concede as much to Rockwell as he does

constitutes a swerve away from modernist orthodoxy—"no mere adjust-
ment of a reputation but a deep shift in how we identify and value visual
art." As a reviewer on the beat it's not incumbent on him to theorize that
shift, but the very lucidity of his examination of Rockwell's art—along
with his finally reassuring realization that he can't commit himself to the
artist's cause—makes it easy to overlook the depth of the transforma-
tion that the attempted rehabilitation of Rockwell would represent if
taken seriously. It's not a change Schjeldahl wants to resist. He thinks he'd
like art to be rescued from the "cultural oligarchy of experts" to whom
Cézanne delivered it and that eventually solidified into the academy of
the Minimalists. Schjeldahl dreams of the artist "as story-teller, as bard"
—an artist who would be illustrative and popular but just as great, as
dangerously soulful, as the modernists.

The problem is that the artists who fill that bill already exist. They have
names like Robert Altman and Clint Eastwood and Spike Lee. If Schjeldahl
really wanted to dwell on that kind of art he could have become a film
critic. Luckily, that never happened. When he tries to convince himself that
"important painting of the past forty years, from Gerhard Richter to John
Currin, has become ever more illustrative," well, that never happened ei-
ther. Such artists quote illustration without deigning to engage in it. And
Rockwell hasn't really been accepted, we've just gotten used to him. The
end of modernism shows no sign of ushering in a more popular form of
fine art. Of course, you never know what's just around the corner, so why
not stick around and see?

MAKING IS THINKING

Richard Sennett and John Roberts
on Skill and Deskilling

The division between art (autonomous, critical, conceptual) and craft (functional, decorative, manual)—though never uncontested—has been obdurate and to some extent has become conventional. More surprising, perhaps, is the realization that, within the fine arts themselves, the same distinction has been reproduced: because painting and sculpture depend on manual skills, within some parts of the art world they have been repeatedly denigrated in favor of art prac-

John Roberts, *The Intangibilities of Form: Skill and Deskilling in Art after the Readymade* (London: Verso, 2007).

Richard Sennett, *The Craftsman* (New Haven, CT: Yale University Press, 2008).

tices deemed conceptual; conceptual art is to painting as art is to craft. While few have been as blunt as Joseph Kosuth was in his 1969 essay "Art after Philosophy" when he remarked on "the minimal creative effort" evidenced by "all painters and sculptors (working as such today) generally" insofar as "if you make paintings you are already accepting (not questioning) the nature of art," his general drift has not been uncommon, at least in certain academic circles.

Philosophically, the problem of craft seems to be a subset of the mind-body problem. Politically, it is involved with the relations among social classes. But the seemingly self-evident distinction between intellectual and manual labor is much less significant than it might appear, and under serious scrutiny, it vanishes before one's eyes. In her book *The Human Condition*, Hannah Arendt pointed out, "Whenever the intellectual worker wishes to manifest his thoughts, he must use his hands and acquire manual skills just like any other worker. [...] The work itself then always requires some material upon which it will be performed and which through fabrication, the activity of *homo faber*, will be transformed into a worldly object. The specific work quality of intellectual work is no less due to the 'work of our hands' than any other kind of work"—albeit "a writer's hand is no better than a ploughman's," as Arthur Rimbaud complained. But Arendt's wise considerations had no currency in the art world of her time or our own.

More recently, two very different writers have once again proposed to reexamine the place of manual skill in our culture. If taken seriously, their work has the capacity to stimulate discussions that

might eventuate in more dialectical conceptions of the relations be-
tween art and craft, and of the place of craft within art, or even vice
versa. Richard Sennett, a former student of Arendt's, is a sociologist
at New York University and the London School of Economics and the
author of many books on class, work, and urban life, among them *The
Culture of the New Capitalism*, *The Corrosion of Character: The Personal
Consequences of Work in the New Capitalism*, and *Flesh and Stone: The
Body and the City in Western Civilization*. His new book, *The Craftsman*,
is the first volume of a projected trilogy on material culture. Even be-
fore the book's first numbered page, in its acknowledgments, he an-
nounces its "guiding intuition": "Making is thinking." His book does not
directly address problems of art, but its every page resonates with
aesthetic issues.

John Roberts is Senior Research Fellow in Fine Art at the University
of Wolverhampton, in England. His previous books include *The Art of
Interruption: Realism, Photography and the Everyday*, *The Philistine
Controversy*, and *Philosophizing the Everyday: Revolutionary Praxis and
the Fate of Cultural Theory*. His new book, *The Intangibilities of Form:
Skill and Deskilling in Art after the Readymade*, is above all a contri-
bution to the theory of art and to the interpretation of the work of
Marcel Duchamp—whose efforts seemed to signify the finalization
of the divorce between art and craft in the early twentieth century—
but has much broader implications for what he calls "a labor the-
ory of culture." As such it may be the most important contribution
to the understanding of Duchamp since Thierry de Duve's *Kant after*

Duchamp in 1996—during which time ambitious studies of the artist have become almost too numerous.

There are distinctions between the two writers' approaches that go well beyond what one might expect from the fact that they practice two different disciplines, sociology and art theory. One is that Roberts is a Marxist, whereas Sennett evinces an unreasoning hostility to Marxism (and even to Karl Marx as a personality, in old age "a bitter, rigid ideologue," according to him). Sennett's is not a mistake inherited from his teacher; Arendt explicitly recognized Marx as one of the two great theorists of labor (along with Adam Smith). With Roberts the problem is just the opposite; assuming as common knowledge the long and complex debates around Marxist theory, he risks alienating readers who are unfamiliar with this material, or who (like Sennett) think they are unsympathetic to it. It's a shame that writers like these seem destined to talk past each other, finding common ground without realizing it, because each represents an insight that is real but partial and which would be stronger if synthesized.

Roberts takes his starting point from a reinvestigation of Duchamp's readymades, being interested in what these tell him about "the place of intellectual labour in artistic production." For him it is essential to see that the readymade does not, as it might appear, announce "the *end of craft* in art as such" but rather a transformation of its relation to other forms of work in art making and in society as a whole: "Artistic labor and other forms of labor define each other" rather than be-

ing separated. Moving on to a reading of the American Objectivist poets, especially Louis Zukofsky—who, as he reminds us, were certainly responsive to Duchamp's work—he sees that this revised sense of artistic craft can be summed up in "ego-diminished attentiveness to the object of thought."

However, Roberts's "mentalism," if I may call it that—his overemphasis on artistic skill as a form of "conceptual acuity" rather than as an interchange between this intellectual skill and manual ones—demonstrates the *déformation professionelle* of an academic more than the true inherent force of his argument. There is no denying "the genius of the hand," despite what Roberts seems to think, because the hand is a tremendous storehouse of experience and information, all of which prepares it for imaginative as well as habituated use. For as Sennett knows (but Roberts forgets) it is no mere metaphor to speak of an intelligent hand—even, possibly, of its genius. If only Roberts had read Sennett's account of how "development of an intelligent hand does show something like a linear progression," he might have developed his own ideas a little differently.

The "conceptual acuity" Roberts praises sounds too much like the scholar's analytical intensity rather than the shrewdness of a craftsman, including that of an artist like Duchamp. "Craftwork embodies a great paradox," Sennett explains, "in that a highly refined, complicated activity emerges from simple mental acts like specifying facts and then questioning them." Indeed, the most acute turns in the

art of the past century have often been based on actions of the utmost simplicity that call one's attention to facts that can be questioned. Generally speaking, an abstract work is simpler than a classically representational one, just as a conceptual work is simpler than an abstract one. Its genius is in its simplicity. Yet all such works, even the most rarefied, have some basis in manual skill as well as in analytical insight or else, as Arendt emphasized, they would never have become manifest.

Often going to art schools as a visiting critic, I have the impression that they fall into two rough categories: those in which the students are steeped in theory and full of ideas about what they want their work to say but are not so good at actually making the things that are supposed to embody these notions (this is the smaller group), or ones where the students are pretty good at making things but don't have a very clear sense of why they should be making the things that they make (most of the schools are like this). Schools where I find most of the students to be equally good with both their brains and their hands are few and far between. That said, I have a better time and my job feels easier when I visit the brainy art schools, but I secretly have more hope that all this flailing around might someday end up leading to good art at the handy ones. Perhaps it's for the same reason that, as Sennett amusingly notes, "it has proved easier to train a plumber to become a computer programmer than to train a salesperson; the plumber has craft habit and material focus, which serve

retraining." What Sennett is arguing is that, although our culture has promoted what he calls "superficiality," that is, quick study and multitasking rather than the craftsman's in-depth familiarity with his material, it might actually be the latter that would serve best in our rapidly changing present.

Roberts the Marxist would undoubtedly answer that Sennett's optimism is itself a form of superficiality. He agrees with Harry Braverman in the classic *Labor and Monopoly Capital* that under capitalism "the very concept of skill becomes degraded along with the degradation of labor." For Roberts, Duchamp is important as the artist who "does not embrace heteronomous labour in order to dissolve art into social technique, but in order to re-pose what artistic skills might be in the light of their transformation by heteronomous labour." Yet Roberts's assumption that this means that with Duchamp "the sensuousness of artistic labour is transmuted and deflected into immaterial forms of labour" unwittingly and ironically makes it impossible for him to show how the artist's goal can be realized, the desire for "the subjectivity of the artist to penetrate the materials of artistic labour *all the way down*." Like Sennett, Roberts only offers part of the theory of artistic labor we need, which would essentially be an account of the idea of skill that art is continually contesting. Making us feel more acutely the lack of this theory may be their strongest contribution to its articulation.

DELAYS IN WORDS

Thierry de Duve on the Name of Art

Kant after Duchamp will be seen as the most important and lasting recent book on art, but it's going to take a while to sink in. I'm tempted to say that, just as Marcel Duchamp referred to his *Mariée mise à nu*

Thierry de Duve, *Clement Greenberg between the Lines: Including a Previously Unpublished Debate with Clement Greenberg*, trans. Brian Holmes (Paris: Éditions Dis Voir, 1996).

Thierry de Duve, *La déposition: À propos de "Déçue la mariée se rhabilla" de Sylvie Blocher* (Paris: Éditions Dis Voir, 1995).

Thierry de Duve, *Du nom au Nous* (Paris: Éditions Dis Voir, 1995).

Thierry de Duve, *Kant after Duchamp* (Cambridge, MA: MIT Press, 1996).

Thierry de Duve, Boris Groys, and Arielle Pelenc, *Jeff Wall* (London: Phaidon, 1996).

par ses célibataires, meme (1915–23) as a "delay in glass," *Kant after Duchamp* might be called a delay in words. Not just that it's dense, which it is, but that it's cagey. Every sentence, it seems, makes a claim, which means that every one demands thought, argument, criticism. All that tends to stop you in your tracks, makes you want to pour over it: has de Duve really gotten this just right or not? But the reason answering that question matters so much is that each sentence is not just significant in itself, but is also going to count for something at various other points in the book, perhaps widely scattered. So that same writing that keeps stopping you in your tracks also keeps sending you backward and forward to other passages elsewhere in the book, and the supposed linearity of reading, and of writing, is thereby completely short-circuited.

When de Duve's book *Résonances du readymade: Duchamp entre avant-garde et tradition* was published in 1989, its back cover announced the imminent publication that same year of another book, *Kant after Duchamp*, which, as it turned out, did not appear. Also in 1989, de Duve published *Au nom de l'art: Pour une archéologie de la modernité*, whose three chapters (one of them titled "Kant [d']après Duchamp") were described by their author as "complementary pieces" to the same "puzzle" as the four of *Résonances*. Interleaved, with some revision, and with the addition of an eighth essay, those seven chapters (composed, according to the dates appended to them, between 1978 and 1989), form the present *Kant after Duchamp*, some of whose chapters were composed in English, others in French.

Whether the volume that finally appeared under that title seven years later is or can be the same book is a nice question, but when dealing with a self-proclaimed nominalist like de Duve, the presupposition ought to be that the same title names the same book.

Who knows what accounted for the delay that brings this (presumably definitive) version seven years behind schedule; certainly the preparation of a long book puts a writer to a severe test, and his publisher as well. Reading one can also be a trial for readers, and the most consequential books often do not achieve their resonance until well after their publication, because it takes so long to assimilate them. I suspect that *Kant after Duchamp* is one of those books whose importance will grow with time, but in any case it is difficult to assimilate, and my remarks on it here are meant to be provisional at best. (An example of the difficulty of assimilating de Duve's thought: in his recent book *The Muses*, translated by Peggy Kamuf, Jean-Luc Nancy more than once cites *Au nom de l'art*, but in posing the question, "Why are there several arts and not just one?" he fails to confront de Duve's notion of the historical advent of an "art in general." On the other hand, Nancy gives some perspective on de Duve's claim by reminding us of what he calls "the permanent subsumption of the arts under 'poetry'"—and it is certainly true that this subsumption held from the time of Plato through the Romantics. So the question phrased by neither de Duve nor Nancy should perhaps be, how did the general term shift from "poetry" to "art"?) In short, this is one of those books you

don't read, but only reread, and, apparently, it has also been the sort of book you can't write, but only rewrite.

The book consists of eight more or less self-contained chapters—at least it was possible to read the chapter on "The Readymade and the Tube of Paint" and "The Monochrome and the Blank Canvas" as self-contained essays when they were first published in, respectively, *Artforum* and the book *Reconstructing Modernism*—yet these separate chapters are woven of many of the same fine threads, though they shuttle back and forth among disparate levels of analysis, between "the universal and the singular," between "the specific and the generic," between "anything and everything," between "after and before," to quote the titles of the four overarching sections among which the eight chapters are paired.

De Duve's project, to the extent it can be summarized, would be to understand the relation between the readymade and painting, the avant-garde and the tradition—or, as it is personified here, between Duchamp and Clement Greenberg. It has to do with reconciling one's love of painting with the feeling that Duchamp's *Fountain* (1917)—the notorious upturned urinal signed "R. Mutt"—is central to artistic modernity. One might call it an impossible project, except that I believe de Duve is correct in finding it to be an essential project for the understanding of art in the twentieth century (which does not necessarily make it any the less impossible). The swarming Duchampians may be no more satisfied with the result than the sparse Greenbergians,

but those who prefer the cortex and the retina a little more tightly wired—and who would wish to mend the diremption between aesthetic experience and artistic form which de Duve acutely diagnoses —will not fail to find encouragement here.

That the book is all of a piece, with subtle interconnections belying the apparent diversity of its parts, does not mean it is all equally convincing. (That's the problem with projects grand enough to be impossible.) The opener, "Art Was a Proper Name" (representing the universal as opposed to the singular) is an immensely lucid dialectical tour of ways that the question of art might be, and has been, approached. I call it dialectical because, while de Duve seems to want it to be seen as a Foucauldian archeology, it much more closely resembles a Hegelian phenomenology. (Not only is de Duve more Hegelian than Foucauldian, despite his dedication of his book to the memory of Michel Foucault; it is also more Hegelian than Kantian, despite Kant's nomination in its title.) In any case it is a bravura demonstration of the way ideas, reaching their limits or exposing their limitations, reveal their substance only as they morph into other quite different ideas. But de Duve reveals his own limitations here, for his notion of art as a proper name—"just as with Peter, Paul, or Harry, or Catherine, Fanny, or Valerie"—completely falls apart when he tries to make this something more than an image or metaphor and calls upon Saul Kripke's theory of proper names in *Naming and Necessity* to undergird his account, thereby claiming to "take the chance that if

some day the theory you accept is shown to be false, your theory of art will collapse." While I can hardly claim the philosophical acumen necessary to verify Kripke's theory, which is that proper names are such insofar as they have reference and not because of any meaning they may also possess, what is clear is that de Duve fails to show that the word "art" could possibly be such a thing, and yet his theory does not collapse. Why is art not a proper name? One could cite a number of reasons, all from within de Duve's own argument, but here I will adduce just one: because, as he says, "aesthetic judgments are always comparative, even though it would be useless to try to say precisely what they compare." A moment's thought will suffice to remind us that Peter, Paul, or Harry, Catherine, Fanny, or Valerie are not, as such, subject to comparison: we "baptize" something as art taking into account our understanding of the tradition of art, and although we may sometimes say, "Funny, you don't look like a Valerie," we are embarrassed to have done so because we know that being Valerie has nothing to do with resemblance to, critique of, or any other relation to other individuals with the same name. Proper names are not bestowed through judgment. As Walter Benjamin puts it: "The names [parents] give do not correspond—in a metaphysical rather than etymological sense—to any knowledge, for they name newborn children." The reason de Duve's theory does not, nonetheless, collapse is because what he wants to get at with this notion of the proper name is something important and until now inadequately conceptualized: the moment of

impassioned judgment in which one declares, "Now this is art," or, perhaps, inversely, "This has nothing to do with art."

De Duve's fumble over Kripke, and the unimportance of that fumble for the substance of the book, tells us that, although he uses philosophy brilliantly but often awkwardly, *Kant after Duchamp* is not a work of philosophy. De Duve calls himself, rather, a historian. This is a title that Molly Nesbit, for one, has denied him, however. As evidence, she offers de Duve's crucial interpretation, in his chapter on "The Readymade and the Tube of Paint," of Duchamp's readymade in the form of an inscribed metal comb—*peigne* in French. De Duve understands the readymades punningly, and *peigne* not only means "comb"; it is also a subjunctive form of the verb *peindre*, to paint: it implies, for de Duve, *qu'il peigne* (let him paint!) or, better, *que je peigne* (I ought to paint; if only I could paint). But Duchamp, Nesbit says, always avoided any use of the word *peigne* to designate this object; as a title, she tells us, it is a later accretion.

If Nesbit is right—and no more than I am philosopher enough to argue with Kripke am I historian enough to want to argue with her—then de Duve has some serious explaining to do. Not that his theory (here, that "the readymade is to art in general what the tube of paint is to modern painting") would necessarily fall apart without the word *peigne*, but he would have to produce a convincing account for the absence of the word. This might not be so difficult—so studious an avoidance begins to seem significant in itself, like Sherlock Holmes's

dog that didn't bark in the night—but failure to do so would severely undermine de Duve's position. Still, de Duve's account can be said to be historical in basis precisely because it is more likely to stand or fall on such historical particulars than on its philosophical treatment of concepts.

De Duve is more Hegelian than Kantian precisely because, to the extent that philosophy does come into his purview, it is always embedded in a story. What art was, what art is, what art will be are not necessarily the same but can be seen as undergoing a historical development. Aesthetic judgment once took the form of a statement like, "this is beautiful"; subsequently, according to de Duve, it took the form, "this is art"; something different, he gives us to understand (because "art *was* a proper name"), must be in the process of emerging. Perhaps because of this philosophical historicism, *Kant after Duchamp* provides—for the first time, to my knowledge—a genuine intellectual meeting place for practitioners of art, of art criticism, of art history, and of philosophical aesthetics, though this possibility comes only at the price of some severe challenges. Will philosophers, for example, be willing to undertake the fine-grained examination of actual artistic activity that would give their discipline a more concrete content? Will historians become more searching in their treatment of the concepts that organize their field? Will it suit artists and critics to become any less simply opportunistic in their use of ideas on the one hand and facts on the other?

Clement Greenberg between the Lines constitutes a sustained footnote to *Kant after Duchamp*—to the big book's acknowledgments, in fact, where we read of de Duve's first encounter with Greenberg, at the latter's Central Park West apartment, which led not to a theoretical discussion but to an exchange of judgments: Warhol vs. Color Field painting. "A few years later," de Duve continues, "we had our theoretical discussion—in public—but that's another story," the story that is told in *Clement Greenberg between the Lines*. I suspect that some readers, rendered faint of heart by the 460 pages of small print in *Kant after Duchamp*, will turn to the smaller book in hope of gleaning something of de Duve's position without having to work quite as hard at it. That would be unfortunate. *Kant after Duchamp* is a book that concerns everyone who cares about modern or contemporary art; *Clement Greenberg between the Lines* concerns only those who care about the right reading of Greenberg (even if that means anyone who has been convinced of the importance of that by having previously read *Kant after Duchamp*).

There are a number of reasons why that right reading would be important. One of the most interesting, and one that intersects most significantly with *Kant after Duchamp*, has to do with its bearing on de Duve's opening question: "is artistic emotion textually transmissible?" It's not just that both books are full of arrestingly original and cogent arguments, but that those arguments exist not, primarily, to prove a point, but to communicate a feeling. In *Kant after Duchamp*

de Duve does not attempt, for example, to demonstrate that *Fountain* is central to modern art, but rather to unfold the complex of feeling (a feeling, to be sure, informed by a great deal of learning and thinking) that would place *Fountain*, like it or not, at the center of one's internal organization of the field. In the book on Greenberg, he does not want to prove that Greenberg had a good eye or a good theory, but to show the interrelation of his feeling for Greenberg's writing with that for Jackson Pollock's painting.

Speaking of Greenberg's early reviews of Jackson Pollock, de Duve laments, "It's a long time since I've read anything similar (or wrote anything similar, I admit)." I myself would have wished to see from de Duve more day-to-day criticism of new art; I remember asking him for that some time in the late 1980s, when I was editing an art magazine, but the bait was not taken. Although de Duve once wrote an excellent essay on Robert Ryman (it's in his book *Essais datés I: 1974–1986*) his explication of the work of a young French artist, Sylvie Blocher, and (in a collection of essays, *Du nom au nous*), of the grand old man of Canadian art, Michael Snow, show a strange refusal of Greenbergian incisiveness: these are, unfortunately, fairly typical ventures of an academic into the contemporary scene, lumbering and overelaborated, however learned; and in the case of Blocher, the reproductions suggest that work in question was hardly worth the chin-pulling. And yet the critic comes into play when the historian's at work. In *Du nom au nous*, "Vox Ignis Vox Populi," a re-

markable essay on the controversy surrounding the $1.76 million pur-chase by the National Gallery of Canada of Barnett Newman's *Voice of Fire* (1967), is witty, profound, and totally comfortable in connecting past and present: everything we want criticism to be.

Almost as good is de Duve's essay for the Phaidon monograph on Jeff Wall. As a compendium of reproductions, this volume is more re-dundant than one expects with the series, since images of his work are already widely published, but its selection of Wall's writings and interviews (including a new one with Arielle Pelenc) is useful, and while the essay by Boris Groys is disappointing, de Duve's contributes something new to the literature on this artist. De Duve's title—"The Mainstream and the Crooked Path," echoing ones like "The Universal and the Singular," "The Generic and the Specific"—immediately an-nounces it to be a sort of sequel to the essays in *Kant after Duchamp*. But it's still a refreshing surprise to read an essay on Wall in which Greenberg is more important than Walter Benjamin, and Paul Cézanne more central than Édouard Manet (though neither Benjamin nor Manet is given short shrift). Although de Duve's history has its questionable moments here—he concedes far too much to the myth of photogra-phy's cataclysmic effect on nineteenth-century painting—he finally succeeds in wresting the content of Wall's work away from the social history of art. De Duve does not acknowledge the Mexican artist Yishai Jusidman's understanding of Wall's work as representing a sort of salonization of the avant-garde, but his discussion of Wall's *Dia-*

tribe (1985) as a "politically correct but aesthetically unconvincing work" shows how the tendencies Jusidman decries are indeed present in Wall's work, though as a problem Wall has elsewhere overcome. Among the signal features of de Duve's style is his ability to modulate between an impressive forthrightness—how many of us would be willing to say, for example, that Cézanne solved a problem for which Nicolas Poussin has produced no more than an "expedient"—and an almost sibylline reticence, as in what seems to be a tactful demurral about Wall's recent ventures into a digitalized "grotesque." Only his willingness to assume considerable familiarity with the existing literature on Wall gives the essay a last whisper of scholasticism.

ABSOLUTE ZERO

Kirk Varnedoe on Abstraction

"With a speed that still seems amazing," wrote Clement Greenberg some sixty years ago, "one of the most epochal transformations in the history of art was accomplished": the arrival of abstract art. This was, in the eyes of Greenberg and many others, not simply one new possibility added to the rest, but the one that would inevitably come to dominate: an art uniquely answerable to "the underlying tendencies of the age." Today, the transformation seems less epochal. Artists, critics, and theorists are more likely to point to Marcel Duchamp's discovery of the readymade than to the advent of abstraction as the really amazing transformative leap in art in the early twentieth century. And good abstract painting and sculpture are still being pro-

Kirk Varnedoe, *Pictures of Nothing: Abstract Art since Pollock* (Princeton, NJ: Princeton University Press, 2006).

duced, it might be conceded, but only in the same way that, for Greenberg, "good landscapes, still lifes and torsos will still be turned out" under the reign of abstraction. Step into the contemporary wing of any museum and you will see far more representational art, in the form of photographs, videos, and installations—or even more or less traditional representational painting—than you will abstraction.

Has the great adventure of abstraction faded with the century that gave birth to it? If so, then we should at least be able to get a historical grip on the phenomenon. We are still far from having such a history at our disposal, but one might hope to find a contribution to it in a book with a title like *Pictures of Nothing: Abstract Art since Pollock*. The volume itself is a glossy, heavy-weight production, with copious illustrations of the many works discussed. Its text has been transcribed from the 2003 A. W. Mellon Lectures given at the National Gallery of Art in Washington by the former Chief Curator of Painting and Sculpture at the Museum of Modern Art, Kirk Varnedoe. There is thus considerable experience behind these lectures, and considerable institutional weight. The annual Mellon Lectures have produced some landmark, and often very popular, contributions to the literature of art, from Kenneth Clark's *The Nude* and Ernst H. Gombrich's *Art and Illusion* in the 1950s to Arthur C. Danto's *After the End of Art* and John Golding's *Paths to the Absolute* in more recent years.

Varnedoe himself was an energetic and highly influential figure in the American art world. A charismatic lecturer (and rugby player), he was born in 1946 to a wealthy family in Savannah, Georgia;

his grandfather had been the city's mayor, his father a stockbroker. Varnedoe was educated at Williams College, which has produced an unusual number of today's prominent museum curators and directors (in his foreword, the National Gallery's director, Earl A. Powell III, recalls their encounters "in the undergraduate classrooms and on the muddy playing fields" of the college); at Stanford, under Albert Elsen; and in Paris, studying Auguste Rodin. An early contribution was "The Ruins of the Tuileries, 1871–1883," a social-historical account of Impressionism centered on the charred remains of the royal palace after the Commune. Varnedoe began curating while teaching in New York in the 1970s. His early exhibitions suggest an eye for undervalued artists and schools, such as the lesser-known Impressionist Gustave Caillebotte, or fin de siècle painting from Scandinavia. His collaboration with William Rubin at MoMA produced the contentious "Primitivism" exhibition in 1984.

As Rubin's chosen successor, Varnedoe was named Chief Curator of Painting and Sculpture at the Museum in 1988. He opened the new decade with the massive "High and Low: Modern Art and Popular Culture" (organized in collaboration with Adam Gopnik, who contributes a preface to Pictures of Nothing) and continued with major retrospectives of such postwar American artists as Jackson Pollock, Jasper Johns, and Cy Twombly. In 2001, already ill with cancer, Varnedoe stepped down from MoMA to take up a post at Princeton, where he devoted himself primarily to preparing the Mellon Lectures. Varnedoe must from the beginning have intended these as a summa-

tion of sorts. There is for this reason a terrible poignancy to what would otherwise have been the standard disclaimer issued at the start of the last lecture in the series, when he says, "I am so painfully aware of how much has gone unsaid, and how much I would still like to say"; all the more so as he then goes on to quote Rutger Hauer's words in *Blade Runner*—"All those moments will be lost in time, like tears in rain. Time to die."

For all that, there is nothing of the valedictory about Varnedoe's account of abstraction. He urges us to forget the "wearisome habit" of always seeing ourselves "at the end of something rather than possibly near the beginning," the way "so many scholars and critics—and artists too—are accustomed to thinking that the party was over before they got there, and that everything has to be described in terms of the ruination of a former set of ideals." In fact, Varnedoe does not much like the extremism of abstraction's beginnings either, and seems most comfortable *in medias res*. At the beginning of his first lecture, he explains that he will be speaking about the abstract art of "the last fifty years or so" and that the payoff to this discussion would be an answer to the question, "Why abstract art?" But there is something odd about the promise to offer an explanation for the existence of abstract art that has little or nothing to say about its originators—about what artists as geographically far-flung and ideologically diverse as Piet Mondrian, Kazimir Malevich, and Arthur Dove might have had in mind when they began painting abstractly in the second decade of the last century. Varnedoe has little sympa-

thy for the origins of abstraction; these amount in his view to "a culture of crypto-religious, timeless certainties, associated closely with the new monolithic collectivism in society"—a breathtaking simplification that allows him to dismiss both the theosophical and the revolutionary aspirations of the pre-World War II abstractionists at once.

Strangely for a book whose subtitle cites Jackson Pollock, Varnedoe does not dwell for long on the great American Abstract Expressionist—nor has he much to add on Pollock's New York School colleagues, such as Mark Rothko, Barnett Newman, and Willem de Kooning. Pollock seems to matter most for the way his art might be said to draw a line between abstraction's past and its future—the way it made what Varnedoe characterizes as "the math-based, systematic art" of European Constructivists like Richard Paul Lohse look "very retrograde" and thereby cleared the ground for the Minimalism of the sixties. (The admiration of arch-Minimalist Donald Judd for Lohse then becomes very hard to explain, however.)

Varnedoe is also drawn to Pollock as an excuse to air his annoyance with what he calls the art-historical left who believe, he claims, "that Abstract Expressionism like Pollock's succeeded because of a CIA plot." Varnedoe is thinking mainly of the critics Max Kozloff and Eva Cockcroft, who in 1973 and 1974 wrote about Abstract Expressionism as, in Cockcroft's words, a "weapon of the Cold War"; and of the Canadian art historian Serge Guilbaut, who in 1983 published a book with an attention-grabbing title, *How New York Stole the Idea*

of *Modern Art: Abstract Expressionism, Freedom and the Cold War.* Never mind that these writers never said anything as simple-minded as Varnedoe implies, for him, the real point is that Abstract Expressionism could never have been effectively used as propaganda because its meaning is just too indeterminate. Looking at Pollock, "some are going to feel that this work is about savage energy, others about lyricism; some will think it dances, others that it explodes; etcetera, etcetera." That abstraction is amenable to facile interpretation is beyond a doubt, even without Varnedoe's exemplification of it; but for him, its whole effort is to evade "a monolithic social solidarity that would limit the potential meanings produced by the art." According to Varnedoe, the best American abstract art achieved its freedom by shedding the weight of ideas that burdens European art: Pollock, he says, offers "a translation or extrapolation of Surrealism [...] that leaves behind the earlier style's ideological baggage and its metaphysical claims," and Frank Stella does the same favour for Constructivism. It does not seem to occur to Varnedoe that he is himself using this art as support for an ideology, namely the one that, in American political terminology, is called liberalism; that precisely in purporting to refute its usefulness as propaganda, he is making a sort of propaganda out of it.

Yet that art should be something of the order of propaganda or advertising is evident in the particulars of Varnedoe's taste. If he prefers a painting by Frank Stella to one by Josef Albers, this not

only has something to do with his perception that the Stella painting is, one might say, manlier than the Albers—"powerful and aggressive" and "as big as a man," in contrast to the "demure," "staid" work of Albers—but also that it is more attention-grabbing, that it is "jazzy and bold," qualities one would seek in a billboard. But if the paintings are advertisements for individualism, will, and contrariety, then such traits may be apt. Even Dan Flavin's typically austere, delicate fluorescent light sculpture can eventually be redeemed by turning "loud and extravagant [...] indeed *imperious*."

In the wake of Abstract Expressionism, neo-Dada and Pop played up art's potential kinship with advertising for all it was worth. Varnedoe is fascinated by the way Pop artists and many others had such an easy time making fun of abstraction: Roy Lichtenstein reproducing the pattern on the cover of a child's composition book and thereby making a visual pun on the look of a Pollock painting, for instance; or making a comic-book-graphic rendering of a big splashy brushstroke, of the sort one might see in a work by de Kooning; or painting the sole of a sneaker in a way that recalls the geometrical patterning in a Victor Vasarely painting. Varnedoe seems to believe that such gags successfully puncture the pretensions of abstract artists—whether to the "ineffable" and "soulful," in the case of the American Abstract Expressionists, or to a "radically democratic" visual Esperanto with European geometrical abstraction. Maybe, but more to the point is Lichtenstein's thinking about the relation between representation

and abstraction: that abstraction is always representable because representation is always based on an abstract code. In a sense, for Lichtenstein, the early abstractionists were right to believe they had discovered the distilled essence of art—and for that very reason had to be wrong in believing that abstraction could mark a radically new beginning or offer any hope for transcendence. It was only ever going to be able to repeat the gist of what art and design had always already been.

Varnedoe's inclination to shrug his shoulders over questions of the definition of abstraction can be a problem. He cites Philip Leider's argument that we should discriminate between "abstract" art and what he called the "literal" art of the Minimalists. He sees why the opposition between these two approaches was a crucial issue for the art of the sixties—why something "noble, serene, and ethereal, a lushly beautiful statement of humane values" such as an abstract painting by Morris Louis had to seem irreconcilable with "a work that is intentionally dumb and banal, whose only virtue is its quiddity, its insistent 'thereness,'" such as a sculpture by Robert Morris, Carl Andre, or Donald Judd. But he does not seem to grasp that, in proclaiming that "the right choice [...] was to go for Morris, Andre and Judd," he is speaking of an art that has, so to speak, passed through abstraction and come out the other side, not back into an art of representation but to an art of things in themselves. Yet, neither "pictures" nor "of nothing," they are no longer quite what was understood as

abstraction, and closer than most of the Minimalists ever intended to the heritage of Duchamp.

The things that interested the Minimalists were simple, almost identityless things—Carl Andre's railroad ties and copper plates. But even such simple objects have uses, histories, associations, so it is not surprising that the first Minimalist works were soon followed by ones that turned such associations into metaphors—among the examples Varnedoe cites are Joel Shapiro's tiny cast-iron houses—or that put the potential uses of things into operation, as Scott Burton's furniture sculpture does. Varnedoe insists that there are other disciples of Minimalism who hold fast to "imageless abstraction," such as Robert Smithson and Richard Serra, but Smithson's "non-sites" are rich with paradoxes about representation; they do not abjure it. In the case of Serra, it makes more sense to speak of abstraction: as Varnedoe says, he "reintroduces the idea of composition" that Andre and the others had renounced. It is as if Serra were bending Minimalism back toward its abstract sources rather than falling easefully forward toward its surprisingly (and perhaps disappointingly) poetic future.

Looking back to his venerable predecessor as a Mellon lecturer, Varnedoe speaks of wanting to "have an argument for abstraction as good as Gombrich's argument for illusionism." Gombrich's history of illusionism explained how pictorial representation developed, but it never claimed to explain what gave the art that employed it aesthetic value; one might agree that representation had progressed

between the time of, say, Giotto and that of Michelangelo, but this would not necessarily be to say that art had progressed. A strong component in the rise of abstract art was the desire to catch hold of this specifically *artistic* quintessence—the desire for an art that would be nothing but art, whatever that turns out to be. As Ad Reinhardt put it, "The one object of fifty years of abstract art is to present art-as-art and as nothing else [...] making it purer and emptier, more absolute and more exclusive." Perhaps the unexpected lesson of abstraction is the discovery that this pure, unadulterated art cannot be distilled, that art only ever appears as an admixture—with pedagogy, or personal emotion, or propaganda, or whatever.

Gombrich saw pictorial representation as involving a process of "making and matching"—simple representational schemata could be continually compared with their real-life referents and modified to attain greater and greater verisimilitude. Abstraction, one might say, retains the schemata but eliminates the process of matching them to any referent. For the historian the problem arises that, without the matching, one no longer knows what impetus to development remains. There might be a process by which abstraction is gradually attained, but once that has happened, is there anything left but repetition? If not, one might be able to write a chronicle of the successive recurrences of abstraction, but not a history. For Reinhardt, this was precisely the point: "The one direction in fine or abstract art today is in the painting of the same one form over and over again," creating

the proper art for what he proclaimed as "a true museum's soundlessness, timelessness, airlessness, and lifelessness."

Reinhardt, strangely enough, is never mentioned in *Pictures of Nothing*, perhaps because Varnedoe was unwilling to confront such an implacable vision of the static essence of abstraction. But rather than attempting to forge a view of abstraction as a project capable of development, he elides the problem by presenting it as a moment within the development of representation, the "constant cycling between representation and abstraction, between drawing forms out of the world and adding new forms to it." He traces, for instance, the employment of mirrors in sculpture, from a mirrored cube made by Robert Morris in 1965 to Jeff Koons's famous stainless steel *Rabbit* (1986)—from "a neutral, formal element" to "a symbol for the hard sheen and glamour of American consumer culture." In such ways, he explains, "abstract art, while seeming insistently to reject and destroy representation, in fact steadily adds to its possibilities."

Pictures of Nothing is bound to disappoint anyone hoping for a strong response to questions like, "Why abstract art?" or "What is abstract art good for?"—let alone an account of the project of representation in European art as good as that of Gombrich. Instead, as undoubtedly befits a writer whose credo is that "works of art in their quirkiness tend to resist generalities," the book ends up as little more than a sequence of observations on works by a number of artists whose oeuvre Varnedoe considers of value, along with a few lesser

figures whose limitations serve to set into relief the virtues of the chosen few. Gopnik's preface to *Pictures of Nothing* points to the similarities between Varnedoe's trajectory and those of Simon Schama, in history and art history, and Stephen Greenblatt's, in literature: from social-historical contextualization, to neo-Darwinian notions of change through individual variation, to the dissolution of cultural processes into myriad particularities and micro-choices. But isn't the resistance of particulars to generalization one of the most platitudinous generalizations of all? One might be sympathetic to the idea that, rather than representing a single, developing project, abstract art is "generated precisely from giving the greatest vent to those things that make us individually different and separate from each other," yet still wonder: why does Varnedoe's triumphant conclusion come so easily, and feel like such a let-down? Perhaps for the same reason that the "modern, liberal, secular society" of which abstract art is, in his view, the emblem, seems swept by malaise even when it claims to have prevailed at the "end of history." From the Russian Futurists' "Victory Over the Sun" onward, abstract art has been impelled by desires of a greater than individual scope—destructive and creative on a collective scale. If cultures still need these desires undreamt of by liberalism, then abstract art as a total project—or at least a more vivid memory of it than emerges in Varnedoe's pages—may have a future yet.

UNDER THE FLAG

Anne Middleton Wagner on American Art

Having recently returned to the States after a decade living abroad, I now realize I'd allowed certain facts about this place to slip my memory. Some of those facts came back to me with full force last summer, when I watched what I could bear of the two big presidential nominating conventions. It came as a shock to be reminded how unreal the rest of the world is in the rhetoric of Republicans and Democrats alike. Each speaker I heard had a similar tale to tell of how a mother or grandfather or some other forebear had made his or her way, despite untold hazards and nearly insuperable difficulty, from some inhospitable foreign land—Italy, Cuba, Mexico, wherever—to find a new life, get ahead, and gain that holy grail, a *small business*, right

Anne Middleton Wagner, *A House Divided: American Art since 1955* (Berkeley: University of California Press, 2012).

here in the greatest country on earth. If it was a Republican speaking, great-grandpa had done it by dint of sheer personal pluck and determination; from the mouths of Democrats, we were reminded this heartwarming success had been achieved with a helping hand up from a benevolent government may have been big, but, for heaven's sake, never too big. Likewise in the summations delivered at the conclusion of the last of the candidates' televised debates, the incumbent spoke as the representative of "the one indispensable nation," the same one of which his opponent then declared, "This nation is the hope of the earth." The rest of the world is just a place to escape.

American exceptionalism may not be very evident either on Main Street, where the vaunted chance at upward mobility is in short supply, or on Wall Street, where the fabled one percent knows its fortunes to be more deeply entwined with those of its cousins in London and Hong Kong, and with its accounts in the Cayman Islands, than with those of its lesser conationals. But it may still hold some traction in art. Anne Middleton Wagner offers her new collection of essays, *A House Divided: American Art since 1955*, as an approach, however partial or fragmentary, to "the character of art in the United States during the strange (now ended) half-century of American world dominance," therefore to a "culture [...] more or less synonymous with export and empire."

As far as the interface of art and nation, aesthetic and empire goes, Wagner has been there before. After all, her first book, published in 1986, was *Jean-Baptiste Carpeaux: Sculptor of the Second*

187

Empire, with its finely woven articulation of an individual artist's biography within the interlocking institutional frameworks of his time and place. It succeeded in showing Carpeaux as a representative figure in both senses of the word: typical and definitive, thereby justifying her decision to omit the indefinite article from her subtitle. Carpeaux was not merely a sculptor of the Second Empire but implicitly *the* sculptor who, some believed, had "created a body of work perfectly suited to contemporary life, and in so doing resuscitated the art of sculpture in France." A decade later, with *Three Artists (Three Women): Modernism and the Art of Hesse, Krasner, and O'Keeffe*, moving into the twentieth century, and the Anglophone world, which have succeeded nineteenth-century France as the main focus of her interests, Wagner engaged with the representational role of the artist in a different way, by showing three distinct ways of dealing with the conundrum of inventing and embodying the role of woman artist—of "solving an unknown factor of art and an unknown factor of life," as Eva Hesse once put it. In 2005, with *Mother Stone: The Vitality of Modern British Sculpture*, she showed how the supposedly personal, individual, even biological themes of pregnancy and maternity became central *public* concerns for sculpture through the work of Jason Epstein, Henry Moore, and Barbara Hepworth, among others.

Wagner's latest book is more loosely knit than its three precursors, consisting of eleven studies of individual artists and a final chapter

more broadly devoted to performance and video circa 1970. Yet its subtitle seems to promise something of an overview, even a survey, which turns out to be elusive. These days, it's common to find undergraduate art history courses with the title, "American Art since 1945." Had Wagner followed this convention of taking the war's end as her starting point, she would surely have begun her book with an essay on Jackson Pollock, whose mythology was always predicated on his being the most American of American artists. Starting her time clock ten years later, her opening is equally preordained—which is not necessarily to contradict her assertion that "I made the choice carefully": if Abstract Expressionism constituted what Irving Sandler once called "the triumph of American painting," its aftermath or rejoinder begins with Jasper Johns and his paintings of the American flag. Hers is thus a beginning in media res, since, as Wagner says, Johns's first *Flag* of 1954–55 "was made, not in the wake of abstract expressionism but directly in its midst"—though one would have to reprove her specification that this means "it constitutes a refusal of invention for convention," since one would be hard pressed to argue that the Abstract Expressionists ever claimed invention as their goal, true as it is that they meant to disregard convention. In any case, the core of the book concerns the art of the 1960s and '70s, with only Johns and David Smith to represent the '50s, and Kara Walker bringing us up to the present.

As for the title of Wagner's book, its citation of Abraham Lincoln

inevitably evokes nationhood under stress. But in her hands that ancient metaphor, state as household, gains force, comes alive again. "Why should we believe that America's powers and persuasions have been exercised only abroad," she asks, "or in the public realm?" Rather, she will attend to the *domestic*, in both senses of the word. She distinguishes between artists whose work imagines "seamless belonging to the nation" and those focused on "productive isolation from its ambitions." This distinction may not exactly be congruent with the famous aporia of "complicity versus critique" that Wagner recognizes as a recurrent quandary in the literature on the subject of her second essay, Andy Warhol, a question that by its own nature is "not answerable in any very reliable way," despite or because of the unambiguous fact that the artist "paints as a liberal" in his "Race Riot" pictures of 1963, or to the theme of "conformity and difference" that she identifies in some of his early work, but it is certainly related. For that very reason it is hard to follow her in seeing this as a genuine division between her artists' stances, which consistently seem quite ambivalent. Thus Johns's flags "speak to how decisively yet subtly our unconscious belonging to the national project can disrupt the surface of our daily life." That's beautifully put, and accurate in explicating Johns, precisely because of how it mutually implicates belonging and disruption.

Wagner emphasizes in its very first sentence that hers is "a book of individual essays, each stemming from its own moment and head-

ing in its own direction," though oddly enough she does not specify the date or occasion of any of the essays but one, which originated in a 2002 lecture on Hesse. Yet whatever the originating moment or direction of these essays, they cross paths sufficiently to make the reader wish they could have been made to answer more explicitly to the moment of the book itself and its own particular direction. Examples: in the opening essay, Wagner teases out the unexpected sense in which Johns's flag series speaks about "whiteness and male identity." Likewise, in the following essay on Warhol, she reminds us that his "Race Riot" paintings are as much about gender as about race, "the endless spectacle of conflict between white and black *men*" (my italics, but her emphasis). She thereby locates a silence regarding "the social threats against women and children, whatever their color," in the discourse Warhol inherited and rearticulated. One can hardly help think back to the foregoing identification of themes of whiteness and manhood in Johns and in doing so it's hard not to wonder in retrospect why Wagner did not find it necessary there to signal whether this should be taken as implying a similar sort of exclusion, and if so, how and why. Suddenly one wishes Wagner had pushed this point in her explication of Johns just that much farther, and that her discussion of Warhol could have speculated a bit on how and why he differs from Johns in his negotiations of gender and race. All the stranger, therefore, that in an essay on Walker's silhouettes, she specifies that "Walker's work (as opposed to Andy Warhol's, say), race took visual

form initially through her use of black and white"—strange because what her parenthetical aside on Warhol overlooks is that his use of silkscreening takes off from black-and-white photographs and in the process, tends to eliminate the intermediate grays; yes, he prints these on colored grounds, but we experience these still as black-and-white images with added color. An essay occasioned by Gordon Matta-Clark's *Splitting* (1974)—his famous project involving a suburban house being cut in half—rightly looks closely at the relation/distinction, at this particular point in American art history, of/between sculpture and architecture. Likewise, in the essay that follows the one on Matta-Clark, Wagner does not directly address the sculpture-architecture dichotomy in speaking of Maya Lin's Vietnam Veterans Memorial, built in 1982 (though in many ways a belated offshoot of the Minimalism of the 1960s)—though she does instead in conclusion nod back to Johns's *Flag* to draw a telling distinction: Johns embedding matter from the quotidian world in the painting's surface while "Lin's polished black wall [...] made them its surface."

The five essays I've cited constitute the book's first section, also titled "A House Divided." The implication would seem to be that these concern the more conflicted of her artists, while those in its second half, "A Place of Safety," are the ones who were more successful—or simply complacent?—in finding something like a haven in a heartless world through their art and its subsumption to the "artificial wholeness" of nationality. This turns out not to be the case. Artists like

Dan Flavin, Louise Bourgeois, and Hesse, to cite three of her subjects here, are the opposite of conformist; Wagner rightly emphasizes their intractability. If anything distinguishes the book's two sections, it's rather that the essays in the latter rather downplay whatever might be specifically American about the work of these American (or in Bourgeois's case, French American) artists. In these essays, Wagner's thematic connections range well beyond the national, some of them not unfamiliar though more subtly articulated than elsewhere (Smith and labor, Bruce Nauman and the body), others more counterintuitive (Agnes Martin and cybernetics). And unlike the essays in the first part of the book, which unpack their subjects by staging subtly polemical dialogues with other works, either expected (Lin's memorial is compared to the competing one that is really juxtaposed to it, Frederick Hart's heroic bronze of three hunky soldiers) or less so (Warhol's paintings are put in play with a number of works by black artists as well as with Norman Rockwell's "brilliant and passionate" image of a young black schoolgirl, a pioneer of integration, protected by a quartet of faceless US marshals).

One of the most telling of Wagner's compare-and-contrasts is between Walker as an artist of black and white and Byron Kim as a painter of "inexhaustible differences," of almost indistinguishable tonalities of skin tone. She gives Walker the better of the argument, but her own method is closer to Kim's: she is most adept at teasing out shades and nuances, and shies away from the definitive or declara-

tive. Yet in her final essay, Wagner revisits Rosalind Krauss's essay for the inaugural issue of *October* magazine in 1976, "Video: An Aesthetics of Narcissism," and substantially refutes it. I should say here that this essay, like several of those on individual artists (I am thinking in particular of those on Warhol, Smith, and Martin) should become obligatory references for future writers on their subjects. The essential issue for early video art, and for the performance art that was so closely allied to it (Vito Acconci, Joan Jonas, etc.) was not "narcissism" but rather, Wagner claims, the question, "How can a work make itself public?" What is the nature of the mutual copresence of object and viewer? Although Wagner adds here that such questions "rephrase other anxieties of the moment: for example, the artist's relation to his fellow citizens, or the conflicted dualism of belonging and alienation," her argument seems to have led her to concerns that are more metaphysical than political or social, since she seems to call attention to effects of technology as such. Through technology these artists address a sort of public, to be sure, but only in a minimal sense: not a people or *the* people, not "fellow citizens," but simply people, any people whatsoever. In Acconci's video *Centers* (1971), the artist is seen pointing at the video camera—therefore at himself being taped, as Krauss emphasizes, but also at the viewer, which is what counts for Wagner's argument. But the viewer who is being pointed at is not being interpellated—to use the word that Louis Althusser put into circulation at around this same time—as an American or a for-

eigner, a bourgeois or a worker, a man or a woman. Acconci is pointing to any viewer whatever, and the possible identification or disidentification between the concrete individual Acconci who is pointing and the unspecified viewer X at whom he is pointing, and in whose position he might find himself, is the quandary at the heart of the work.

What makes us return to the work of an artist like Acconci—and what Wagner reproaches Bill Viola, a maker of more technologically spectacular video art than that of Acconci, for lacking—is an "inbuilt mistrust of his medium." Yet how much smaller this mistrust sounds than that anxiety, surely related but not synonymous, that Pablo Picasso once proclaimed as the lesson of Paul Cézanne. I wish Wagner had remembered that this mistrust is not enough to make Acconci, or the other artists whom Wagner values, "citizen artists in all but name." At least not if it's only the medium that the artist distrusts—and at least if distrust is not all that he has to bring to the medium. Wagner herself spreads her skepticism far more widely than that. And yet her writing reaches its greatest power in those passages where she can finally overcome her own innate wariness. In the essay on Smith, for instance, she reminds us that sculpture "is in constant dialogue with other forms of manufacture, forms that extend to the whole complex history of human making. [...] All worthwhile sculpture resonates with other sculpture, yes, but even more with such milestones as the brick, the wall, the barrel, the bowl, the coffin, the hand ax, the howitzer, the missile, the microchip." The strength of Smith's sculpture lies in the

depth of his familiarity with many of these forms and indeed in his trust that his work could wrest something meaningful from its connections with them. In principle, the technology of video imaging is no more (though also no less) alienating than the technology of microchip production, the forging of weapons, or the baking of bricks. We should never tire of reminding ourselves that it is the structure of social relations within which any technology is deployed, and not the technology itself, that determines its most powerful effects. Most of the time, Wagner remembers that there are reasons beyond the use of any given medium for the "dissonance of identity" in the work of American artists, which "both shores up the nation's larger power and imagines an alternative order of things." But in this as in so many other things, America may be less exceptional than it would like to believe.

POST-COMMUNIST AESTHETICS

Boris Groys on the Taste for Politics

Boris Groys made a strong impression with his first book, *Gesamt-kunstwerk Stalin*, in 1988—but more so with its publication in English and French in 1992 (as *The Total Art of Stalinism* and *Staline, œuvre d'art totale* respectively) than with its original German publication. This delayed impact undoubtedly has something to do the larger role of English and French than of German as languages for the diffusion of discourse on art, but of course it has even more to do with the world-historical changes that had taken place in the intervening four years; after the dissolution of the Soviet Union it undoubtedly became easier to read with equanimity a book showing Stalin as a kind of artist. And yet there is still a third reason why the book could be

Boris Groys, *Art Power* (Cambridge, MA: MIT Press, 2008).

received differently in 1992 than in 1988: the entry of unofficial and conceptual Soviet art into the Western art system—thanks, of course, to the same processes that led to the dismantling of the USSR—but also, to a certain extent, that of Stalin-approved Socialist Realism. Shortly after statues of Lenin were torn down all across Eastern Europe, exhibitions of official Soviet art began to appear in venues whose programs normally reflect a taste for modern and postmodern avant-gardes (Museum of Modern Art, Oxford, 1992; PS1, New York, 1993; documenta Hall, Kassel, 1993).

There had occasionally been exhibitions of unofficial Soviet art in the past, primarily drawn from the collections of Westerners who had managed to smuggle it out of the country. Only around 1986 did state-approved exhibitions of it become possible; Soviet artists were quickly swept up by the Western art market and in 1988 Sotheby's held its first Moscow auction. Writing in 1990, on the occasion of the first major American museum exhibition of Soviet conceptual art, one of its curators, David Ross, observed that "Moscow in July of 1988 had a smell of land-rush fever to it, as a literal horde of American and European art dealers, collectors, journalists and carpet-baggers descended on Moscow for the auction." Whether this gold rush ever amounted to a genuine reception of nonconformist art remains doubtful. Certainly few of the artists whose works sold for astronomical prices twenty years ago are still considered major figures internationally. Ilya Kabakov, the artist with whom Groys is most closely as-

sociated, is one of the rare exceptions. Nonetheless, an acquaintance with this art remains the best preparation for understanding Groys's work, both in *The Total Art of Stalinism* and since, despite the fact that it is not the subject of that book.

That a certain art became known as unofficial or nonconformist can be misleading if it is taken to imply that its makers were "dissidents" in the sense that one uses the word of writers and activists like Andrei Sakharov or Alexander Solzhenitsyn. They were not primarily protesting against a despotic order. Soviet conceptual art (and literature) faced social and political realities with neither dissent nor assent, but with an uncanny neutrality that endows its best works with a disquieting air of paradox. In this neutrality, evident in such well-known paintings as Erik Bulatov's *Brezhnev in the Crimea* (1981–85), or Komar and Melamid's *I Saw Stalin Once When I Was a Child* (1981–82) (produced after their emigration to the United States, and now in the collection of MoMA, New York), it is actually closer to the mainstream of American Pop art than to the conceptual art with which it shares a name—Pop, the art that drove critics of the early '60s like Max Kozloff to ask whether one was supposed "to regard our popular signboard culture with greater fondness or insight now that we have Rosenquist? Or is he exhorting us to revile it—that is, to do what has come naturally to every sane and sensitive person in this country for years?" One can easily imagine an admirer of Solzhenitsyn reacting similarly to a painting by Bulatov, just as an admirer of the

Russian avant-garde of the early twentieth century would wonder if Bulatov means the viewer to adore or to curse his stylistic models in the work of Socialist Realist painters of the '20s and '30s like Isaak Brodsky and Alexander Gerasimov. And today, as Groys points out in his new book, *Art Power*, "in Russia, the former dissident culture is dismissed for still being 'too Soviet.'"

It is precisely this kind of sphinxlike neutrality that Groys displayed toward "his" Stalin. Asserting that "Stalinist poetics is the immediate heir to Constructivist poetics" insofar as it "satisfied the fundamental avant-garde demand that art cease representing life and begin transforming it by means of a total aesthetico-political project," Groys contradicted every standard interpretation of Soviet art history. Yet he was hardly, as it seemed to some readers at the time, denigrating the utopian aspirations of the Russian avant-garde any more than he was extolling the author of the Great Purge as a model artist. The effect of his argument was to undermine the Manichean legend of heroic avant-gardists defeated by dictatorial power and to contest the belief, still unquestioningly asserted by textbooks today, that Socialist Realism "conflicted profoundly with the already existing practices of the Soviet avant-garde" and was merely "a historically and geo-politically specific variant of the universally prevailing antimodernist tendencies of the late twenties and thirties: the *rappel a l'ordre* in France, Neue Sachlichkeit in Germany, Nazi painting in the Third Reich, fascist neoclassicism in Mussolini's Italy, and the

various forms of social realism in the United States." That is, Groys denied that Socialist Realism was inherently alien to the genuine revolutionary energies of Soviet avant-garde art and he underlined the essential thing that Socialist Realism took from the artistic avant-garde: a sense of the aesthetic, not as a matter of style (whereby superficial similarities between more or less simultaneously emergent bodies of work can be taken as definitive) but as a total project for the forming of society.

This sense of the aesthetic was a subject of fascination for the Soviet conceptualists of the '70s—though in the absence, in their case, of any alliance with a power offering any possibility of realizing such a project—and Groys's work can for this reason be seen as an offshoot of theirs. It is not surprising, therefore, that the roots of his project are not in academic art history or aesthetics. Born to Russian parents in Berlin in 1947, he grew up in Leningrad and studied mathematical logic at Leningrad State University before becoming a research fellow in the Department of Structural and Applied Linguistics at Moscow State University. He emigrated to Germany in 1981, gaining a PhD in Philosophy at the University of Münster. His connection to art was forged through a direct involvement in the underground art and literary scene dating back to his student years in Leningrad. "I liked the art of Kabakov, Bulatov, Prigov and some other unofficial artists," Groys told me, "and began to write about them—partially because nobody else did it at that time."

Since *The Total Art of Stalinism*, Groys (who is now Professor of Art Theory, Philosophy, and Media Theory at the Staatliche Hochschule für Gestaltung in Karlsruhe as well as Global Distinguished Professor of Russian and Slavic Studies at New York University and the organizer of a number of exhibitions, most notably "Dreamfactory Communism," in Frankfurt in 2003, and "Total Enlightenment: Moscow Conceptual Art, 1960–1990," in Madrid in 2008–09) has continued to publish regularly in German as well as, more recently, to produce essays in video form. Many of his books have been translated into French and other languages, but except for scattered essays, his subsequent writings have been unavailable in English. This lack has recently been partly filled, first with the publication of *Ilya Kabakov: The Man Who Flew into Space from His Apartment*, a brief but trenchant essay on one of the artist's key early installations, and now with *Art Power*, a gathering of fifteen previously published essays dating from 1997 onward. While this collection hardly makes up for absence in English of Groys's more substantial works—one would particularly like to see translations of *Über das Neue* and *Das kommunistische Postskriptum*—it offers a taste of their style and glimpses of their content. With his taste for paradox and self-revision, Groys is a genuine essayist, and even in small doses, one of the most stimulating minds in the contemporary art world.

The essays in *Art Power* are grouped into two untitled sections, the first of them roughly dealing with the contemporary Western art sys-

tem and its institutions: the museum, criticism, curating, and so on—themes treated at greater length in *Über das Neue*. The second group of essays follows up instead on themes related to *The Total Art of Stalinism* and *Das kommunistische Postskriptum*, themes of art, power, and their alliance in the projected creation of a new world. Despite their miscellaneous origin, each of the two sets of essays has a clear implicit argument. In the Western art system, as Groys explains in the first part of the book, there reigns a "logic of aesthetic equal rights" —anything, after Duchamp, can be an artwork—and yet differences in artistic value are still pertinent. The reason is that "good artwork is precisely that work which affirms the formal equality of all images under the conditions of their factual inequality." It is the museum, he explains, that makes this possible, because the museum is the site where observers can learn to discriminate among images as historical phenomena—a skill that the open market and mass media are unable to foster. Museums don't just conserve the past; they effectively generate the new by allowing it to emerge from the background of familiarity. The museum cannot predict the appearance of the new but "shows what it must not look like." Because the newness of art emerges from a process of comparison and differentiation, the work of art can never be revealed in its full presence; art is understood to be something essentially unrepresentable and art objects tend to become documents of art. Only the installation of the work gives it "the here and now of a historical event. [...] If reproduction makes copies

203

out of originals, installation makes originals out of copies." This phe-
nomenon achieves an extreme in the case of digital imagery, where
the underlying information is sublimely invisible. "So we can say: the
digital image is a copy—but the event of its visualization is an orig-
inal event."

Eventually, of course, the newness of new art fades and becomes
simple difference—difference from all the other works that share
space in the museum of things that need not be redone. "The need
then emerges to replace the old new with the new new, in order to
restore the romantic feeling of the infinite real"—the real being ev-
erything outside the museum. Ordinary things become different when
they enter the museum; one thinks of Arthur Danto's phrase: it is
the place where the "transfiguration of the commonplace" occurs. In
Groys's formulation, "the museum provides the possibility of introduc-
ing the sublime into the banal. In the Bible, we can find the famous
statement that there is nothing new under the sun. That is, of course,
true. But there is no sun inside the museum." The market, unlike the
museum, is based on a logic of difference. Presumably this is why, as
Groys notes, the "museum value" of a work need not correspond to
its market value. However dependent the museum may be on the mar-
ket, and whatever the subterranean ties by which they are mutually
imbricated, the two institutions are never in complete accord.

In essence, what the museum provides is a space of disinterested
contemplation such as aesthetics has always called for. Contempo-

rary mass media have nothing to do with this, but in a different way, neither do the arts of totalitarian states such as the Soviet Union. Today, through the media, "terrorists and warriors themselves are beginning to act as artists," as Groys says in the second part of *Art Power*. "Video art especially has become the medium of choice for contemporary warriors. [...] The act of war coincides with its documentation, with its representation." Likewise, "politically explosive problems are ignited almost exclusively by images"—Danish cartoons of the Prophet Muhammad, for instance. But the new warrior art has taken its cues, not from the traditional aesthetic glorification of the conqueror, but from the modernist cult of destructiveness, cruelty, and disfiguration. There remains, however, an important difference between the contemporary artist-warrior and the modernist artist: in the place of the critique of representation conducted by the latter, the former "tries to create images that have a claim to be true and real—beyond any criticism of representation." The artist is fundamentally iconoclastic; the warrior, an iconophile.

The theme of an art that would no longer be a form of representation, but of action, reemerges in "The Hero's Body: Adolf Hitler's Art Theory." Hitler called for an art that would not simply represent heroism, but would produce heroic individuals. "The ultimate artwork [...] is the viewer whom the heroic politics makes into a member of the heroic race. The true art of politics is, for Hitler, the art of the continuous production of heroic bodies." Similarly, Stalinist culture inher-

ited this fundamentally modernist desire to break with any actually existing public in order to form a new one, as Groys emphasizes in "Educating the Masses: Socialist Realist Art." Contrary to Clement Greenberg's assertion in "Avant-Garde and Kitsch" that the Soviet Union encouraged "kitsch" because that is what pleased the masses, Groys asserts that, given the absence of a market in which the artwork had to prove itself, "the actual tastes of the masses were completely irrelevant to the art practices of Socialist Realism, more irrelevant, even, than they were to the avant-garde." Despite the conservative appearance of Socialist Realist art, it was part of a project "in many ways much more radically modern in its rejection of the past" than anything envisaged in the West with its cult of creative destruction à la Joseph Schumpeter. Thus the dismantling of the Soviet Union and its culture can only be experienced as a progression from the future to the past. "Post-Communist life is life lived backward, a movement against the flow of time." Western mass culture, too, creates artificial communities without a past, which is "the source of their enormous potential for modernization, which is so often overlooked," but giving little scope for these temporary communities to recognize themselves as such.

We are all familiar with the idea that artistic forms and positions have political implications, but Groys's emphasis falls on something that is far more rarely noticed, and if there is an essential point to take away from his work it is this: that political forms have aesthetic

implications and are dependent on them. "Radical politics," writes Groys, "cannot be dissociated from a certain aesthetic taste—the taste for the universal, for the zero degree of diversity. On the other hand, liberal, market-oriented politics is correlated with the preference for diversity, difference, openness, and heterogeneity. Today, postmodern taste still prevails. Radical political projects have almost no chance today of being accepted by the public because they do not correlate with the dominant aesthetic sensibility." If we could only learn to love the gray, monotonous, and overwhelming Soviet architecture of the '60s, we could still become communists.

Groys never tells whether he thinks we should reclaim the austere aesthetics of Soviet communism, merely observing that it is possible that we could, though to do so would entail falling out with the polymorphous aesthetic of liberalism to which we are accustomed. What are the politics of Groys's own terse and paradoxical style? Dialectical materialism as propounded by Stalin, on his account in *Das kommunistische Postskriptum*, is paradoxical thinking par excellence, since it must always embody both the unity and conflict of opposites: "it was not what was asserted that led to a deviation being designated as such; the basis for this was instead the refusal to accept that the opposite of what had been asserted was an equally true assertion." Refusing to call himself a Marxist, let alone a Stalinist, he nonetheless attributes to the dictator something like his own gnomic manner of thinking. The essential unresolved question behind Groys's work

would appear be that of the failed encounter between the totalizing aesthetic of closed order committed to a radical project and the universalizing aesthetic of the expansive and happily pluralistic capitalist market—conflicting opposites that have yet to be unified.

Groys bluntly states that his aim in *Art Power* is "to find more space [...] for art functioning as political propaganda"—that is, for the art of revolutionary movements and totalitarian societies. However, his interest in such art is primarily historical, if not nostalgic. When he encounters any form of image-making that fulfills such a function in the present—not, of course, the politically topical art that arises as one of the multiplicity of possible positions within the pluralistic field of the global contemporary art market, but in, for instance, terrorist videos of beheadings or their Western counterparts, the images from Abu Ghraib—he can only agree with the consensus that denies such things can be contemplated as art. This is not only because of "all the ethical and political considerations and evaluations," which "are more or less obvious," or even because there is no artistic author-function at work within such images, but because of their lack of self-criticality. One can only agree. But in view of Groys's seductive vision of an art that would reject all present reception in favor of an implacable idea of the future, it is somehow disappointing that he never really takes a position that would earn him a burning at the stake. Admittedly, his swerves away from danger are always eminently logical, even virtuosically so. Groys possesses a genius for brilliantly provocative for-

mulations whose upshot usually turns out to be less shocking than one had thought it would be. This is not to deny that he is one of the most astute commentators on the art scene today but to show how difficult it is, in this context, to move from the desire for radicality to its attainment.

AGONY AND ECSTASY

Sarah Thornton on the Art World

In recent decades the philosophy of art has been much preoccupied with the enigma of why a given object does or doesn't count as a work of art. Since the challenge of Marcel Duchamp's *Fountain* (1917) and other readymades, according to the Belgian writer Thierry de Duve, the form of aesthetic judgment has undergone a shift: from "this is beautiful" to, simply, "this is art." For the philosopher, art status is like a light switch, either on or off. But the everyday art world is nothing like that, which is why the sociologist Howard S. Becker complains

Howard S. Becker, *Art Worlds*, 25th anniversary ed. (Berkeley: University of California Press, 2008).

Sarah Thornton, *Seven Days in the Art World* (New York: W. W. Norton, 2008).

that the philosopher's art world "does not have much meat on its bones." For Becker, as for artists, collectors, and critics, whether something is an artwork or not is the least of it. In the sociologist's art world, hierarchies, rankings, and orders of distinction proliferate. Status, reputation, is all, and questions about them abound. Why does the seemingly kitschy work of Jeff Koons hang in great museums around the world while the equally cheesy paintings of Thomas Kinkade would never be considered? Why is Gavin Brown's Enterprise but not the outdoor painting show at Washington Square a venue for art ? Why can the works of some artists fetch millions at auction while those of others with good reputations and long exhibition histories can be sold for thousands but possibly never resold? How do conflicting views on the value of different kinds of artworks gel into a rough and shifting consensus about the boundaries of what will be considered art in the first place?

The same kinds of questions could be asked in other fields, but in the art of the last hundred years or so such questions have been of the essence. Art is the field that exists in order for there to be contention about what art is. And such questions are not just for the cognoscenti; they've caught the fancy of a broad public as well. Once the man in the street saw a Pablo Picasso painting and said, "My kid could do better." Today, that child has grown up and is bemused but no longer outraged to read that a shark in a fish tank is worth a fortune but has been generously loaned to the Museum of Modern Art.

Now he admires, at least grudgingly, the clever scamp who could orchestrate that, and finds the whole affair rather interesting to talk about—even if the object itself might not, he suspects, be much to look at.

Sarah Thornton has spent her seven days in the art world of the reigning consensus, the one in which the Koonses thrive but not the Kinkades—an art world that claims the right to call itself *the* art world. Thornton attempts neither to refute nor support this will to monopolize the power to define art; she accepts it at face value. Becker once roughly divided art practitioners into four rough categories: "integrated professionals, mavericks, folk artists, and naïve artists." Only the professionals turn up in Thornton's book, and even then, most are disqualified: a professional supplier of landscape paintings for hotel rooms has no more place here than the most eccentric hobbyist. Thornton's *Seven Days in the Art World* is a book I'd recommend to anyone who wants to know what the exclusive professional art world is like. For anyone who wants to understand why it's that way, and who requires more history and more comparative context than Thornton provides, the best choice is Becker's classic sociological study *Art Worlds*, which has recently been reissued in an updated and expanded twenty-fifth anniversary edition. It's as timely as ever, and Becker knowledgeably draws his examples from the very different "art worlds" inhabited by jazz musicians, theater people, and poets as well as the one surrounding painters and sculptors. Gian

Lorenzo Bernini's relations with Pope Urban VIII are as relevant to his view of art as a form of collective action as E. E. Cummings's difficulties with typesetters.

Each of Thornton's seven "days" is an immersion in a typical setting for art world activity: an auction, an art school critique, a fair, the build-up to the Turner Prize, the offices of an art magazine, an artist's studio (that of the Japanese Pop artist Takashi Murakami), and the Venice Biennale. It's strange that one of the days was not spent at a museum, surely the ultimate destination for every professional contemporary artist. Perhaps this reflects the fact that, despite Thornton's warning that "the art *world* is much broader than the art *market*," her view of the art world reflects the centrality of the market over the past decade. In any case, the "you-are-there" immediacy she cultivates—underlined by section headings within each chapter that track the time of day as it passes—is a convenient fiction; more to the point are the five years that Thornton, a London-based Canadian writer, spent researching the book and interviewing a wide range of art world participants. (To prove how deeply she's dug, even my own name is among the hundreds listed in her acknowledgments.) Thornton is not your typical journalist, but rather a former sociologist whose previous book is a quasi-ethnographic study of British rave and club culture in the early '90s. She is an experienced hand at using participant observation to tease out the tacit system of accords and conflicts that comprise a community and the fine hierarchical distinctions

that structure it. In writing *Seven Days*, Thornton has striven perhaps too avidly for an open, popular tone unencumbered by any overt theorization, indulging in too much description of people's outfits. Yet her academic training stands her in good stead as she attempts to map the "loose network of overlapping subcultures held together by a belief in art."

Thornton's reference to the art world as a subculture ought to be surprising. A visit to one of the great museums of modern and contemporary art that today exist in every important city might easily convince the observer that art is just plain culture, not a subculture—that is, something central and dominant in society. After all, so much money and so much civic pride have been invested in it. But the fact is that the people who make up the art world often worry whether their culture is really central at all. Undoubtedly they believe that it ought to be, but they are deeply aware that there is something eccentric about their relation to the culture at large, something fragile. Like the club culture that Thornton previously studied, the art world is a specialized milieu based on taste; both depend on the value of authenticity and a disdain for the aesthetics of mainstream mass culture. (A collector who loves Roy Lichtenstein will not therefore become an aficionado of comic books.) The owner of *Artforum* reluctantly admits that his magazine "is establishment in a funny sense"; likewise contemporary art is a culture, but in a funny sense. The art world doesn't know

whether it is a subculture pretending to be a culture or a culture pretending to be a subculture.

Nor does Thornton know, and as for the art world denizens' proud but uneasy belief that they are somehow different from other people, she can only agree. "Even in the straightest part of the art world," she finds, "the players have character"—echoing the art magazine publisher who explains his love of the art world through the fact that "It's the place where I found the most kindred spirits—enough oddball, overeducated, anachronistic, anarchic people to make me happy." But they don't know whether their passion is noble or base; one collector speaks about it both as a religion and as addiction. A gallerist nicely sums up his profession this way: "Our business is to sell symptoms articulated as objects." What's ambiguous is whether the symptoms are merely those of a few odd individuals, or of the culture at large. The artists believe in their vision—"a total vision of how things have to be," as one puts it; "an individual's radically idiosyncratic interpretation of the world," says another—and in order for the artist to be successful, dealers and collectors and critics have to believe in it with them; "what we're looking for is integrity," say the collectors. Obsessiveness becomes a badge of honor: "Takashi worked so hard on this painting that several staff quit," a dealer enthuses over a work he's selling, neatly eliding the labor of Murakami's assistants with that of their boss. But at the same time, they believe, "a collection is a personal vision" too—it embodies the collectors'

unique and idiosyncratic view of things (which, like the artists, they would nonetheless like to see collectively acknowledged).

Just as the value of an artwork is always up for contention, especially when it hasn't been hallowed by time (that is, by habit), so the people who populate the art world can rarely feel secure about their position in it. "'Collector' should be an earned category," says one; there is an implicit distinction between the "real" collectors who buy for the "right" reasons and those who just shop for art—but this means the collector's money offers little protection from the sense of being under judgment by dealers (at least those the collector respects as the "right" dealers), artists and above all fellow collectors (the real ones, of course). Likewise, the artists are constantly prey to worry about how they are seen by dealers, critics, and other artists. Success itself can be a sign that one has become boring and uncreative. And of course, while Thornton depicts artists, critics, curators, dealers, auction-house experts, and collectors as all part of one big art world, they don't always mutually recognize each other as such, as when an artist casually speaks of "noncolleagues like collectors and museum people." On the other hand, the person pointing out faces in the crowd at the Venice Biennale and saying, "He's C list. She's B list," would probably not even put most artists, let alone a critic, on any list.

One unusual aspect of the art world—at least among the people who buy it rather than make it—goes unmentioned by Thornton, al-

though a number of her interlocutors subtly allude to it: the fact that, at least in the United States and England, art's collectorship is heavily Jewish, and perhaps to a lesser extent, so is its "administration." Consider the fact that in London, today's unprecedented intensity of interest in contemporary art might never have happened were it not for the efforts of just two men, both Jewish: Charles Saatchi, the Iraqi-born collector, and Nicholas Serota, the director of the Tate Gallery. One collector compares an evening sale at Christie's to "going to synagogue on the High Holidays. Everyone knows everybody else, but they only see each other three times a year, so they are chatting and catching up." A Turner Prize judge compares art to the Talmud: "an ongoing, open-ended dialogue that allows multiple points of view." Thornton observes the director of Art Basel, the world's most important contemporary art fair, making his round of the stands: he schmoozes his clients, the dealers, in French, Italian, and German, and, Thornton adds, "I believe I even heard him say 'Shalom.'"

The implicitly Jewish ethos surely feeds into the feeling that the art world is somehow set apart, part of the establishment perhaps but only "in a funny sense." It also helps explain why the aesthetic of the art world is really an ethic, one that seeks something higher than mere pleasure. One of the deepest observations in *Seven Days* comes not from any of the renowned artists or brooding academics Thornton has spoken to, but the collector who, when asked if he likes work by young artists, says, "I don't necessarily like it, but I buy it." It's a joke,

but it's serious, and from the viewpoint of collecting represents an advanced stage of consciousness—just as for the artist, making something that he doesn't necessarily like does. And this was already the case at the beginning of the last century, for instance in 1905 when Leo Stein bought Henri Matisse's *The Woman with the Hat* (1905), now one of the treasures of the San Francisco Museum of Modern Art. The "nastiest smear of paint I had ever seen," Stein called it. "I would have snatched it at once if I had not needed a few days to get over the unpleasantness." But of course there's a proviso: buying something before you've learned to like it, or making something that you haven't yet learned to like, is not the same as buying something because someone else likes it, or making the art that someone else would like you to make—though of course that is precisely what innumerable collectors and innumerable artists do. To detach oneself from the vagaries of the taste of one's milieu is a considerable accomplishment. But to detach oneself from one's own taste is much rarer. To know one's taste and follow it represents integrity, but to know the limitations of one's taste and aspire to circumvent them is a more refined form of integrity as well as of business acumen. A painter explains of her work, "I know it's finished when the work feels independent of me." A sculptor says, "I don't necessarily love the things that I'm making. It's about allowing yourself to accept what you do."

At a time when art still makes headlines mostly for the absurd prices people are willing to pay for it, it may sound surprising to say that

the ethic of the art world entails a deep ambivalence about its financial basis—the "umbilical cord of gold" that, as Clement Greenberg once observed, has always tied it to the ruling class. Although the art world is filled with people who possess an incredible talent for moneymaking, my observation is that for most of them—dealers and collectors included—there is little true economic rationality to their behavior, or anyway what economic rationality is there is a façade for more obscure motives. This is not to say that those motives are somehow "pure," but rather that even art that seems totally fixated on commercial culture is fixated on it in the mode of fantasy, of image.

Thornton refers to her seven chapters as narratives, but most of them are more like collages of snapshots. Only one chapter yields a conventional narrative arc with aspiration, obstacles, suspense, and final success—and it turns out to be the book's high point. This is the chapter on Murakami, whom we see struggling to realize the biggest work of his career in time for a retrospective at the Museum of Contemporary Art in Los Angeles. The chapter is also an illustration of the strange relation between art and money. Murakami's "studio" is essentially a complex business with centers in both Tokyo and New York City and employing ninety people. But as his dealer admits after the visit, the studio "sends a message. It says, 'We're not some messy workshop. We're a clean, pristine, professional business.'" After which he has to add, "Of course, the organization is totally dysfunctional." To Andy Warhol's dictum that "Being good in business is the most fascinating kind of art ... Making money is art and working is art and

good business is the best art," Murakami's own laughing response is, "That is a fantasy!"

And he's right. It's the last romance, the romance of the mundane. "I threw out my general life," Murakami tells Thornton, "so that I can make a concentration for my job. You maybe expecting more romantic story?" To which one can only hope she responded, what could be more romantic than that? A prominent art theorist has recently written, "The claim of a single artist that his or her work is an unpredictable, creative act, seems obsolete, and is not taken seriously by today's art world." What Thornton's field work shows is that the art world takes this idea very seriously indeed. At the climax of the chapter on Murakami, his giant sculpture of the Buddha, whose construction has caused enormous technical and logistical difficulties, emerges from the foundry. Only now does it become clear that the sculpture is Murakami's self-portrait. "Unfuckingbelievable!" exclaims the curator who has been waiting for this moment of success or failure. He's been rewarded with the most romantic art experience of all, the pure myth itself, and still incredibly powerful: the revelation of creative selfhood through the manipulation of impersonal materials. It's straight out of *The Agony and the Ecstasy*, and we still love it.

GOOD-ENOUGH OBJECTS

Reading Craft

Until I started riffling through *The Craft Reader* I'd forgotten a rather disorienting experience I had a few years ago. Having been asked to give a lecture and studio crits at the California College of the Arts and Crafts in San Francisco, I flew to the West Coast the evening before my talk, checked into my hotel, and got a good night's sleep. But the next morning, when I arrived at the address I'd been given, I was surprised to see a slightly different name above the door: California College of the Arts. Had I somehow shown up at the wrong school? But no, I double-checked the address, found it right, and since, after all, the name was not all that different, I walked in. Yes, I'd come to the right place. But why was the school's name different from the one

Glenn Adamson, ed., *The Craft Reader* (Oxford: Berg Publishers, 2010).

that had been on all those e-mails over the past few months, I asked? Ah, well, I was told, last week the administration had suddenly decided to change the school's name.

I guess I shouldn't have been surprised. After all, the American Craft Museum in New York had just changed its own name, a few months before, to the Museum of Arts and Design. Clearly, at the dawn of the new millennium, craft or crafts had become a calling that dared not speak its name. Why and how did that happen? The historians and sociologists of culture will no doubt eventually have more nuanced answers but for now, the perception of the British furniture designer and woodworker David Pye that "most people are beginning now to associate the word 'crafts' simply with hairy cloth and gritty pots" seems to be on the right track. To identify oneself with craft rather than with art or design was to associate oneself with things that are corny and outdated; to accept greater limits on access to social and cultural capital than come with the designation "art." "I love and admire craftsmanship," the Turner Prize-winning ceramist Grayson Perry says, "but 'craft' has become a concept that I do not always want to be identified with. I fear it has become the domain of ladies in dangly earrings." (Of course, since Perry is a transvestite, he might be one of those ladies himself.)

I don't want to speak of a pendulum swinging back, but more recently I've been sensing a more widespread desire to question this unthinking denigration of craft. Even before the great financial crash

of 2008, there was an uneasy feeling in the air that the level of abstraction at work in all levels of culture had gone too far, that the digitalization and virtualization of practically everything—work, sex, money, war, friendship—had somehow torn society from its moorings in nature, and if it were not too late it might better to stop and reflect, in case it was still possible to get in touch with some bedrock materiality. And then the crash itself, the outcome as it seemed of an uncontrolled and perhaps uncontrollable mannerist spinning off of derivates of derivates of derivates so that in the end there was only the most tenuously nominal relation to whatever reality they were supposed to have been derived from, only stoked the nostalgia for a tangible reality. The sociologist Richard Sennett was thus in sync with the zeitgeist when, in his 2008 book *The Craftsman*, he nominated the artisan as the lead figure in a hoped-for resistance to what he decried as the "superficiality" of contemporary culture, while for the British Marxist critic John Roberts (in his book *The Intangibilities of Form*) the "deskilling" of art in the wake of the Duchampian readymade must be dialectically matched by a "reskilling" so that "what separates artistic labor from productive labour is access to the subjective transformation of materials *all the way down*."

This new attention to craft, to work done through some close contact between hand and thing, means it's a good time for *The Craft Reader*, an imposing compendium edited by Glenn Adamson, an American

who holds the positions of Head of Research and Tutor in History of Design at the Royal College of Art and Head of Research at the Victoria and Albert Museum in London, and coedits a scholarly publication, *Journal of Modern Craft*. He's cast his net wide for this anthology, which covers two centuries of thinking by craftsmen, critics, historians, anthropologists, philosophers, and so on, including many you might not have thought would have had their say on such matters. Here, Alexis de Tocqueville rubs shoulders with Karl Marx, John Ruskin with Vladimir Tatlin, and Lee Ufan, the Korean Japanese protagonist of the Mono-ha ("school of things") art movement, with Norbert Weiner, the father of cybernetics. And of course there are proper high-class makers like Anni Albers, Bernard Leach, and George Nakashima too. Although the book has been made with a student readership in mind, its kaleidoscopic mix of materials means it can open fresh perspectives for anyone interested in crafts—and that even readers who think they're not interested in craft will be more engaged than they expected, if they give it half a chance.

As many of the writers whose words are collected in *The Craft Reader* are at pains to emphasize, the boundaries between "craft" and neighboring fields such as "art" or "design" are extremely porous, and sometimes seem almost entirely capricious. The art world in particular has a way of ring-fencing itself off as exclusive territory in ways that turn out to be self-contradictory. It wasn't so long ago, for instance, that photography could not be shown in a gallery that

showed serious painting and sculpture. The likes of Lee Friedlander or William Eggleston were not seen to have anything in common with contemporaries like Brice Marden or Richard Serra; they were part of a different market and a different critical discourse. Then, in the eighties, artists like Cindy Sherman and Richard Prince began using photography in ways that made new sense to the art world, but by working in ways that seemed to contradict the aesthetics of the photography world. The result was an invidious distinction between "artists who use photography" and "photographers." But eventually it became clear that artists who use photography use it in so many different ways that artists who use photography like photographers and just plain photographers could no longer be told apart. Now Friedlander and Eggleston are okay. And yet the art world remains suspicious of photographers whose "art" credentials seem insufficient.

The barriers between art and craft are still more strongly policed than those between art and photography. As art historian Tanya Harrod points out, already in the era of early modernism "there was a disjunction between a desire to experiment and the capacity of the art world to take in craft genres. Ceramics could synthesise painting and sculpture but this very hybridity proved problematic." Although, most notably, Paul Gauguin and Pablo Picasso did important work in ceramics and other craft media, for instance, these are marginalized in museums and written histories. Yet the resort to craft techniques was an important resource for many artists in their resistance to the aes-

thetic status quo. "While we have histories of the role of the 'ready-made' as an avant-garde challenge to accepted art practice," she points out, "the more complex, messier and less conceptually transparent world of the 'hand-made' remains under-documented." More recently, the art world has made grudging space for crossovers from the realm of crafts, such as the ceramists Betty Woodman or Andrew Lord, but for the most part it wants no more to do with such figures than it wanted with Friedlander or Eggleston twenty-five years ago. There's greater receptivity when an artist using such media has clearly emerged from an art context rather than from the crafts world. The ceramic sculpture of Sterling Ruby, for instance, is more readily received since it comes from someone who also practices painting and video; should more of his ilk emerge then the art world may have to begin a more thoroughgoing revision of his biases, but so far he seems an exceptional case.

Where does the crafts' tangential relation to contemporary art leave those who aspire to devote themselves to a craft medium like ceramics, weaving, or glass with the same single-mindedness that Marden has pursued painting, Serra sculpture, or Eggleston photography? For Garth Clark, a leading historian of and dealer in ceramics, it's been precisely craft practitioners' "inferiority complex" with respect to art that gave impetus to the crafts movement starting with William Morris and eventually "grew from an annoying neurosis to a full-blown path-

ological obsession" that finally destroyed it. Crafts became increasingly influenced by fine art, but the influence was one-way—or if crafts did have an influence on art, it was underground and unrecognized. The American Craft Museum may have rebranded itself as the Museum of Arts and Design but "behind the scenes," he insists, it "was becoming the laughing stock of New York's arts" and could not hide the fact that the crafts were becoming more rather than less nostalgic, regressive, and academic. Clark's solution is a new strategic alignment with design, on the model of the Dutch Droog design group.

Clark has a point. Designers never fail to emphasize that industrial production could not exist without handwork. When it comes to furniture and similar products, according to Andrea Branzi, "Often, in fact, the adjective 'industrial' is intended as an indication more of a style than of a genuine mass-production of models. [...] The new handicrafts accept the positive side of this somewhat ambiguous situation, at least from the stylistic point of view, and turn it to advantage in a production that is free from the problems of mass scale and involves a high degree of experimentation and research." Again and again, not only designers but historians, sociologists, and craftsmen themselves emphasize that the commonplace idea that industrial production has replaced handicrafts is mistaken; the two exist alongside each other and to a great extent industry is dependent on craft and has subsumed it. But if they are seen to be in competition, craft cannot win. Between Pye's claim that "the best possible workmanship [...] al-

lied to the best possible design" cannot be mass produced econom-
ically and that of the philosopher Gilbert Simondon that only "at the
industrial level" has the object "acquired its coherence," and this be-
cause of an internal necessity—"It is not the assembly lines that pro-
duces standardization, but intrinsic standardization that permits the
assembly line to exist"—we would reluctantly have to judge the lat-
ter to be closer to the truth. But in fact both thinkers are victims of
their own idealism. It is the belief that there is a single "best" or "most
coherent" way of fulfilling a function that creates the greatest mis-
chief. But every function exists with respect to a need, and industrial
culture produces new and ever more finely differentiated needs even
more prodigiously than it produces new objects. Perhaps we should
take a cue from the psychologist D. W. Winnicott's idea of the "good-
enough mother" and speak of the good-enough object. And just as
the good-enough mother is not necessarily the one that fulfills all her
child's needs but the one who enables the child to handle her failure,
the good-enough object might be one that overshoots the need it
aims to satisfy and thereby gives its user a new sense of his or her
own spontaneous potential.

Of course, my idea of the good-enough object won't tell any
craftsman (or designer, or artist) what to make or how to make it. Nei-
ther will most of the suggestive concepts they will find throughout this
anthology—not Pye's distinction between workmanship of risk and
workmanship of certainty or Martin Heidegger's between a thing

and a mere object nor Johanna Drucker's between affectivity and en-tropy. Still less will it be obvious how to "use" the many essays by an-thropologists included, which examine the place of crafts in cultures apparently far removed from our own—though these are among the book's most fascinating pages. Tales of car mechanics in Nigeria, a ball bearing factory in Russia at the close of the Soviet period, or even of high-end Parisian chocolatiers may seem to have little to say to a budding glassblower or weaver wondering whether to think of himself as an artist or not. But that very mismatch may help get him thinking about how his place in the world might not be the one he thinks it is—that things might be otherwise. In that sense, *The Craft Reader* is a good-enough book. Someone coming to it hoping to find evidence that the crafts posses a coherent and fully developed critical discourse is likely to come away disappointed. Actually, it seems, they have something that might be better—the scattered pieces of what might be a few too many critical discourses, waiting for someone to put just enough order into them to shake things up (but not enough to nail them down).

CREDITS

"Absolute Zero" was originally published in *New Left Review* 44 (March/ April 2007).

"Agony and Ecstasy: The Art World Explained" was originally published in *The Nation*, December 1, 2008.

"A Benjaminian View of Color" was originally published in *Contemporary* 58 (2003).

"Delays in Words" was originally published in *On Paper* 1, no. 6 (July/ August 1997).

"Fever Charts: On Jack Tworkov" was originally published in *The Nation*, October 12, 2009.

"Ghostly Presence" was originally published in *The Print Collectors Newsletter* 27, no. 2 (May/June 1996).

"Good-Enough Objects: On Craft" was originally published in *The Nation*, October 11, 2010.

"Graphological Gifts" was originally published in *New Art Examiner* 22, no. 6 (February 1995).

"Makeshiftness" was originally published in *London Review of Books* 25, no. 8 (April 2003).

"Making is Thinking" was originally published in *American Craft* 68 (October 2008).

"Modern Love" was originally published in *The Nation*, October 16, 2006.

"Octoberfest" was originally published in *The Nation*, December 26, 2005.

"Out of Sight" was originally published in *The Print Collector's Newsletter* 25, no. 4 (September/October 1994).

"Post-Communist Aesthetics?" was originally published in *New Left Review* 56 (March/April 2009).

"Realism Revisited" was originally published in *Raritan* 28, no. 2 (Fall 2008).

"Resistances: Meyer Schapiro's *Theory and Philosophy of Art*" was originally published in *Journal of Aesthetics and Art Criticism* 55, no. 1 (1997).

"Seeing Past the Gorgons" was originally published in *The Nation*, July 7, 2008.

"Under the Flag" was originally published in *New Left Review* 78 (November/December 2012).

"Use as Meaning" was originally published in *Art on Paper* 4, no. 4 (March/April 2000).

"Words for Art" was originally published in *Art in America* 97, no. 2 (February 2009). Courtesy of BMP Media Holdings, LLC.

Barry Schwabsky

Words for Art: Criticism, History, Theory, Practice

Published by Sternberg Press
Managing editor: Leah Whitman-Salkin
Proofreading: Caitlin Blanchfield, Susan Morrow
Design: Quemadura
Printing and binding: fgb. freiburger graphische betriebe
Cover image © Mary Barone

ISBN 978-3-95679-002-7

Sternberg Press
Caroline Schneider
Karl-Marx-Allee 78
D-10243 Berlin
www.sternberg-press.com